# THE HEROIC RULERS OF ARCHAIC
# AND CLASSICAL GREECE

# The Heroic Rulers of Archaic and Classical Greece

Lynette Mitchell

B L O O M S B U R Y
LONDON • NEW DELHI • NEW YORK • SYDNEY

**Bloomsbury Academic**

An imprint of Bloomsbury Publishing Plc

50 Bedford Square          175 Fifth Avenue
London                      New York
WC1B 3DP                    NY 10010
UK                          USA

**www.bloomsbury.com**

First published 2013

**British Library Cataloguing-in-Publication Data**
A catalogue record for this book is available from the British Library.

ISBN: HB: 9781472505965
PB: 9781472510679
epub: 9781472513465
epdf: 9781472511386

**Library of Congress Cataloging-in-Publication Data**
Mitchell, Lynette G. (Lynette Gail), 1966-
The heroic rulers of archaic and classical Greece / Lynette Mitchell.
pages cm
Includes bibliographical references and index.
ISBN 978-1-4725-0596-5 (hardback)– ISBN 978-1-4725-1067-9 (pbk.)– ISBN 978-1-4725-
1138-6 (epdf) – ISBN 978-1-4725-1346-5 (epub)  1.  Greece–Politics and government–To
146 B.C.  I. Title.
JC73.M57 2013
938–dc23

2013002698

Typeset by Fakenham Prepress Solutions, Fakenham, Norfolk NR21 8NN
Printed and bound in India

For our dear friend, Peter Weeks
*In memoriam*

# Contents

# Acknowledgements

As always, at the end of a project, there are so many people to thank, whose support, encouragement and comfort cannot properly or sufficiently be acknowledged. In the first place I need to thank the Arts and Humanities Research Council, who gave me a period of leave in which a large amount of the final work on this book could be done. I would also like to thank most sincerely Peter Funke and Matthias Haake, who were so generous in allowing me to use the library at the Westfälischen Wilhelms-Universität, Münster, in early 2011 during my period of leave, and who showed great kindness and hospitality during my time there.

I would also like to thank the library team at Exeter University, who have always worked hard to produce books for me, even under trying circumstances, and the librarians at the Sackler and Bodleian libraries in Oxford, particularly in the last weeks when I was trying to finalize the manuscript. Thanks also to the Classical Association, who gave permission for me to reuse some material from my article, 'The Women of Ruling Families in Archaic and Classical Greece', *CQ* 62 (2012), 1–21.

Grateful thanks also are owed to Deborah Blake, Charlotte Loveridge and Dhara Patel from the Press for their enthusiasm and encouragement of this project. I am also grateful to the anonymous readers whose comments have made this book a better one. Also Peter Rhodes read a very early draft, when I had not yet thought of it being a book, and my student, James Smith, made helpful comments on a draft. Many thanks to all for your generosity and gentle criticism.

Thanks also to colleagues and students at Exeter University, family and the many friends who continue to endure and even encourage my obsession with Greek history. Especial thanks must go to my own two men, Stephen and James, who have, as always, been patient and resilient. Words can never say enough for what they give me.

This book, however, is dedicated to Peter Weeks, a very dear friend and fellow sojourner from Australia to the UK. He came before us and showed that it could be done. Peter, Stephen and I were friends together at Macquarie University in Sydney. Peter was best man at our wedding, and godfather to our son. He died suddenly and unexpectedly in Stamford in September 2012. We miss him sorely.

*LGM*
*December 2012*

# Abbreviations

Periodicals are abbreviated as in *L'Année Philologique*, with the usual English divergences (e.g. *AJP* for *AJPh*). Note also the following abbreviations for modern sources (for full publishing details of items listed here, except standard collections of texts and reference works, refer to the Bibliography).

| | |
|---|---|
| *APF* | J. K. Davies, *Athenian Propertied Families, 600–300 BC* |
| Bernabé | A. Bernabé, *Orphicorum et Orphicis similium testimonia et fragmenta.* |
| Brill's *NP* | Brill's *New Pauly* |
| DK | H. Diels and W. Kranz, *Fragmente der Vorsokratiker*[6] |
| *F. Delphes* | *Fouille de Delphes* |
| *FGrHist* | J. Jacoby, *Die Fragmente der griecischen Historiker* |
| *IG* | *Inscriptiones Graecae* (14 vols) |
| *IvO* | *Die Inschriften von Olympia* |
| Jouan & van Looy | F. Jouan and H. van Looy, *Euripide*, vol. 8 (4 vols): Fragments |
| Kuhrt | A. Kuhrt, *The Persian Empire. A Corpus of Sources from the Achaemenid Period* (2 vols) |
| Kassel & Austin *PCG* | R. Kassel and C. Austin, *Poetae Comici Graeci* (8 vols) |
| Kock | Th. Kock, *Comicorum Atticorum Fragmenta* (3 vols) |
| Lobel and Page *PLF* | E. Lobel and D. Page, *Poetarum Lesbiorum Fragmenta* |

| ML | R. Meiggs and D. M. Lewis, *A Collection of Greek Historical Inscriptions to the End of the Fifth Century*, rev. edn |
| --- | --- |
| *RE* | *Real-Encyclopädie der klassischen Altertumwissenchaft* |
| RO | P. J. Rhodes and R. Osborne, *Greek Historical Inscriptions, 479–323* BC |
| *SEG* | *Supplementum Epigraphicum Graecum* |
| Snell *TrGF* | B. Snell, *Tragicorum Graecorum Fragmenta*, vol. 1, 2nd edn |
| Tod | M. Tod, *A Selection of Greek Historical Inscriptions* (2 vols) |
| West *IE/IE²* | M. L. West, *Iambi et Elegi Graeci* I/II² |
| West *ThPhF* | M. L. West, *Theognidis et Phocylidis Fragmenta et Adespota Quaedam Gnomica* |

## Note on transliteration and translation

I have used the Latinized equivalents for most Greek names, and, in the interests of accessibility, have used a transliterated form (with the nearest English equivalents) of a few more specialized terms and individual Greek words, or proper nouns or names where direct transliteration would be more normal (e.g. Dike). All translations are my own unless otherwise stated.

# Introduction

In Greek political thought there was a fundamental principle that there were by nature rulers and the ruled (Plato, *Laws* 689e; Arist. *Pol.* 1.1254a28–33). During the archaic and classical periods, as communities experimented with ways of organizing themselves, they attempted to resolve conflicts over who held power, who had a right to power, who should be making decisions for the community, and how the political will of the community should be expressed and acted on. In this vibrant political culture, democracy was born and oligarchy articulated. Legitimate individual rule, on the other hand, according to the modern orthodoxy, dwindled with the rise of the *polis*, to be replaced by tyranny, which itself largely disappeared by the end of the archaic period. However, as will be argued here, rule by one man, or a family dominated by one man, had a continuous existence as a legitimate political form from the Early Iron Age to the Hellenistic period, and held a significant place in the Greek political landscape.

This book, then, is setting out deliberately to be provocative. In opposition to many current trends in the scholarship, it will argue that 'kingship' remained an important and legitimate political option in the world of the archaic and classical *polis*. It will demonstrate that while heroic pedigree was important, what was more crucial was the heroic stature of the ruler (which itself was a proof of heroic ancestry). It will also argue that in most cities where one man ruled, ruling was consensual and involved constant negotiation between rulers and those they ruled. One consequence of this study should be the disappearance of an 'age of tyranny', at least as it is normally understood. As the product of a discourse (in the manner of the 'invention of tradition'), the so-called tyrants will be normalized as rulers who were ruling legitimately, in the sense that they were trying to maintain control through persuasive strategies rather than necessarily through force.

On this basis, this book will challenge Thucydides' periodization of the 'age of *basileis*' and the 'age of tyrants'. It will also reject the idea that there were

two kinds of 'tyrants', those of the 'archaic' period and those of the 'classical' period (or at least those of the late fifth and fourth centuries),[1] on the grounds that there were trends in the ideologies of ruling which were maintained from the eighth century (and probably before), and continue on into the Hellenistic world. That does not mean that there were not changes in the ways these ideologies were expressed, but, as we shall see, there were core values that remained central for the legitimization of rule over a period of about 600 years (or more). It also does not mean that 'periodization' in itself is problematic – as Morris emphasizes, it is a fundamental part of doing history.[2]

It will focus on the periods known as 'archaic' and 'classical' since this is the time when the *polis* was taking shape, and it is in these periods generally assumed that rulers were antithetical to this kind of political form and political thinking. On the other hand, the eighth to fourth centuries is also the period in which we can find in our evidence actual rulers, whose rule can be analysed, as opposed to the mythical rulers which Drews rightly rejected as reflections of real-life kings.[3] Out of convenience, it will use the terms 'archaic and classical' though for the most part these should be taken together. Nevertheless, it will also be aware that this composite 'period' of 'archaic and classical' in itself is artifical.

On the other hand, it will argue that there is also a different kind of periodization at work, one that is created out of our literary tradition. If there is to be an 'age of tyranny' at all, then it must belong to the late fifth and fourth centuries when the theoretical stereotype of the illegitimate tyrant outside law was developed in contrast to a legitimate ruler, who ruled under law. This discourse of the 'age of tyrants' has had a profound effect not only on how we need to interpret and analyse the literary tradition, and the histories of rulers who might be described in those terms, but also, once the contrast between *tyrannis* and *basileia* had been invented and taken its full shape in the late fifth century, on real-life rulers, like Dionysius of Syracuse, Agesilaus in Sparta, and Alexander the Great, who had to rule self-consciously within the awareness of the stereotype, and walk the line – or even exploit it – between being considered a *basileus* or a *tyrannos*.

There is also another issue relating to terminology, and one that does not just relate to whether one was a *basileus* or a *tyrannos*. This book will argue that ruling was based on the family, and the family joined in and shared

responsibility for ruling, and that co-ruling, polygamy and closely consan-guineous marriages, all familiar from the Hellenistic world, were common as a means of extending and consolidating power. As a result, partly because of the fact that rule was often a family affair, and that co-ruling could be practised, it is difficult to find modern English words as equivalents to describe the phenomenon of 'ruling' in the ancient Greek world. As we shall see in the next chapter, there is some dissatisfaction in modern scholarship with calling *basileis* and their equivalents 'kings', so this term will usually be avoided, although it has to be noted that the alternatives are also often unsatisfactory. Modern understandings of 'monarchy' and 'autocracy' (based on Greek words themselves), for example, do not really do justice to the nature of ruling in archaic and classical Greece, though in fact almost always one man predomi-nated and was the figure-head and driving force of clan- and family-based rule, even where there were co-rulers. It is telling that even the Greeks seem to have struggled with the language of ruling, so that, for example, Herodotus said that the clan of the Bacchiads in Corinth were *mounarchoi* (5.92β), an apparent oxymoron.

## The Evidence

Terminology, and the slippage within that, is one problem. Another is the diverse nature of the evidence across such a long period which presents challenges of interpretation. For the earlier, preliterate, periods we have to rely on archaeological evidence, and the 'mute stones' do not necessarily, or readily, speak. However, as we shall see, they can show us attitudes and interests in their visual representations and their architecture. The construction of large buildings, for example, which show evidence of both domestic and communal use, are suggestive of community and hierarchy – someone lived in them as well as organized events for the rest of the community, events which also appear to have a ritual character.[4] An interest in heirlooms also suggests an interest in the past, and making connections with that past. Images on pottery of war, feasting and chariot-racing speak of elite activities, competition and hierarchy. Warrior burials likewise point to a high value on martial virtues. To this extent we can see an elite behaving politically, in the sense that they are

identifying and living out particular political values, which in turn produces an organizational structure for their society, even if neither these structures would impress very much those looking for an early form of statehood, nor these behaviours, which were not necessarily self-conscious, those looking for the beginnings of Greek political thought.[5]

Once we move into the literate world of Homer and Hesiod, these values are still present, although there is also a proliferation of *basileis* who seem willing to espouse and express them, even if organizationally not necessarily in ways that are easy to understand. Scholars have struggled, and still do struggle, with how we can use Homeric epic as a means of grappling with archaic history and politics.[6] As we shall see in the next chapter, many have doubted whether Homeric *basileis* could really be called 'kings', or even rulers in any meaningful sense, and it is not entirely clear how we should interpret the many *basileis* on Ithaca, or the bribe-swallowing *basileis* of Hesiod who judged in favour of Perses' greed. While some can find meaningful political structures, such as effective assemblies, in the Homeric poems, others cannot. On Phaeacia, Odysseus meets the twelve *basileis*, among whom Alcinous is thirteenth (*Od.* 8.390-1). For Murray, Alcinous and his Phaeacian *basileis* reflect real life aristocracies.[7] Van Wees, on the other hand, thinks that there are *basileis* and *basileis*, and has made a case for hierarchies among them, as between Alcinous and the other twelve, being a familiar pattern in the archaic period.[8] However, both Murray's and van Wees' arguments are drawn almost entirely from epic, and not validated by external evidence, so we return to the issue of how, and in what ways, epic and real life coincide.

On this particular issue, archaeology can probably help us, at least to a degree, since as we have noted there is evidence of an Early Iron Age elite, and of individuals who ruled them. While this does not prove van Wees' case for tiers of rulers, it does seem that in the formative years of epic we have a more hierarchical society than Murray was imagining. Further, while it is true epic compresses the political practices from a number of centuries, we can discern not just the shadows of archaic political forms, but more particularly the values relevant to archaic society, and especially the interest in competition, martial excellence, and the importance of just relationships between men.

When we move beyond epic, our sources become in some senses more tractable, but no less complicated. For early Greek poetry, as has so often

been noted, the performance context is a central issue. Homeric epic was recited at religious festivals, such as the Olympic games or the Panatheneia at Athens, and so can be said to reflect, on some level, public values. Other sorts of poetry were also probably performed publicly, such as narrative historical elegy, which could include foundation stories, defining a community identity, even if these performances – and the *polis* identities they presented – were also competitive and contested.[9] Nevertheless, a great deal of the poetry that we have was private, at least to the context of the symposium, even if it was also repeated widely.[10] The closed but politically charged world of the symposium is certainly where we should locate in its original instantiation the political poetry of Solon, the military poetry of Tyrtaeus, and also the bitter invective of Alcaeus.[11]

Pindar and Bacchylides, on the other hand, are praise singers and court flatterers who tell rulers, at least to some extent, what they want to hear, which is that they are living out the acceptable ideologies of ruling. In that sense the epinician poets are valuable sources for the ideological drivers which support rulers. Pindar in particular, however, is a sophisticated and complex poet, who is willing to pepper his poetry with caution and restraint. It is Pindar who in *Pythian* 1 for Hieron of Syracuse on his victory at the games of 470 and the foundation of Aetna in the closing lines of the poem also tells of Phalaris of Acragas (another Sicilian ruler), who burned men in his bronze bull: 'no household harps receive him in gentle companionship with the songs of boys' (96–7). This is no doubt intended as a cautionary tale, but also it seems that Pindar is aware of the negative discourse that was forming about individual rule. This point makes even more significant the terms in which the epinician poets offer their own praise, and suggest that they are self-consciously engaging with the alternative discourse of positive rule, which itself must be have become self-conscious about how the ideologies of positive rule were to be defined.

In the late fifth and early fourth centuries, we are now in what was truly the 'age of the tyrants', in the sense that the stereotype of tyranny was now fully developed. It is clear that a number of our sources from Athens, particularly those of the fifth century, are themselves very distant from the realities of *basileia*, and so were in general determined to view it as rule by one man alone who exercised absolute control, on the basis of Athenian perceptions of

Persian monarchy. Nevertheless, the picture that they paint of monarchy was by no means a simple, or monochrome, one.[12]

Greek tragedy, in particular, was greatly taken up with the idea of the sole ruler. Indeed, Seaford argues that in Athenian tragedy the tyrant was antithetical to the *polis* and that the destruction of the royal house was liberating for the city.[13] It is certainly the case that it is from tragedy that we get some of our clearest negative images of autocracy. In Aeschylus' *Persians*, for example, the contrast between Persian servitude and Greek freedom is explicit. For example, Atossa, the Persian Queen, dreams of two sisters, one dressed in Persian clothes, the other in Doric, whom Xerxes attempted to yoke. While the 'Persian' sister submitted, the other broke free (176–99).[14]

In Sophocles' *Antigone*, on the other hand, Creon declares that his abilities as a ruler can only be known through the way he rules and the laws (*nomoi*) he makes (175–7; cf. 446–9), and only sees security in the maintenance of the laws of the state, which, as the representative of the people, he has made (188–91, 661–78). And yet as the play unfolds it is clear that the nature of both law and rule is being questioned. While Creon claims to admire the man who can rule well (as someone who would also be ruled well: 668–9), he himself becomes a tyrant in deed as well as in name.[15] Antigone accuses him of being able to do and say whatever he pleases (506–7), the citizens (who support Antigone's actions) fear him so that free speech is no longer possible (509, 685–700), he objects to being told how to rule, and rules as if he alone constitutes the city (734–9); ultimately 'ignobleness is part of his character' and he must be rejected by the city, to become *apolis*.[16]

Euripides also takes up the theme of the dangers and disruptive nature of tyranny. For example, in the *Phoenician Women*, a crisis is caused for the city of Thebes because the brothers Polyneices and Eteocles both want to hold the tyranny of the city by themselves rather than sharing it. Eteocles says that he will do anything to have Tyrannis, the greatest of the gods (504–6). Jocasta, their mother, urges him instead to seek Equality rather than Ambition (531–48), and asks, 'Why do you honour *tyrannis* so much, a prosperous injustice, and consider this a great thing? A costly thing to be coveted; and empty too' (549–51). Likewise, in his *Suppliants*, Theseus, the ruler of Athens who has made the people a *monarchia* 'having liberated this

city as equal-voting (*isopsēphos*)' (352–3), says to the Theban herald (who has demanded to speak to the tyrant of the city):

> This city is not ruled by one man, but is free,
> and the *dēmos* rules in turn by annual rotation,
> not giving the most to the wealthy,
> but also the poor having an equal share. (404–8)

When the Theban herald makes a defence of one-man-rule, Theseus replies:

> There is nothing more hateful for a state than a tyrant,
> where the common laws do not hold first place,
> and one man, holding the law for himself,
> rules; this is no longer equality.
> Where the laws have been written down, both the weak
> and the wealthy have justice equally,
> and it is possible for the weaker to tell off
> the fortunate, whenever he is abused.
> And the lesser man has victory over the great when justice is on his side.
> This is freedom [when it is declared]: 'Who desires to bring some good plan for
> the city to the assembly?'
> Whoever desires to do this gains renown; he who does not want to
> is silent. What is more equal for the city than this?
> And indeed where the *demos* is manager of the land,
> it delights in young men near at hand.
> But a man who is king considers this hateful,
> and the best element, whomever he considers to have sense,
> he kills, fearing for his tyranny. (429–36)

Thus, there was one kind of 'tragic' tyrant who was represented as one who held rule absolutely through force and control of the law, did not allow free speech, and killed without trial (cf. Hdt. 3.80.2–5, 7.39; Plato, *Rep.* 8.565e–566a, Arist. *Pol.* 4.1295a17–24). To be the subjects of this man was to lose the possibility of equality, and even to be enslaved (cf. Hdt. 7.135). As we shall see in the final chapter, these representations of rulers belong to the discourse of fifth- and fourth-century Athenian democracy, which liked to represent itself as espousing the opposite of these values and practices. Nevertheless, such negative images of autocracy have sometimes been viewed as normative, and

so skewed our understanding of early rulers and their relationships to those they ruled.

Yet there are other rulers in tragedy who do not easily conform to this type. While Pelasgus in Aeschylus' *Suppliants* is answerable to the assembly (365–9, 397–401, 516–19, 600–1605–24; cf. 370–5)[17], at the end of the play he seems to be succeeded by Danaus, who probably goes on to rule in Argos and is probably himself succeeded by the Aegyptiad Lynceus, the husband of the Danaid Hypermestra, presenting an ultimately confusing representation of ruling and *polis* identity.[18] Likewise, in Sophocles' *Oedipus Tyrannos* Oedipus' crimes, while they brought down the house of Thebes,[19] were not performed self-interestedly, or even willingly. Theseus, in Euripides' *Suppliants*, is also deeply ambivalent, and despite his claims that the people rule still expects that his opinion will prevail, a ruler in fact if not in theory.[20] Further, in making links between Athenian tragedy and *polis* ideology, we need to be aware that some Athenian tragedians produced plays for royal courts (Aeschylus probably for Hieron of Syracuse and Euripides certainly for the Macedonian court of Archelaus),[21] and some tragedies that won prizes at Athens were not by Athenian dramatists; most telling of all is the Sicilian Dionysius I who won a prize at the Athenian Lenaea of 367 BC for his play the *Ransom of Hector* (Snell *TrGF* 1² T3.3, 1.5; cf. F 2a).[22]

For Aristophanes, on the other hand, the Great King provides a vehicle for thinking about rulers, at least in their more theatrical aspects, since he is known for his wealth (*Acharn.* 102, *Wealth* 170), his exotic clothing (*Birds* 486–7), exotic food, exotic animals and oriental luxury (*Acharn.* 62, 68–76, 85–6, 88–9). Yet, while Aristophanes can mock the King's ambassador in the *Acharnians* (61–125), it is the Great King who becomes the model in *Knights* for Demos, the *monarchos* of Hellas, who wears a 'cicada', antique robes, and is anointed with myrrh (1330–2).[23]

It is Zeus, however, who is for Aristophanes the most important model for individual rule, but not always a very satisfactory one. In *Wealth*, for example, Zeus bears ill-will towards the good (*hoi chrestoi*) (87–92), the only reason he rules over the gods is that he has more money than any of the others (129–31), and his rule is said to be a *tyrannis* (124).[24] In *Clouds*, during the course of the play, it is claimed that Zeus is driven out and replaced as *basileus* by Dinos (Whirlpool) (381, 826–7), though at the end of the play order is restored, and

Strepsiades can say Zeus *is basileus* (1463–74). In both *Wealth* and *Birds* Zeus is completely supplanted; however, in *Birds* Peisetaerus does not restore sovereignty to the birds (who had ruled the world as *basileis* before Zeus: 467–506) or give it to Heracles as he had promised, but becomes a *tyrannos* himself (1708), and a god (1765).[25]

The Greek historians have equally complex and conflicting views about the rule of one man. Herodotus is ambivalent about *basileis* and *tyrannoi*,[26] and does not make clear distinctions between them. For example, Alexander I of Macedon was a *basileus* (9.44.1), but the regime in Macedon was a *tyrannis* (8.137.1).[27] Herodotus also does not seem to think that one man rule is necessarily a bad thing for all people. He says that if the Thracians had united under one man or with a single purpose they would have been unbeatable in battle and the strongest by far of all the races (5.3.1).

However, it is less sure whether he thought individual rule was appropriate for Greeks, since a strong thematic strand in his work concerns individual rule, especially as it is exemplified in Asian monarchy, and the rule of the Persian Kings.[28] For Herodotus, rule by the Persian King was enslavement, whereas Greeks had freedom (see esp. 7.134–5), although this was a qualified freedom since law was their master (7.104). One of the central themes of Herodotus' narrative is that there is a cycle of historical causality (Hdt. 1.5), which is driven by the arrogant over-reaching themselves and bringing about their own downfall, and the Persian Kings framed this type.[29] Certainly, Cambyses conformed to the pattern since he transgressed the customary laws, invented others, and was violent and sacrilegious (esp. Hdt. 3.16, 27–9, 31.1–32.4, 34–5). The characterization of Cyrus, on the other hand, is more nuanced, and although he too finally overreached himself and met a gruesome end – at least in Herodotus' account – he was a 'father', who was gentle (*ēpios*), contrived all things well for the Persians, and brought them freedom (3.82.5, 89.3).[30]

Thucydides, on the other hand, is clear that there was an age of *basileis* and an age of tyrants (1.13.1), and he is the first explictly to make that distinction. On his account, the *basileis* had fixed prerogatives, but *tyrannoi* ruled in the interests of themselves and of their families and were mostly interested in their own security, stifling the development of the cities in which they lived (1.17). We will look in more detail at Thucydides' distinction between *basileia* and *tyrannis* in Chapter One, since it has been so influential on the way modern

scholarship has interpreted an apparent shift between the Early Iron Age (which was once called the Dark Age) and later periods. However, Thucydides wants us to think in terms of his own periodization[31] – he wants to set up his own time frame in the contrast between *basileis* and *tyrannoi*, in order to anticipate the shift between Pericles and his successors. Pericles was the 'first man', who managed the people well in their interests (Th. 2.65.4–5, 8–9), in contrast to his successors who only thought of themselves and their private ambitions (Th. 2.65.10–11). One of the successors of Pericles, Alcibiades, was even thought to be aiming at tyranny (Th. 6.15.4, cf. 6.28.2). Yet Thucydides' views on the contrast between these two men was not straightforward, and in the end he did not desire for Athens the rule of one, but a mixed constitution of the few and the many (Th. 8. 97.2).[32]

For Xenophon the distinction between *basileis* and *tyrannoi* was, at least at first glance, straightforward. In Xenophon, the good ruler obtains the willing obedience of his subjects (as willing obedience brings freedom),[33] although in the *Hieron* Xenophon explores the unhappiness of the *tyrannos* who must be hated for the actions needed to hold onto power. In the *Cyropaedia*, when Cyrus has to choose between remaining in Media and returning to Persia, Cyrus' mother, Mandane, compares the court of the Median king to that of the Persian in strong terms:

> At the court of your grandfather (she says to Cyrus), and among the Persians, there is no agreement about what constitutes justice. For your grandfather has made himself a despot of all among the Medes, but among the Persians it is thought that equality (*to ison*) is just. And your father (the Persian king) is the first one to do what is ordered by the state and to accept what is ordered, and it is not his will which is the measure for him, but law (*nomos*). So be careful that you are not flayed alive when you come home, if on your return you have learned instead of kingship (*to basilikon*) the ways of tyranny (*to tyrannon*), where it is thought necessary for one to have more than all the rest. (1.3.18)

Yet for Xenophon, who is so interested in rulers and ruling, it is also not so simple. Cyrus' relationship with his 'tyrannical' grandfather is good-natured and playful. Even more to the point, it is a Persian king, Cyrus the Great, who in the *Cyropaedia* becomes one of Xenophon's most worked-out models of how one should rule.

For Plato, on the other hand, the Philosopher King is the ideal ruler in a state, but he also thinks that even the best constitutions can decline: aristocracy degenerates into timocracy, timocracy to oligarchy, oligarchy to democracy, and democracy to tyranny (*Rep.* 8.545c–69c). The tyrant continually provokes wars in order to get rid of his enemies and to keep his subjects impoverished so that they do not have the time or resources to plot against him (*Rep.* 8.566e–67a). Whereas 'the most kingly man' (*basilikōtatos*), is the best (*aristos*), most just (*dikaiotatos*), and happiest man (*eudaimonestatos*), the tyrant is the worst of men; he has no good opinions or appetites, but given over entirely to excesses and profligacy he surrounds himself with flatterers, and is trapped in his house through fear (*Rep.* 9.573c–80c; cf. Xen. *Hieron* 1.11–12, 15).

Aristotle defines tyranny as rule by one man, who has no boundaries (*aoristos*) (unlike *basileia* which is rule according to some kind of constitution: *Rhet.* 1365b37–1366a2), or it is rule in the interests of the rulers (rather than the ruled), a perversion of *basileia*, and despotic in nature (*Pol.* 3.1279b4–5, 6–7, 16–17; cf. 3.1279a28–34, 4.1284b13–15). While he can concede that there are some forms of *tyrannis* which are 'kingly' (*basilikai*) because they are according to law and because they rule as a monarch over the willing (these are tyrannies among the barbarians), the most extreme form of tyranny, which is opposite to the *pambasileia*, Absolute Kingship, is monarchy

> which rules without any kind of accountability (*anypeuthynos*) over all his equals (*homoioi*) or superiors (*beltiones*) and for its own interest, but not in the interests of those who are ruled. For this reason it is rule over the unwilling. For none willingly of those who are free (*eleutheroi*) will endure such a constitution. (*Pol.* 4.1295a7–23)

Aristotle does not believe that individual rule can be justified in his own time, not least because in a *polis* citizenship should reside in ruling and being ruled in turn, and for this reason citizens as far as possible should be of roughly equal status (e.g., *Pol.* 1.1255b16–20, 1259b4–6, 3.1279a8–13, 4.1295b25–6).[34] In fact, he says, people hold in esteem those who can rule and be ruled, and for a good citizen virtue (*aretē*) is being able both to rule and be ruled well (*Pol.* 3.1277a25–7). Aristotle says that *basileia* did not exist in his own day, but where there is rule by one man they are *monarchoi* and *tyrannoi*, because it is

rule of the unwilling, with sovereignty in most things, and that no man is so distinguished as to be worthy of ruling (*Pol.* 5.1313a3–8).

It has been possible to use only broad brush strokes to outline the response of the Greek literary tradition to rulers and ruling, which, for the most part, was also an Athenian tradition, and which can be traced back as far as Solon's resistance to one-man rule in Athens (frr. 9, 32, 33, 34, cf. 11 West *IE*²). It is largely negative, but not always so. It creates a stereotype of a tyrant based on the Great King, but then recognizes that there was more than one kind of Persian King, and plays with Persian kingship, both as an opposite of democracy and as a model for imperial rule – we will return to a number of these matters in the final chapter. Most of what we can know about rulers in archaic and classical Greece derives from this tradition, and descriptions of rulers across this period are often coloured by this discourse. This is as evident in the way that Lysias writes about Dionysius I of Syracuse, as it is in the way that Herodotus writes about Gelon. Although modern commentators have often found it difficult to resist these readings, so that even archaeological evidence has been interpreted within this framework, there are also other ways of viewing these rulers and what they were trying to achieve, which has been obscured for us by what has become the dominant literary discourse.

Lavelle, for example, has argued that, despite the largely negative tradition that has survived about Peisistratus' rule and the way he came to power, the contemporary response to him at Athens was positive, and that he was a 'democratic' tyrant in the sense that he was elected by an assembly, at least in the first two periods of rule (cf. Hdt. 1.59.4, 60.5).[35] While election of a bodyguard seems to be a more clear-cut indication of the assembly's involvement – in Aeschylus' *Suppliants*, Danaus is voted a bodyguard by the assembly (Aesch. *Suppl.* 985–8), which seems to indicate his new status as ruler in the city – than acceptance by the *dēmos* of Phye as Athena, it is still the case that our meagre sources for Peisistratus' rise to power do seem to underplay the level of support he enjoyed, both within the city and from the demes.[36]

Likewise, Lewis has shown that the portrait of Euphron of Sicyon as presented by Xenophon is created within the discourse of tyranny, which in turn has become the basis of modern accounts of his rule.[37] In general, Xenophon's account of Euphron is negative and he is accused by Xenophon

of both embezzling public and sacred funds, and killing and banishing his political rivals (Xen. *Hell.* 7.1.46, 3.8): 'Consequently, he took everything into his own hands and evidently was a tyrant'. Yet as Lewis notes, Xenophon himself shows that there was another way of viewing Euphron's position, since Xenophon begrudgingly admits that he was given heroic honours by the citizens of Sicyon after his assassination as 'founder' of the city (Xen. *Hell.*7.3.12). In fact, there is no certainty that Euphron did set himself up as ruler in Sicyon. Even his assassin seems to admit that there might be doubt about his position (Xen. *Hell.*7.3.8). As an elected general in the newly formed democracy (Xen. *Hell.*7.1.44–6), Euphron's role looks very much like that of Pericles at Athens,[38] albeit Euphron had his own personal mercenary army (Xen. *Hell.* 7.2.11).

So, in analysing our sources we need to read them closely, but with wary eyes which are prepared to look through and beyond the many-faceted discourse of the 'age of tyrants' to attempt to strip it away, or at least to understand how it is being used to manipulate the material. By changing the lens through which we are viewing our sources, we then need to look to see whether there are other patterns and other stories which are able to emerge. In this task – in finding the gaps between political *realia* and the discourse through which it is described – we can be helped by using comparative material, both from within the Greek world to see what is happening in different communities, but also from neighbouring cultures, such as Persia and Assyria, and other periods.

The point is made if we compare the strategies used by the Cyrenean *basileis* and those of the Deinomenids of Syracuse. Sarah Harrell, in her treatment of the public representation of the Deinomenids, shows how Pindar presents them as *basileis*,[39] since he ascribes to the Deinomenids heroic status as founders, and says that Hieron wields a *themisteion skaptron*, a sceptre of lawfulness (*Ol.* 1.12; cf. 6.93), and recommends that he guides the people with a just rudder (*dikaios pēdalios*) (*Pyth.* 1.186). He connects Hieron as *basileus*, as well as the *nomoi* of the Aetnaeans, with the Dorian Heracleidae, good order and the 'divinely built freedom of Hyllus' (*Pyth.* 1.60–5), and says that as leader (*agētēr anēr*), by apportioning honours to the people, he turns them to harmonious quiet (*symphōnos hēsychia*) (*Pyth.* 1.69–70). Likewise Bacchylides (5.6) praises Hieron for having a mind with straight justice (*phrēn euthydikos*).

However, Harrell considers that there is an implicit contrast between the 'tyrannical' rulers of Sicily with 'traditional kings', since 'the epinician praise of Hieron places the tyrant within a line of traditional kings that includes Zeus as well as his real and legendary counterparts'.[40] She claims that '[T]he tyrant in reality must have faced a difficult negotiation between asserting and justifying his absolute control over his people', and that epinician poetry 'played a role in this negotiation through conferring the legitimacy of an epic past on a figure with sole political control over his community'.[41] Yet, as we shall see in later chapters, typecasting the so-called tyrants as unrestrained autocrats is anachronistic. In fact, there was not necessarily the tension between ruler and ruled in the newer dynastic regimes that Harrell and others have assumed,[42] and, revealing her own stereotypes, she seems to suggest that the Deinomenids were trying to conceal, or at least repackage, their real status as [usurping, illegitimate and absolute] tyrants. She compares the Deinomenids to the Battiads at Cyrene, and says that '[t]he Battiads had an advantage over the Deinomenids in that they were hereditary kings and descendants of Cyrene's founder, Battos. Arkesilas' ancestor Battos was worshipped as a hero at his tomb in the city's agora, a fact that Pindar emphasizes'.

The comparison between the Battiads and Deinomends is a particularly apt one, but not because the Deinomenids were trying to ape legitimate rulers. Rather the Battiads themselves were not a 'traditional' dynasty in the normal sense, but like the Deinomenids were a new foundation. What is so interesting, then, is that the Deinomenids and Battiads encouraged the same formulations to support the dynasty by insisting on heroic foundations and the cosmic significance of ruling. It is here, where these new dynasties are using the same or similar strategies to assert their legitimacy, that we should be looking for the heart of Greek ideas about rulers and ruling: rulers, at least on an ideological level, were the providers of good order, straight judgements, and heroic qualities. The point is that while in the early archaic period different circumstances may have heightened political stressors and forced political changes, the actors in these circumstances were not necessarily attempting to do something new, but rather were deliberately attempting to situate themselves within a tradition of ruling dating, as we shall see, from the Early Iron Age. That is, although these early archaic rulers were adapting to

circumstances, they were also making these adaptations within a traditional framework.

As shall be argued in the chapters that follow, this kind of rule, which sought legitimization for the exercise of authority, was a feature of the Greek experience of the rule of one man. Rule by one man or by a family dominated by one man remained a feature of the Greek political landscape throughout the archaic and classical periods, although it is obvious that there was diversity across the Greek world. In particular, with the development of urban centres, similar political forces could produce different results.[43] At Athens, the tradition held that the son of the last *basileus* became the first *archōn* who had life-tenure (cf. *Ath. Pol.* 3.1–3; Arist. *Pol.* 2.1272a5–7), and annual archonships were thought to date from 683 BC.[44] Likewise, at Dreros on Crete, laws were put in place to prevent any one official (the *kosmos*) from holding on to power, and instead magistracies were shared out between the local elite (ML 2; cf. Arist. *Pol.* 2.1272a8–10),[45] and it is stipulated that a man shall only be *kosmos* (the chief magistrate) every ten years.[46] At Corinth, the Bacchiads had a hold on power, where Strabo says they were rich, numerous and illustrious, and that they 'reaped profits from trade with impunity' (8.6.20).

It was certainly the case that, across the Greek world, rule by one man, or rule by one man and his family, did not sit easily in a political culture that was competitive and which also had a strong egalitarian ethos, particularly among the political elite. Where there were rulers they had to work within the framework of competition, both from other members of the political elite to prove that they were 'best' to rule, while satisfying the demands of the whole political community who also desired to have their share in political power. The dynamism and vitality of Greek politics arose out of the multiplicity of oppositions, not just the few against the many (as Morris has suggested),[47] but also between the one and the few, and the one and the many.

It was easy to revile a successful ruler. In the seventh century, Alcaeus complains about the 'base-born' tyrant, Pittacus (fr. 348 Lobel and Page *PLF*),[48] and in the sixth century Solon warns against the dangers of the great men who destroy cities (fr. 9 West *IE²*). Theognis prays that *mounarchoi* may never take pleasure in the city (52), and describes a 'tyrant' as *dēmos*-eating (1181). Yet, although some Greeks may have rejected rule by one man, not all

did, and we need to ensure that we do not consider the views of some to be the views of all, as has been the tendency in much modern commentary on rulers in the archaic and classical periods.

There was more than one response to the rule of one man. The idea of tyranny as rule of the unwilling, which brought slavery, was one that reached back to at least the sixth century. It is implied in Xenophanes' complaints against the hateful tyranny of the Lydians, as it is in Aeschylus' *Persians*, when Atossa learns that the Athenians are free and subject to no man (241–2).[49] Yet, Diodorus can say that through his *aretē*, his excellence, Gelon was said to have set Sicily free, while Dionysius enslaved it (14.66.1). Dionysius I obviously felt the need to pre-empt such accusations, and in his own poetry declared that *tyrannis* is the mother of injustice (fr. 4 *TGF* Snell).[50] It is also significant that Dionysius named his daughters Arete, Dikaeosyne and Sophrosyne (Plut. *De Alex. Fort.* 5.338c), which, as Sanders notes, was self-consciously buying into fourth-century political theorizing on the virtues that a *basileus* should espouse.[51] For Herodotus, Cyrus the Great of Persia liberated his people (1.125–30, 210, 3.82.5); Plato says that Cyrus brought a balance of freedom and slavery by making the Persians free and others slaves (*Laws* 3, 694a–c). The eviction of the Peisistratids at Athens was celebrated as the beginning of Athenian freedom and end of slavery (e.g. Hdt. 6.109.3), but when the tyrant, Maeandrius, offered to give the Samians their freedom (3.142.4), the Samians, Herodotus says, chose not to be free (3.143.2). Just as Pindar supports sole rulers, so also he admonishes them, and urges them to be what they should be (e.g. *Pyth.* 1.86–100), and probably prefers that they did not rule alone.[52]

In the chapters that follow we will explore various aspects of personal rule, predominantly during the period from the eighth to fourth centuries, although we will sometimes look both backwards to the Early Iron Age and forwards to the Hellenistic period. In Chapter One we will begin by looking at some of the issues that have surrounded the study of individual rule in this period, both in terms of the scepticism regarding what sort of models we should be using to consider its role in Greek society. This will include discussion of whether we can talk about individual rule as either an appropriate or an effective political form, especially in the context of the early *polis*. We will also look more closely at the distinctions that are made between earlier ancestral *basileis* and later wealthy *tyrannoi* and see whether this kind of periodization really stands up

to scrutiny. This chapter will consider the continuities in the importance of ancestry, especially heroic ancestry, in claims to rule, and finish by considering the importance of wealth as a route to power through the acquisition of *aretē*, loosely translated at excellence. It is important for the argument of this book that the nature and understanding of 'excellence' was not itself a stable category, but could be more military in the earlier centuries and more ethical towards the end of the period we are considering, though this distinction was always blurred, just as the moral and class differences between *agathoi* and *kakoi*, the 'good' and the 'bad', were never clearly defined.

In Chapter Two, on the other hand, we will move to a discussion of charismatic rule and of *aretē* as the driving ideology for the legitimization of rule. In order to rule with legitimacy, rather than by force or coercion, one had to prove one's right on the basis of one's *aretē*, and having more of it than anyone else. Thus those who aspired to rule had to show that not only were they descended from heroes, but also they were heroes themselves. In this sense, rule was personal as it was based on an individual's qualities. In order to demonstrate the ability to rule – and to maintain belief in that heroic ability – those who ruled or wished to rule had to continually prove their heroic worth through their abilities in war, their victories in the games, especially at the panhellenic centres, and their acts of city foundation. Through these strategies, rulers were able to show the abundance of their *aretē*. This excess of *aretē* was important not just during the ruler's lifetime, but also in death, since through their *aretē* rulers could attain immortality. This gave to rulers not only a life after death, at least in the sense of perpetual commemoration, but also to their communities a guarantee of continued protection, especially in times of war.

Chapter Three will turn to another aspect of ruling in the Greek world, and that is the fact that it was rooted in the family or clan. The chief paradigm will be the Argeads of Macedonia, but this chapter will show how the pattern of clan-based rule already well-known from Macedon was widespread across the Greek world from the early archaic period to the fourth century. It will also discuss the marriage strategies in ruling families and the implications of these practices for succession. An important part of the discussion will centre on competition, not just from external aspirants for rule, but also from members of the same family. This competition meant that even clan- and family-based

rule, which drew its strength from the family and the ways in which it could be deployed as a unit, could also be remarkably fragile, especially where there was no clear framework for ensuring a smooth transition in the succession, as more than one member of the ruling family sought to show that he had the right to rule on the basis of his *aretē*.

Chapter Four, on the other hand, looks at the constitutional framework for rule, and argues that rule by one man was not inconsistent with the life of the *polis*. That did not mean, however, that other members of the *polis* did not try to constrain rulers and their powers, but in fact the vibrancy of *polis* life, and the generation of its political nature, was centred on different interest-groups who sought to have their proper share of power and limit that of others. This discussion will open the way for a consideration of the 'constitutional' nature of rulers in most *poleis*, where rulers ruled in conjunction with other magistracies or offices of government, such as assemblies and councils. It will challenge the notion of absolutism which is assumed in many discussions of individual rule in ancient Greece, and instead will argue that, in order to rule effectively, rulers also had to rule through consensus.

Finally, in Chapter Five, the discussion will turn to Athens, the *polis* which most vociferously rejected one-man rule, at least in the fifth and fourth centuries. However, we will see that it was largely at Athens, and in the context of Athenian democracy, that rule by one man was theorized, and the relationship between the ruler and the ruled was given a theoretical framework. In this way we will see that, even at Athens, where the many ruled and not the one, the best man, the man with the most *aretē*, had fundamental significance, even it was only to define the worst man, the tyrant, the antithesis of Athenian democracy.

# Notes

1    Cf. S. Lewis (2000); id. (2009), 58–79.
2    I. Morris (1997), esp. 131.
3    Drews (1983), though see further below.
4    Mazarakis Ainian (1997), 287–305.

5  Cf. Cartledge (1998); id. (2009), where he argues that Greek politics presupposes the *polis* (12), and since Homeric epic does not know the *polis* then it is, *ipso facto*, pre-political (33).

6  E.g. Raaflaub (1998); Cartledge (2009).

7  Murray (1993a), 38; see further Chapter One.

8  Paper delivered at Oxford, 12th February 2012: *Dependency, Conquest and Ethnicity in Archaic Greece*.

9  Bowie (1986); Sider (2006); cf. Bowie (2001); Giangiulio (2001). In the Hellenistic period, public performances of poetic accounts of local foundations by itinerant poets are securely attested: see esp. Clarke (2008), 346–54.

10  See esp. Irwin (2005), 79–80: 'Poetry travels … Even when expressing sentiments relevant to a given polis at a given time, there seems to be an eye to the greater audience'.

11  Bowie (1986); Irwin (2005). On the importance of the symposium for archaic society, see Murray (1983b).

12  See further L. Mitchell (2007), 149–58.

13  Seaford (1994), 232–4; id. (2003), and now also (2012), *passim*; cf. V. Parker (1998), 158–61.

14  On the sisters, see further L. Mitchell (2007), 186–7.

15  See Blundell (1989), 128.

16  See esp. Crane (1989).

17  See Duncan (2012), 149–51, on the Just Ruler as a stock character of suppliant dramas.

18  L. Mitchell (2006b), esp. 211.

19  Connor (1985), 93.

20  L. Mitchell (2008).

21  For Aeschylus' activities at Hieron's court, see Boscher (2012).

22  Cf. Dearden (1990), esp. 234–6; Duncan (2012).

23  Kallet (1998), 53; see also L. Mitchell (2007), 150.

24  See Sommerstein (2001), 141–2, who notes that *tyrannos* and *tyrannis* always has a pejorative tone in comedy.

25  Sommerstein (1991), 309.

26  See, however, Ferill (1978), who argues for a predominantly negative usage of *tyrannos* in Herodotus.

27  However, it should be noted that generally Herodotus designates Alexander simply as 'Alexander, son of Amyntas, a Macedonian man' (7.173.3, 8.136.1, 140.1, cf. 9.4.1).

28　On Herodotus and Persian autocracy: Hartog (1988), 322–39; Lateiner (1989), 171–80; Georges (1994), 167–206; Munson (2001), 49–50; Dewald (2003), 32–40; L. Mitchell (forthcoming 2013c).

29　The theme of hybristic monarchs itself seems to derive from the Near East: Naram-Sin, otherwise known as a glorious ruler, over-reached himself and, as recounted in *The Curse of Agade*, destroyed the temple of Enlil in Nippur; as a result his own city of Agade was destroyed by the vengeance of the god.

30　Although the Greeks developed their own local response to issues surrounding how one ruled and thought about being ruled, and sometimes explicitly rejected Near Eastern models, the Greeks also belonged to a much larger cultural and thought world that intersected with the Near East at more than one point in time. Near Eastern ideologies of ruling are reflected in Greek literature from Homer to Xenophon. For example, the ruler as 'shepherd', well-known from Homer, was a Near Eastern motif, just as also the ruler as 'gentle father' may well have had Persian antecedents (cf. Hdt. 3.89.3 on Cyrus). The Homeric *basileis* were given the epithet 'shepherd of the people': e.g. *Il.* 1.263 [Dryas], 2.85 [Nestor], 2.243 [Agamemnon], 6,214 [Glaucus]. The king as 'shepherd' was known as early as the Sumerian king lists of the late nineteenth century BC (Jacobsen [1939], col.i.15: 'divine Dumu-zi(d), a shepherd, reigned 36,000 years'; col. ii.16 ('Etana, a shepherd'); col. iii.12 ('divine Lugal-banda, a shepherd'); on the date, see Kuhrt [1995] 1.29). The king as 'shepherd' was a *topos* of Assyrian inscriptions; e.g. the ninth-century statue of the Assyrian king Shalmaneser III (see Læssøe [1959]). For these Near Eastern parallels of the ruler as 'shepherd', see West (1997), 226–7, although he is doubtful whether we can trace the provenance of the Greek metaphor. Odysseus is said to have ruled 'as a gentle [*ēpios*] father': *Od.* 2.47,234, 5.12. In the fifth century, Athens used the symbolism of the Persian empire to express her own imperial ambitions, just as in the fourth Dionysius I of Syracuse was willing to risk being labelled an enslaving *tyrannos* through his deliberate evocation of the lifestyle of the Persian King. For Cyrus in the Greek literary tradition, see esp. L. Mitchell (2013b); id. (2013c).

31　Cf. Strauss (1997).

32　On Thucydides on Pericles and Alcibiades, see esp. L. Mitchell (2008).

33　See further Chapter Five.

34　On the 'principle of ruling' in Aristotle, see F. Miller (2005), 333–4.

35　Lavelle (2005); cf. id. (1993), esp. 90–5.

36　See further Chapter Two.

37　S. Lewis (2004).

38  See further Chapter Five.

39  Harrell (2002).

40  Harrell (2002), 447.

41  Harrell (2002), 448.

42  Cf. McGlew ([1993], 49–51), who forms a subtle argument about how tyrants were unable to manage the positive picture the epinician poets painted of them. While on one level this is true, since by the late fifth century discussions of tyranny as a form were generally negative, in assuming that tyrants felt the need to repackage their regimes in more positive terms, he also is reading later stereotypes of tyranny back onto an earlier period when tyranny *per se* may not necessarily have been considered an illegitimate regime.

43  Compare Whitley (1991b), 193–4, who emphasizes the diversity of political forms in Dark Age Greece.

44  See Rhodes (2003), 98–9.

45  R. Osborne (2009), 174–7; cf. Gagarin (1986), 81–6. Aristotle says that on Crete 'kingship', *basileia*, was replaced by officials called *kosmoi*, who were ten in number (*Pol.* 2.1272a5–7).

46  It is the *polis* that passes the decree (ML 2.1), although at this early date it is likely that decisions of the *polis* were made by the elite, as seems to have been the case in Athens (cf. *Ath. Pol.* 3.6). Cf. Rhodes (1993), 106–8.

47  I. Morris (1991).

48  Kurke has analysed these breaks in the decorum of Alcaeus' language to reveal the ruptures in society, and sees in the poems the break-up of 'traditional society', and the disappearance of 'the aristocratic power monopoly': Kurke (1994).

49  See Raaflaub (2004), 89–91.

50  Sanders (1987), 2.

51  Sanders (1987), 2.

52  Burnett (1987).

# *Basileia* and *tyrannis*: Exploding myths

In the early archaic period, *basileus* and *tyrannos* (which was an imported word, and does not appear at all in Homer) seemed to be used synonymously. It is often noted that the first usage of *tyrannos* is in the poetry of Archilochus, who rejects the wealth of Gyges, but not necessarily the rule of one man (fr. 19 *IE* West). It is clear that by the late sixth century, however, *tyrannos*, or at least Asian rule with which *tyrannis* seems to have been associated, could be understood more negatively.[1] Certainly Xenophanes rejects Lydian tyranny, just as he rejects Asian luxury (fr. 3 West = DK 21 F3):

> Having learned useless luxury from the Lydians,
> while still free from hateful tyranny (*stugera tyrannis*),
> they come into the market-place wearing purple cloaks,
> as often as not in their thousands,
> proudly glorying in their beautiful locks,
> steeping their body odour in rare unguents.

However, even in the early fifth century Pindar could call the Deinomenids both *basileis* (Pindar, *Ol.* 1.23 [cf. 114], *Pyth.* 1.60, 3.70) and *tyrannoi* (Pindar, *Pyth.* 3.84–6), which he could not have used interchangeably if *tyrannos* was a negative term, especially since he was a singer of praise. It is worth noting in this connection that *basileis* and tyrants could also be vilified in the same terms – Achilles called Agamemnon a *dēmoboros basileus*, a 'people-eating' *basileus* (*Il.* 1.231), just as Theognis can say:

> Cyrnus, respect the gods and fear them,
> for this prevents a man from doing or saying impious things.
> But for laying low a *dēmos*-devouring (*dēmophagos*) *tyrannos*, in whatever way you wish,
> there is no retribution (*nemesis*) from the gods. (1179–82)

There were always reasons to resent a man who stood alone.

There has been a lot of uncertainty in modern scholarship about the historical relationship between *basileia* and *tyrannis*. On one level this has to do with how ruling in early societies might be understood, and whether, and in what terms, we can really talk about rulers in early or pre-state contexts. The other major issue is the apparent contrast between *basileia* and *tyrannis*, and the change from an age of *basileis* to an age of *tyrannoi*, marked by an alleged shift in values between the two different kinds of rulers. One of the major issues in this book is whether *basileia* and *tyrannis* are two separate, temporally distinct phenomena, or whether they can be considered together as part of the same ideological and value system. This question, of course, as already indicated in the Introduction, has a bearing on how and where we are prepared to make the breaks in our analyses of ancient societies, and whether we always have to make the distinctions our sources suggest to us are important. Yet before we turn to the problems for our interpretation created by ancient sources, and Thucydides in particular, we need to address the issue of ruling itself, and discuss who or what a ruler might be.

## Kings, Big Men, and chiefs?

The ambivalence in our sources about rulers has caused problems for modern scholarship on actual rulers in the archaic and classical periods, as opposed to the mythical or stereotyped ones found in sources which post-date the mid to late fifth century. The uncertainty has been exacerbated by a lack of clarity about how the office of *basileus* might be defined (if it is an office), and how it might relate to other forms of one-man rule (including tyranny). A prominent feature of modern discussions about ruling in Greece is also the extent to which *monarchoi*, *basileis* and *tyrannoi* compare with 'proper' kingship, or 'our sense' of kings. What seems to be meant by 'proper' kings are the feudal rulers of medieval Europe. However, confidence in medieval Europe for providing stable comparanda against which other rulers could be judged is misplaced. In medieval Europe there is no single model for kingship, but the variety of forms was great and included elective kingship as well as both hereditary kingship and sometimes not much more than warrior chieftainship. Not all of

these rulers were strictly feudal, and relatively few provided lasting political stability. What is more interesting, and more notable, is the extent to which, and the ways in which, most applied energy, resources and strategies to prove that as a sole ruler they held rule legitimately.[2]

Defining kingship is as much a problem for anthropologists as for classicists, since a stable and consistent theorization of kingship in political terms is difficult to pin down and analyse. The problem has not been helped by the fact that the technical terminology for chieftainship and kingship has not been defined conclusively, and is sometimes used interchangeably. For Sahlins, for example, a chief belongs in a ranked society and a king in a state (or stratified society);[3] for Carneiro a chief belongs to a chiefdom (an aggregation of villages, organized as a stratified society) and a king to a kingdom (a post-stratified formation, that is, a state), both taking an explicitly evolutionary view of state development.[4] On the other hand, in regard to Africa, chieftainship and kingship have often been used interchangeably, which makes it difficult to adhere to technical terms and meanings.[5]

Indeed, the political nature of the phenomenon of kingship (*qua* kingship) has rarely been analysed in detail. Since Frazer's *Golden Bough*, anthropologists have generally been more interested in kingship in terms of ritual and symbol as expressions of power.[6] So, for instance the idea of 'sacred' or 'divine' kingship, which has been a particularly powerful tool for understanding the phenomenon of kingship, has been explored and analysed in a number of societies in Africa, the Near East, Europe and the Mediterranean, and comparatively across societies in different periods.[7] Divine kingship as a means of understanding Near Eastern kingship has been particularly productive, especially in Egypt, where the divine king maintained order in the cosmos through the performance of ritual and ceremonial, and in the Islamic world where the so-called 'absolutist imperative' reflects the relationship of the king to his subjects by mirroring that of God and mortals.[8]

Yet even in Egypt this focus on the divine only takes us so far as a means of understanding kingship as a whole phenomenon,[9] and more recent scholarship has wanted to emphasize the mortality of the pharaoh as an adjunct to his divine status. O'Connor and Silverman state clearly the current scholarly orthodoxy:

Kingship [in Egypt] is a divine institution, in a way itself a god, or at least an image of the divine and capable of becoming its manifestation; each incumbent, each pharaoh, is fundamentally a human being, subject to humankind's limitations. When the king took part in the roles of his office, especially in rituals and ceremonies, his being became suffused with the same divinity manifest in his office and the gods themselves. With this capacity, the king would be empowered to carry out the actual symbolic acts that contributed to the maintenance and rebirth of cosmos. Indeed in these contexts, the king acted as a creator deity and *became* the sun-god. On these occasions pharaoh would be recognized by those who saw him as imbued with divinity, characteristically radiant and giving off a fragrant aroma.[10]

On the other hand, the case of Persia is also often cited as one where the king is not involved in divinity, although this is now being challenged, and the new consensus seems to be moving towards an understanding of Persian monarchy which emphasizes the ambiguity of the king as man and god.[11] As we shall see, the relationship of ruling to the divine was also a matter of concern in Greece, although it was not until the fourth century that a living ruler dared to call himself a god (and even Alexander may have recognized the twin aspects of a mortal and immortal existence: Plut. *Alex.* 28).

In Greece ruling was not just about divinity, although the roles which rulers may have played, especially in the developing *polis*, have been debated. In part, this discussion has become mired in questions about the relationship of the Homeric texts to archaic society, state development and the legitimacy of tyrannical rule. Furthermore, modern scholarship has sometimes been uneasy about whether we can refer to 'kings' at all in archaic and classical Greece. Drews and Murray, in particular, are sceptical about early Greek kingship. Drews has made a case for discounting most of the supposed Dark Age kings of later sources, and argued for rule by aristocracies.[12] Murray tends to take a more moderate view, but suggests that *basileis* were the heads of noble families whose primary responsibilities relate to debate, warfare and the arbitration of disputes.[13] Pierre Carlier is more positive about the number and role of kings in Homer and archaic Greece, although he rejects *tyrannoi* as illegitimate rulers and so does not consider them.[14] He also detects a decline in kingship with the rise of the *polis*, and a tendency in the classical period for the office of kings to be presented as magistracies. Starr expresses surprise

at what he thinks is the quiet disappearance of the *basileis*, but thinks that the decline was swift.[15] For Qviller, the institution of kingship was 'seriously dysfunctional' in early Greece, and so disappeared unnoticed.[16]

For those who think that it is not appropriate to talk about 'kingship' in Greece, there is little agreement about what models we should be adopting in its place. Drawing on the influential (though sometimes controversial) economic modelling of Service and Sahlins for pre-state societies, where power is achieved through production and redistribution of resources,[17] Donlan, for example, has discussed archaic society as one focused on either 'Big Men' or 'chieftains'.[18] Within this schema, Big Men achieve their status by personally acquiring dominance over tribesmen, and then have to work to maintain their positions, while chieftainship is ascribed to the individual either through age, appointment, or succession, and the chief can hold extensive power through the rights of office.[19] Donlan argues that Homeric society was a chiefdom, and that the *basileis* perfomed the redistributive functions of chiefs in a kin-based ranked society.[20] For Qviller, the term *basileus* denotes a leader emerging from a Big Man and developing into a chieftain; *basileis* ruled by might alone, and it was the need for wealth that 'prevented kingship from developing into a stable and lasting institution.'[21]

Despite its early popularity among ancient historians, Sahlins' economic model for chiefdoms is not universally accepted among anthropologists. Carneiro, for example, explicitly rejects Sahlins' economic basis for chiefdoms on the grounds that Sahlins (and his circle) have failed to realize that chiefdom is a *political* rather than an *economic* phenomenon. Instead, Carneiro defines a chiefdom as 'an autonomous political unit comprising a number of villages or communities under the permanent control of a paramount chief'.[22]

There is also more recently some uncertainty among ancient historians about the application of Sahlins' model to early Greek society. Whitley, who links Big Men to the transcience of unstable communities, thinks that they should only be associated with the eleventh and tenth centuries in Greece, and says that 'Where such small-scale societies did survive, as perhaps they did in Nichoria [in Messenia], they seem to have established a more permanent basis for personal authority'.[23] In fact, Whitley is also not sure that the model of the Big Man can be applied to a number of communities even in the Dark Ages, whether stable or not, but thinks 'it is particularly unsuitable for the

large, permanent communities of Athens, Argos and Knossos.'[24] In fact, Greek rulers, who as we shall see worked within the ideological framework of dynastic rule, do not form a perfect match with Big Men, whose rule was based entirely on personal qualities and did not form dynasties.[25]

Jonathan Hall, however, has suggested that the *basileis* were somewhere between Big Men and 'chieftains', and preceded a world dominated by an emergent aristocracy.[26] For Hall, early archaic Greek society is very much a society which is coming into statehood, although he also urges against evolutionary models of state development.[27] Tyrants, in Hall's scheme, represent a return to a more Homeric world of *basileis* before the rise of aristocracies, and he thinks tyrants were like Big Men, and that their authority rested on networks of clients. Thalmann, who like Hall is uneasy about the appropriateness of Sahlins-esque models of Homeric/archaic society, argues that the economic functions of redistribution do not necessarily seem to be an appropriate way of describing the Homeric, or archaic, *basileus* or his role in society,[28] and suggests that while there is a mixture of types reflected in epic, Homeric society is best described as stratified (that is, a society which has made a structural break from kinship as its main organizing principle), but has not yet achieved statehood.[29] As a result, for Thalmann the *basileis* are not chiefs (in a ranked society), but also not kings 'in our sense'.[30]

For van Wees, on the other hand, basing his own study on the monumental work of Carlier, Homeric *basileis* were 'princes' (and explicitly not Big Men or chiefs), because, he argues, there are indications that their position was hereditary, institutionalized, and expressed its authority through symbols of rule (such as the sceptre).[31] If kingship is to be defined by symbols of power, then the South American Black Bird, 'King of the Mahars' of the late eighteenth century, provides an interesting point of comparison for how the boundaries of kingship could be played with and blurred.[32] Although he came from the wrong tribe to be chief of all the Omaha, Black Bird worked his way to the chiefdom (allegedly by poisoning his rivals with arsenic), legitimizing his position through the performance of distinguished acts and the acquisition of symbolic and magical items, whose ownership was the preserve of the ruling elite. He claimed the right to 'kingly' privileges and ceremonial:

> He had numerous wives; his back was scratched with a turkey feather. He
> was only to be awakened by running a feather across the soles of his feet (or

his nose). He was carried on a litter. One anecdote recounted the obeisant behaviour of his subjects when Black Bird had been long despondent over the death of a favourite wife (whom he had murdered in a rage); to recall Black Bird to his people's needs, a deferential subject knelt and placed Black Bird's foot on his neck.[33]

In terms of royal symbolism, the Persian Darius III, generally recognized as an unequivocal 'king', provides very similar symbols of authority. He took the Persian throne with the help of six conspirators from Smerdis, an alleged pretender, although he himself was not the only possible claimant to the throne (Hdt. 3.61–88).[34] He is represented in reliefs at his palace in Persepolis accompanied by fly-whisk bearers and parasol bearers as signs of his status; he had at least six wives,[35] and was represented in the Bisitun inscription as trampling on his enemies, a statement of royal protection as much as a threat of danger against those who rebel.[36] Lenz, in discussing Dark Age Greece, makes the point that chiefs are sometimes kings demoted by modern analysis.[37]

Much of the anthropological – or anthropologizing – discussion hangs on what kind of a community the Greek *polis* was, and particularly whether *polis* society was a form of stateless society, or whether it had already achieved statehood. In defining the *modern* state (analyses which rely heavily on Weber), emphasis has been placed on the state as an abstract sovereign power over a defined territory, having centralized government with a monopoly on organized force, in which the developmental drives are economic and bureaucratic.[38] For Carneiro, taking a different approach, it is size that matters. He argues that state development is based on population growth and a combination of agricultural and social 'circumscription', in which communities pressing upon each other economically and socially are unable to retain their autonomy and so are forced to coalesce, and that an important mechanism of that development is war.[39] He recognizes, however, that social complexity is not the necessary result of population growth:

> … the contention is that if a society does increase significantly in size and if at the same time it remains unified and integrated, it must elaborate its organization … Cultural evolution then emerges from this discussion as something more than the continuous accumulation of increments. Instead, it shows itself to be an interplay between quantitative change and qualitative change, between growth and development.[40]

Playing down the role of economics, he thinks that state development is about power, and defines a state as 'an autonomous political unit, encompassing many communities within its territory and having a centralized government with the power to draft men for war or work, levy and collect taxes, and decree and enforce laws'.[41] On Carneiro's structural model, what is important is the development of a social complexity which is followed by an increase in tiers of political complexity, and which de-emphasizes the monopoly on force (especially in terms of a police force), in so far as the state still has the power to draft, tax, and enforce law.

Returning to the ancient world, those in favour of the developed *polis* as a state seem to have the stronger case,[42] but there are difficulties over the various levels of development of the *polis* (or micro-state) as it was experienced, especially in the archaic period.[43] Runciman, who rejects Carneiro's argument for population growth but also thinks that the accretion of power is key for the understanding of the state, brought the issues surrounding statehood directly to the question of the *polis*, and argues for a complex of forces which changed the semi-state of archaic Greece into the state (which he defines by the possession and control of resources and means of production, attribution by subjects/citizens of superior honour or prestige, and command of the means of physical coercion).[44] Runciman thinks, however, that the post-Mycenean *basileis* were not true monarchs: 'When in the post-Mycenean period the term designates the single topmost role, it is the semistate role, and once statehood has evolved, the role which is designated is no longer the single topmost one.'

## Kingship in fourth-century Macedon?

A strikingly similar set of issues arises when we turn to discussions of monarchy in fourth-century Macedon. In developing Carney's view on Macedonian *basileia*, in which the whole clan is involved in ruling,[45] Borza has suggested that we should probably think of Philip II and his predecessors as part of a 'military chieftainship exercised over a people', and that we can only talk about 'proper' kingship with the changes made to the whole idea and practice of kingship by Alexander the Great. He seems to mean by this an Asian style of kingship, although it is not entirely clear in what sense this

kind of kingship reaches a supposed ideal kingship more than that of earlier Macedonian monarchs.[46] In fact, it is significant that there is a tendency among many modern scholars to see Macedonian monarchy in the fifth and fourth centuries as 'heroic' and 'Homeric',[47] but this only brings us back to the kinds of question that face archaic society.

Part of Borza's argument about Philip's status is based on the fact that Philip did not call himself a *basileus*. Yet, in general, Greek rulers before Alexander do not seem to have used titles. It is possible that Cypselus used the title *basileus*, since it appears in the Delphic oracle used to justify his acquisition of power (Hdt. 5.92ε) – which is not to say that the oracle itself is necessarily genuine (on which opinion is divided), but that Cypselus may have produced it in order to justify his rule. In an inscription regularizing the citizenship status of Therans living in the colony of Cyrene (ML 5), Battus of Cyrene is called a *basileus* in the part of the inscription which purports to be a copy of an original seventh-century inscription. Even if this part of the document does genuinely reflect an archaic original, it is difficult to know the extent to which it has been edited and adapted. In the inscription on the Delphic Charioteer, a Sicilian ruler (perhaps Hieron or Polyzalus – see Chapter Three) may have originally styled himself as the 'One who is Lord over Gela' (*Gelas anassōn*), but this reading has now been challenged, and was in any case erased.[48] Dionysius I called himself *archōn* of Sicily (e.g. RO nos 10, 33, 34), although at Athens on the one hand he could be listed among the *basileis* flattered by Andocides (Lys. 6.6–7), and on the other regarded as a *tyrannos* on a par with the Persian King (Lys. 33.5). An inscription from the 350s shows that one could date an event to the reign of Philip II (*epi tēs Philippou basilēas*: *SEG* 40.542 = Hatzopoulos no. 4), just as the fourth-century Molossian *koinon* could also use *basileus* in the prescript (e.g. *basileuontos Neoptolemou tou Alketa*: *Cabanes* no. 1). Alexander the Great did begin to style himself as *basileus* on inscriptions, and on some coins issued in Asia Minor, but only towards the end of his reign.[49] None of this gets us very far.

Yet, just as Schofield has argued that even Homeric *basileis* were counsellors as well as warriors,[50] Macedonian rulers were more than military leaders, although their military impulse was exceptional. From the reign of Archelaus in the fifth century Macedon had a centralized infrastructure consisting in establishing the principal seat for the court at Pella (cf. Xen. *Hell.* 5.2.13), a

centralized coinage,[51] a network of roads, defensive forts and a standing army (Th. 2.100.2).[52] From the reign of Philip II, there is evidence of rudimentary institutions and machinery of administration,[53] some level of centralized taxation,[54] and court-structures which supported and controlled the king's power.[55] The Macedonian *basileis* also played an important role in religion, especially as officiators in sacrifices.[56] We know that Philip II was asked to make pronouncements in disputes over territory,[57] and on campaign Alexander seems to have held audiences in a splendid tent,[58] in which he conducted royal business.[59]

It is the fact that the Macedonian rulers had a range of civic, political and religious responsibilities to legitimize their position – although their success in war also had a significant bearing on their authority, and their desire for war seems to have a ritualized aspect – which lifts them beyond mere warlords. This was not just rule 'by the strength of the arm', but an organized attempt to engage in the processes of legitimate and consensual rule.

## Hereditary *basileis* and wealthy *tyrannoi*?

It is not just a question of whether the Greek city is a state, and whether rulers are Big Men, chiefs or kings. Problems also arise more directly from our ancient sources, which appear superficially to confirm what modern scholarship has largely assumed, that by the classical period legitimate individual rule was a thing of the past.

In the introductory chapter we considered the Greek literary tradition in broad outline and reflected on the problems that have arisen in using that tradition for the study of rulers and ruling in ancient Greece. In this chapter we will return to the issues that arise more directly from mostly fifth- and fourth-century Athenian sources hostile to rule by one man. In particular, we will try to break down the distinctions often made between hereditary rulers on the hand, and wealth-based tyrannies on the other, in order to show that the real differences between *basileis* and *tyrannoi*, so entrenched in our sources, were a product of a construct of ruling developed in the late fifth and fourth centuries, especially at Athens, and not a reflection of political realities.

One aspect of the literary tradition is its emphasis on decline. For many

modern commentators the easiest way to analyse individual rule in Greece has been to assume that either an originally robust sole rulership lost its hold on power and was forced to cede all or part of its political control, or it was replaced by tyranny. For example, Carlier sees in states which had magistrates with titles of rulership (such as the *archōn basileus* at Athens) such a decline from sole ruler to elected magistrate.[60] On this view, with the development of the *polis*, as the power of the people grew stronger, so the power of the ruler dwindled.

The Argive *basileia* is usually interpreted in this way. A hereditary *basileus* is attested to at least the early fifth century (Hdt. 7.149), although the *basileia* may have survived to the middle of the century, since a Melantas is named as *basileus* in ML 42, dating to about 450 BC. Pausanias (2.19.2), on the other hand, says that the last king of Argos was Meltas, and that he was deposed by the *dēmos* in the ninth generation after Medon (generally calculated to be mid sixth century). Meiggs and Lewis argue that the Melantas of the inscription is not to be identified with Meltas (as some have tried to do), and is just an eponymous official.[61] Carlier is of the same view, and thinks that the *basileus* of the inscription is an annual and eponymous magistrate.[62] It seems that the Argive *basileus* at the beginning of the fifth century still had responsibility for leading the army in war[63] – he would have represented the Argives on the war council against the Persians, though the Argives chose not to take part (Hdt. 7.149.2) – and already by the early sixth century the Argive *basileus* shared sovereignty with other offices of state, since the *damiourgoi* are also named in inscriptions (*IG* iv 493).[64] Since the *basileus* does not appear at all in the negotiations of 420 BC (Th. 5.47.8), and the Argive army is commanded in 418 by five generals (Th. 5.49.4–60.6), Carlier suggests that the obvious conclusion would be that the *basileus* had either been dispensed with just after 450, or that his political and military importance had become negligible.[65] He does, however, highlight another inscription from the fourth century which mentions a *probasileus*, who he guesses may have had a religious function.[66]

The Argive *basileia* seems to conform very comfortably to Aristotle's description of his fourth kind of *basileia*, which is the kind found in the Heroic Age. According to Aristotle, this kind of *basileia* was rule of the willing; it was family-based (*kata genos*), and also it was according to law where the *basileus* had a defined remit as general and judge and had overall

control of matters relating to the gods (*Pol.* 3.1285b2–23). These *basileiai* declined, Aristotle says, either because the *basileis* themselves gave up their power, or the people (*ochlos*) removed it from them, and they became no more than kings in the Spartan sense, with religious responsibilities or military leadership in external wars. The orthodoxy maintains that these *basileis* then declined into appointed magistracies (as was the case at Argos), or they were replaced by a new kind of political phenomenon (as Thucydides suggests), the *tyrannoi*.

It is Thucydides who has been chiefly responsible for the creation of this orthodoxy. In his 'Archaeology' he says that in the past there had been ancestral rulership (*patrikai baseileiai*) with fixed prerogatives,[67] but as Greece had become more powerful and more wealthy tyrannies (*tyrannides*) were established in many cities (1.13.1). Nevertheless, he says, nothing great was achieved by these tyrants, who ruled only in the interests of themselves and their families, and in the end (except in Sicily where they were very powerful) the tyrants were brought down by the Spartans (Th. 1.17–18.1).

These comments by Thucydides have had a profound effect on the way that modern scholarship has understood rulers and ruling in ancient Greece. Before turning to a more positive account of the shape and ideologies of ruling in subsequent chapters, we need to look in more detail at Thucydides' distinction between the hereditary rule of *basileis* and the rule of wealthy tyrants in order to show that these distinctions do not stand up to scrutiny, and that most rulers in the ancient Greek world were aspiring to similar values and responding to the same kinds of need.

## Ancestral rule

Thucydides says that ancestral *basileia*, which was based on fixed prerogatives (*rheta gera*), was superseded by tyrannies once the cities became wealthy (Th. 1.13.1). The implication is that *basileia* was an institution which, in Thucydides' own time, belonged to the past. Aristotle also thinks that family rule (*kata genos*), which he seems to equate with Thucydides' *basileia*, belonged either to a long-gone age or to the barbarians (*Pol.* 3.1285a16–24; cf. 4.1295a11–12).[68]

The issue of *basileia* belonging to a past age is problematic, not least because the notion of hereditary rule is itself problematic. Furthermore, there are difficulties in making such clear distinctions between putative hereditary and other, more recent forms of ruling, which it is implied are not hereditary or, at least, dynastic (*kata genos*). There are also problems with differentiating between supposed earlier forms of ruling, which traced its origins back to heroes, and more recent types of ruling, usually typified as tyranny. Therefore in what follows we need to look at what hereditary rule might have meant, the duration of these so-called 'ancestral' dynasties, and finally the importance of ancestral rule to ruling ideologies. Through a consideration of these questions we should be able to see more clearly the sense in which rule could be considered 'hereditary' or 'ancestral', whether it occurred before Thucydides' alleged watershed or after it.

When Thucydides, at least, is thinking of ancestral *basileia*, he probably has in mind, as a type, Agamemnon, whose ruling sceptre he received through his family from Pelops, who received it from Zeus (*Il.* 2.100–8). The genealogy of Agamemnon's sceptre, the ancestral sceptre (*skēptron patrōion*: e.g. Hom. *Il.* 2.46), was essential for establishing his right to rule. It is the 'ancestral' nature of *basileia* (and indeed of 'kingship') which, following Thucydides, is often seen by modern scholarship as one of the features that distinguish it from tyranny.

It cannot be denied that the symbolic value of ancestry was substantial. Diomedes in Book 14 of the *Iliad* claims that he has the right to be heard because, although he is the youngest of the Achaean heroes, he was descended from Oeneus (the father of his father), who excelled his brothers in *aretē*, excellence. Therefore they cannot refuse to listen to him by saying that his family was cowardly or unwarlike (*Iliad* 14.115–27). His genealogy is the proof of his own value. However, we need to look more closely at what 'ancestral' *basileia* might have been, and what it might have meant, especially in relation to the development of genealogies.

In the formation of traditions about the past, Vansina has argued that in oral histories there are only two registers, the time of origins and the present.[69] Everything in between is lost from oral memory. Furthermore, Assmann has shown that the temporal distance between when memories change from a recent social memory to a distant cultural memory is about 80 years, or

about three generations.[70] On these terms, the length of a dynasty does not need to extend beyond one's father's father to be able to become 'traditional' or 'ancestral'. Rosalind Thomas has argued that even for classical Athens *progonoi*, ancestors, could mean one's grandfather and everyone who may have come before that. She says: 'We must imagine a picture of the past particularly hard for historians, in which grandfathers constituted the "ancestors" (*progonoi*) as much as a legendary hero, a past of extreme chronological vagueness and fluidity and one which might from the family's viewpoint be a void more than three generations back.'[71] It is telling that, in analyses of Early Iron Age rulers' houses, Mazarakis Ainian suggests that 'a hint in favour of a hereditary ruler may sometimes be the occupation of a dwelling for more than one generation.'[72] In sum, 'ancestral monarchy' in many cases probably had greater ideological value than practical reality.

Furthermore, the notion of 'ancestry' and 'ancestral rule' is made even more problematic by the instability of many of the early communities which produced these 'ancestral' rulers. Population figures for villages could be in the hundreds,[73] but many of these Early Iron Age settlements and their dynasties seem to have been of relatively short duration. For example, a building that has been identified by the excavators as a ruler's house is Unit IV-1 at Nichoria in Messenia, which was in use for over two hundred years.[74] It served a small Early Iron Age community of about forty families (or two hundred people).[75] It was replaced by what Mazarakis Ainian describes as a 'less impressive building' in about 800 BC, although it also seems to have fulfilled the functions of a ruling house.[76] The community went into decline in the eighth century[77] and was abandoned, perhaps because of the Spartan conquest, although the historicity of the conquest has now been doubted.[78] Yet conquest seems to have been not the only reason behind the abandonment of settlements. Crielaard has shown that, at least in the region of the Euboean Gulf, there were significant changes in settlement distributions in the Late Helladic IIIC Middle period, which also seems to suggest the waxing and waning of centres as the locations of importance.[79]

That many Early Iron Age communities, like the one at Lefkandi, were relatively short-lived gives added point to the fact that ruling dynasties may have, in fact, been of relatively short duration and still have claimed to be *patrikai basileiai*. In claiming heroic descent, the founding figure may have

existed on the edges, or just outside the edges, of current memory and become part of Assman's cultural memory. That is, this memory of ancestors (who may be great-grandfathers or even grandfathers) rests on the other side of what Vansina calls 'the floating gap' which marks the limit of current memory.[80] Consequently, mortals who were venerated as heroic at their death (which has its own significance) could quickly become – or at least could come to represent – foundational heroes with mythical significance.

Yet the ideological importance of ancestry for *basileia* is evident with the earliest rulers that emerged after the collapse of the Mycenean palace economies, who were keen to emphasize their links with the Mycenean past, even though the political structures of the Early Iron Age were very different.[81] Evidence from burials in the post-palatial period seems to suggest that, despite the collapse of the Mycenean world, a thriving elite probably emerged between 1200 and 700 BC in communities that 'continued to show very considerable vigour, artistic energy, and some sophistication'.[82] This early elite, released from the constraints of the centralized power-hierarchies of the palaces, continued (or reinvented) an elite culture of hunting, feasting and lavish funeral celebrations, and images on pottery seem to indicate an elite occupied in competitive activities of feasting, hunting, chariotry and warfare.[83] However, they legitimated their claims to power not only through personal accomplishment, but also by making connections through their activities and symbols of power with the former elite.[84]

It is clear that the structures of power and hierarchy of the post-palatial elite were different from those of the Mycenean palaces, although it may be that the basic ideologies of rule were similar.[85] In particular, Maran considers the case of Tiryns in Late Helladic IIIC,[86] where the citadel was repaired and settlement resumed. However, although the Great Megaron, 'the architectural expression' of the Mycenean *wanax*, was replaced, its function seems to have changed dramatically.[87] The new, and competitive, elite at Tiryns seem to have built themselves new houses in the Lower Town, and, rather than providing the focal point of a residence for a ruling family, Maran has suggested the building on the site of the Great Megaron was used for communal gatherings. Nevertheless, Maran believes that power in post-palatial Tiryns rested in the hands of one man, and that the symbols of his rule draw on the world of the palaces: on the one hand, in the continued use of the throne, and on the other,

in the *keimelia*, or treasure, discovered buried in a house in the Lower Town, especially the signet rings, 'typical symbols of authority of palatial times', which were passed as heirlooms through successive generations.[88] Maran concludes that:

> The ideology of the post-palatial period in the Argolid combined two conflicting principles for the justification of rulership, one based on individual accomplishments and the other on the proof of descent from the former elite. The actors in the social arena of the twelfth century BC were families of a new upper class, who used the possibilities created by the collapse of the palatial system and who competed against each other for the roles of leadership. These families were responsible for the restoration of the citadels and for new architectural layouts, like in the Lower Town of Tiryns, and due to their initiative the trade relations which had been interrupted by the fall of the palace was re-established. In the case of Tiryns the archaeological evidence suggests that one of these noble families at least temporarily succeeded in legitimising their supremacy by the claim of descent from the kings of the past and by the monopolisation of fixed and moveable symbols of kingly power. They thus managed to establish a succession of power within the family and to create a kind of dynasty.[89]

Thus a claim of ancestry appears to be part of the ideology of ruling of even the earliest Iron Age rulers, even if this was a claim that was constructed rather than based on an actual kinship link between the elite of the Early Iron Age and their palatial forebears.[90]

On these terms, the need to create a heroic 'founder' may provide one way of understanding the Toumba at Lefkandi.[91] The Toumba has been called a heroön, and links have been made with the funeral of Patroclus described in epic, although there is debate over whether Homer is copying the style of burial expressed in the Toumba, or whether those who constructed the Toumba were following Homer. In fact, the significance of the building has been much debated, and, whatever its original function, it has been doubted whether it could rightly be understood as a heroön at all in its last phase. Nevertheless, while no archaeologically visible cult was offered there,[92] Morris argues that we should not rule out the possibility that it was a heroic burial in the sense of a cult-site, as we do not know what cult may have looked like in this period, as much religious activity seems to be archaeologically invisible in the tenth century.[93] Furthermore, Antonaccio, who observes that to be

a hero did not necessarily entail cult, argues that the inclusion of Bronze Age antiques in the burial 'was a deliberate claim to the inheritance of the *wanaktes*, an invocation of the past to legitimate the present'.[94]

A similar phenomenon may have occurred at the cemetery at the West Gate at Eretria, although these burials and their significance have also been much debated. The 'Hero' (no. 6) buried within the cemetery is a 'heroic' warrior burial, dating to the eighth century, and also contained a bronze lance, which Bérard has interpreted as a royal sceptre.[95] The cemetery was marked off by a wall in the early seventh century, and a structure erected over the tombs. Votive offerings were found and evidence of ritual feasting. In the past, this burial and the cemetery has been interpreted in the light of *polis* development, and as the last days of the *basileis*.[96]

However, interpretations which look to the end of *basileia* as a political phenomenon may not be the only way of understanding this cemetery and the role of tomb 6 within it. Although he also wants to understand the tomb in terms of aristocratic manipulations, Crielaard argues that tomb 6 should be considered together with the other burials in the cemetery, which include men, women and children, and that special funerary treatment was given to the whole family (who are also buried 'heroically' in urns) and perpetuated over several generations.[97] For Crielaard, then, the tomb of the warrior does not mark a break or crisis in the political order at Eretria, but an affirmation by the elite of their position in the community. Furthermore, that the cult belongs to the seventh century may suggest that we are seeing not the end of *basileia* but an attempt to create a foundation for the existing *basileia*. As we have seen, it was a relatively short-term memory which generated genealogies. The warrior of tomb 6 may have been 'remembered' as the founder of the community, and the offering of cult became the affirmation of his status and role in the family and in the community.

Consequently, 'ancestry' itself was not necessarily a claim with actual temporal depth, although it had high symbolic value.[98] Early *basileis* may not have belonged to extended dynasties, and many probably did not. Furthermore, a number of the so-called tyrant-constitutions also maintained dynasties, such as the Orthagorids at Sicyon, who Aristotle says maintained control for one hundred years because of their moderate rule (*Pol.* 5.1315b11–18), or the dynasty in Samos, of which Polycrates was a member, which may

have lasted from the mid sixth century until the early fifth century.[99] The Battiads in Cyrene were themselves established as part of a migration in the seventh century, and maintained a dynasty into the fifth century.

In fact, 'tyrants' too could justify rule by their heroic descent. Peisistratus claimed descent from the Neleids of Pylos (Hdt. 5.65.3), from whom Codrus and Melanthus, *basileis* in Athens, were also descended. This myth involved Melanthus coming from Pylos, defeating in single combat the Theban Xanthus who was threatening Athens, and replacing the Athenian king and last descendant of Theseus, Thymoetes. On Lavelle's interpretation, this myth was very significant for Peisistratus, who was already a war hero from the war against Megara, and who was coming to the city from the Attic hinterlands. He says:

> It is to be noted that Melanthos did not acquire the throne of Athens by taking it forcibly, through subterfuge, usurpation or otherwise illegitimately or even obliquely. Rather he became *basileus* by consent of the Athenians after demonstrating heroic and kingly capacities.[100]

On this reading, Peisistratus encouraged acceptance of his Neleid connection as part of his 'campaign' for tyranny, when he does genuinely seem to have been elected to the position in his first phase of tyranny. Nevertheless, it has to be said that we have no real evidence, beyond educated guesswork, of Peisistratus making this link at this stage.

However, there does seem to be evidence that Peisistratus was prepared to capitalise on the Neleid myth later on. In his third phase of rule at Athens, Peisistratus deliberately draws attention to his heroic heritage in order to make his rule 'take root', through the purification of the island of Delos (Hdt. 1.64.1–2; Th. 3.104.1–2). The act of purification involved the removal of the bodies of the dead within sight of the sanctuary to another part of the island, but it was the associations with Peisistratus' Ionian heritage which gave the act its significance. From at least the second half of the sixth century, it seems that Delos was associated with an Ionian festival (*Hymn to Delian Apollo*, 146–64).[101] Some dominant traditions also saw Ionian origins in the Neleids, who went to Athens and then sent colonists (led by the sons of Codrus) to Asia Minor (Mimnermus: fr. 9 *IE*[48] West; Panyassis of Halicarnassus: *Suda* Π 248; Hellanicus of Lesbos, *FGrHist* 4 F 48, 125; Pherecydes of Athens: *FGrHist*

4 F 155). Peisistratus' activities on Delos have been interpreted as staking an Ionian claim on the island, or as occurring within the context of competitive piety between those who wanted to control this part of the Aegean.[102] Yet surely the aim was also to draw attention to Peisistratus' own heroic and Ionian roots, especially as this was one of his first acts after returning to Athens for the third time, suggesting his priority over the other leading families with whom he was competing for control.[103]

## *Ruling and wealth*

As it seems, 'ancestry' does not stand up as a distinguishing feature of *basileia*, at least if it is to be contrasted with *tyrannis*. However, wealth as a mean of defining *tyrannoi* is equally problematic. As we have seen, Thucydides makes a distinction between *basileis* and tyrants, and Thucydides also linked tyranny with wealth. This association has been developed in modern scholarship, so that, for example, it is often noted that the first usage of *tyrannos* is in the poetry of Archilochus, who despises the wealth of Gyges (fr. 19 *IE* West).[104] Much has been made of the relationship between the introduction of this new word into the Greek political vocabulary, and what is supposed to be a new kind of usurping and wealthy power.[105] However, Thucydides does not suggest that 'tyrants' held all the wealth, or that 'tyrants' necessarily used wealth (exclusive of or above other strategies) to gain power.

A link has also been made between tyranny and coinage,[106] although Osborne argues that in general we should not overstate the revolutionary nature of coinage.[107] It does seem to be the case that the kind of wealth that could be both stored and dispersed may have altered with the introduction of coinage, but rulers in Greece and elsewhere employed mercenaries, for example, before the introduction of coins.[108]

Part of the negative stereotype of tyrants has also maligned their excessive taxation. In particular, Aristotle refers to the Peisistratids' unfinished temple of Olympian Zeus, the dedications at temples made by the Cypselids, and the works of Polycrates at Samos as examples of how tyrants keep their subjects under control by keeping them impoverished and without leisure (*Pol.* 5.1313b18–28). It is true that at Corinth, Cypselus is said to have exacted a tax

of a tenth of each man's possessions ([Ar.], *Oec.* 1346a31–1346b6), with which he is said to have dedicated the golden statue of Zeus erected at Olympia (Agaclytus, *FGrHist* 411F 1),[109] although Salmon doubts the tradition because the sums involved are too high to be genuine.[110] Periander, by contrast, was said to have removed all personal tax and simply imposed harbour dues (Heraclides Lembus 20 = Ar. fr. 611.20 Rose). At Athens the Peisistratids seem to have imposed a tax on farmers (*Ath. Pol.* 16.4–6; cf. Th.6.54.5),[111] although Thucydides is keen to point out that the Peisistratids used the revenue raised for the beautification of the city, for wars and for the sacrifices (Th. 6.54.5). The family was certainly responsible for the development of the agora at the foot of the acropolis as a public space (e.g., the fountain house: Th. 2.15.5; and the altar of Apollo dedicated by Peisistratus son of Hippias: ML 11; Th. 6.54.6), as well as the construction of other public buildings and temples in the city, such as the temple on the acropolis.[112] Kallet notes that despite the stereotype there is nothing particularly tyrannical about the raising of revenue through taxation, and that taxation 'constituted the chief means of a polis, and certainly of Athens, to raise revenue'.[113]

In this section we need to look more closely at the link between ruling and wealth. In the first place we shall see that wealth was intrinsic to ruling from the earliest periods. We will then go on to consider how it was ideologically important for rulers to use wealth for the benefit of the community, before turning finally to the connection between wealth and the accretion of power in archaic and classical Greece.

To begin with, it needs to be stated clearly that even the earliest rulers needed wealth in order to fulfil their role as rulers. Mazarakis Ainian has argued that the evidence from rulers' houses in the Early Iron Age suggests that many early rulers were connected with significant trade in metals, and that early rulers had to be able to control enough wealth to host ritual feasting.[114] Furthermore, in the Early Iron Age, it is evident from the archaeological record that rulers' houses could be lavish, and were built on a monumental scale relative to other edifices in the community.[115] That rulers should live in opulent surroundings is suggested by the house of Alcinous in the *Odyssey*, which is lavishly decorated with gold and silver (7.81–102). Significantly, however, Odysseus needs a guide to take him through the city, and he is able

to enter the house without constraint, which is guarded only by dogs of gold and silver made by Hephaestus (7.91–4).

Rulers, as the wealthiest members of the community, were sometimes perceived to be the most competent to manage the affairs of the community (cf. Th. 6.39.1), and Xenophon compares the rule of states to the management of estates, households and armies (*Oec.* esp.4.4–25; *Cyrop.* esp. 1.6.12–14). On the Homeric Shield of Achilles, the *basileus* has the role of managing the harvest (Hom. *Il.* 18.550–60),[116] and Peisistratus was said to have lent money to farmers who needed help (*Ath. Pol.* 16.2). In the fourth century, Xenophon again provides the example of Polydamas of Pharsalus, who was famous throughout Thessaly and so well regarded in his own city as a good and noble man, a *kalos k'agathos*, that when the city fell into factional fighting they handed over the acropolis to him (Xen. *Hell.* 6.1.2–3). The Pharsalians gave him charge of the city finances for sacrifices and general management. He presented annual accounts to them, and made up any deficit from his own funds, which he recouped when there was surplus.

Significantly, it was important for rulers to use their wealth on behalf of the community. In the first instance, rulers' houses in the Early Iron Age were also generally communal spaces. In fact, one of the identifying features of these early rulers' houses was that they were used for communal feasting and ritual.[117] We can also see the way in which Alcinous' house was a centre for the community. Once inside the court of the house of Alcinous, Odysseus finds it is filled with the leaders of the community, Alcinous' court and council, who pour libations and feast there at Alcinous' expense (*Od.* 7.95–9, 136–8). Similar ideologies seem to inform the later Macedonian palaces. In the fourth century Philip II erected a vast palace at Vergina/Aegae, which Kottaridi argues, as the prototype of later Hellenistic palaces, was designed as a space where ruler and people might meet, unlike the oriental palaces which were designed to be exclusive and limit access to the king.[118] Eastern royal seclusion was, on the other hand, viewed with suspicion (cf. Xen. *Ages.* 9.1–2; note also Eur. *IA* 337–343).[119] Herodotus thinks that the Medish Deioces' demand for a palace in which he cannot be accessed suggests the behaviour of a tyrant (Hdt. 1.98.3–99.1). He says that Deioces, even though he was elected as king of the Medes for his legal expertise and judgement, shut himself in his palace

since he did not want his contemporaries to see that he was no better than they were (1.99.2).[120] Dionysius of Syracuse fortified the acropolis on Ortygia and divided off the island from the city with a towered wall (Diod. 14.7.1–3, cf. 65.3), which 'tyranneia' Timoleon later demolished (Diod. 16.70.4).[121]

Archaeologically, however, the grand houses of the Early Iron Age seem largely to disappear in the early archaic period. This has been taken to mean that rulers themselves disappeared at this time (even though the houses of the so-called tyrants are archaeologically invisible).[122] However, it is more likely that two other factors are at work.

The first is that the ways of displaying wealth had changed between the Early Iron Age and the early archaic period, and that it had become important for rulers to avoid private ostentation. In fact, from about the eighth century it was ideologically important that rulers made a show of exercising restraint in personal as opposed to public display. Periander and Gelon were known, in the tradition at least, for their deliberate austerity, and Pittacus also was a legal reformer whose laws seem to be concerned with restraint (Periander: Heraclides Lembus 20 = Ar. fr. 611.20 Rose; Gelon: Diod. 11.38.2–3; Pittacus: Arist. *Pol.* 2.1274b18–23; D.L. 1.76, 79; Diod. 9.11.1–2).[123] Certainly, it seems to have become a matter of great ideological importance that wealth was used not for the personal aggrandisement of the ruler, but for the glorification and beautification of the city and the community.

Even in later periods, the restraint of rulers could be ideologically important, particularly as it seems at Sparta. In the fifth century the Spartan regent came under suspicion for aspiring to tyranny (Hdt. 5.32; Th. 1.95.3) because he adopted showy Persian robes (Th. 1.130.1; Douris of Samos, *FGrHist* 76 F 14). In the fourth century, Lysander's behaviour was said to be 'contrary to law' (*paranama*) because he was conducting himself in a manner 'more pompous' than a *basileus* (Xen. *Hell.* 3.4.8). Later, Xenophon constructs his story of the meeting between Agesilaus and the Persian satrap, Pharnabazus, in the winter of 395/4 to emphasize the Spartan king's austerity in contrast to the Persian's ostentation (Xen. *Hell.* 4.1.30).[124] By the late fifth century, at least, as we have seen, it had became a preoccupation that tyrants ruled in their own interests whereas *basileis* ruled in the interests of the people (e.g. Th. 1.17; Xen. *Cyrop.* 1.3.18, 6.7–8; Arist. *Pol.* 5.1310b34–1311a5; cf. Isoc. *Panath.* 132–3). Private simplicity and lack of ostentation on the one hand and public building

programmes on the other were important in showing that one ruled not for one's own interests, but in the interests of the ruled, and this seems to have become central for the place of rulers in their communities at an early stage.

There were, of course, some significant exceptions to this principle of austerity. At Sparta there seems to have been a general sense of restraint in terms of public expressions of wealth, except at sanctuaries, both local and panhellenic, which by and large followed trends elsewhere in Greece.[125] Nevertheless, the Spartan kings, despite their attitude of austerity in life, were given lavish funerals, in stark contrast to the more egalitarian trends in funerals among Spartan society.[126] This was to do with their cosmic, as well as their mortal, status. Cartledge says:

> The essential function ... of the elaborate ritual of a Spartan royal funeral was religious. It symbolized, indeed created the honorand's posthumous status as a hero of more than merely mortal status and thus complemented and continued the charismatic status he had enjoyed in his lifetime. For the kings this was a remarkable *rite de passage* ... culminating in their reincorporation in the community of the living as objects of worship.[127]

The status of the ruler, in Sparta as elsewhere, was as important after death as in life. We will return to the heroic and cosmic role of rulers in the next chapter.

Secondly, from about the eighth century there was also a need for rulers and communities to develop other ways of displaying wealth. Morris has analysed the Toumba at Lefkandi and the large house in Nichoria in terms of 'individualising' social structures which downplay public buildings, as opposed to 'group-oriented' structures where 'unpretentious graves are accompanied by "public" display'.[128] However, as we have seen, rulers' houses were public buildings, and the site for communal ritual and feasting. So in the eighth century what we are seeing is not a shift from the individual to the group, but a need to express group needs in a different way. It is of course important that it is this period when temples were also starting to be built.[129]

Furthermore, sumptuary laws, known from Athens and elsewhere in the archaic period, placing controls on the expressions of wealth, have often been seen as a means of the community controlling the elite.[130] However, Sarah Forsdyke has argued that the change in the early archaic period from display

in burials to display at panhellenic centres was not so much an attempt to control the elite as the elite moving the locale of their competition to more symbolically important cult centres.[131] Victories at the stephanitic games were associated closely with wealth, and the qualities that wealth could put on display (Pindar, *Ol.* 2.11–12). Victory was also an expression of wealth, and should be the object of wealth and effort (*Ol.* 5.51–4). It is almost certainly the case that as Greek communities in general became wealthier, new strategies were needed for displaying wealth and competing with other wealthy members of the elite. By maintaining an ideology of restraint, at least in private expenditure, rulers were able to protect themselves at home from other members of the elite who might use wealth to make counter-shows of power.

Since the emblems of power were linked with wealth, rather than private houses used for public use, rulers displayed their wealth publicly both in their own cities and in panhellenic sanctuaries. At Corinth, Cypselus fortified the city, and probably dedicated temples at Corinth to Apollo and at Isthmia to Poseidon, while Periander built the harbour at Lechaeum, the diolkos across the Isthmus, and a temple to Olympian Zeus.[132] Gelon, on the other hand, built temples to Demeter and Kore out of the spoils of the victory against the Carthaginians, and erected a golden tripod at Delphi (Diod. 11.26.7). Pindar exhorts Hieron not to grow weary of spending, since fame proclaimed after death with words and songs alone reveals the way of life of those who are dead and gone (*Pyth.* 1.89–94). Bacchylides suggests that one of the duties of a ruler was to use his wealth well (Bacch. 3), especially in the honouring of the gods at the panhellenic centres.[133]

Yet power did not reside in the possession of wealth itself. Power has sometimes been viewed as an elusive quantity. Cannadine, for example, has said: 'Power is like the wind: we cannot see it, but we feel its force.'[134] As anthropologists have long recognized, however, what constitutes power and how it is achieved is culturally specific, and different cultures understand power in different ways.[135] In Javenese culture, for example, power is concrete, limited and constant: there is only so much power in the universe, and to have more power means that others have less.[136] The Javanese king proves his right to rule by the signs of the concentration of power in his person.

In the Greek world, on the other hand, power was generated by *aretē*, and ruling power by having more *aretē* than any other member of the community.

As Cyrus' father reminds the young commander in Xenophon's *Cyropaedia*, the route to achieving willing obedience is to be wiser and stronger than anyone else (*Cyrop.* 1.6.21–5), and Cyrus justified his rule by showing that he was more adorned than all others with excellence, *aretē* (*Cyrop.* 8.1.22). In order to have power one had to be the best. Proving that one was the best of all, as we shall see in Chapter Two, was a demonstration of one's right to rule, even if not all communities recognized that right, or, in the competitive *polis*, others made the same claim.

The importance of wealth was its function in being able to generate the activities through which one could prove the abundance of one's *aretē*, such as success at the games, foundations of cities, and leading the city in war. Thucydides' Alcibiades, who was accused of aiming at tyranny (Th. 6.15.4), justified his display in these terms:

> Those pursuits for which I am criticised bring me personal fame (*doxa*), as they did my family before me, but they also bring benefit to my country. My outstanding performance at the Olympic festivals made the Greeks revise and even exaggerate their estimate of the power (*dynamis*) of Athens, when they had expected the city to be exhausted by war. I entered seven chariots – more than any other citizen had done before. I won the victory, and second and fourth place too: and my whole display at the games was of a piece with my victory. Quite apart from the regular honour which such successes bestow, the plain fact of their achievement hints at reserves of *dynamis*. (Th. 6.16.1–2)

Panhellenic victories brought personal fame, but they also hinted at reserves of power. In this sense Kurke's observation that victories in the games held a kind of 'talismanic magic' is suggestive, but the product of a victory was more than simple magic, but the expression of power suggesting strength and the ability to deploy strength.[137] In fact, Kurke also talks about how wealth and display, especially at Athens, gave rise to concerns about tyrants and tyranny,[138] and Thomas has discussed the way that fear of tyranny lay behind display and success at the games.[139]

In this way, ruling and wealth were intrinsically connected. In order to prove that one had more *aretē* than anyone else, one had to be able to make the kind of display of excellence that Alcibiades made through his victories at Olympia, for example, and then to create a perpetual memory of that victory

(and so of one's *aretē*) through dedications and epinician song. However, it was also important that this showed not only one's own power but the power of the city. As we shall see, it is notable that often rulers made dedications at sanctuaries not only in their own names, but also in the name of the community. In this way the community shared in the victory, the accretion of power and its expression.

As Sian Lewis has so astutely observed, 'the more various ancient kingship is seen to be, the less distinct its boundary with tyranny appears'.[140] By looking at Greek rulership in the long view, and as a single phenomenon, rather than as imposing the traditional opposition between *basileis* and *tyrannoi*, it is possible to see that there are significant trends in the ways that rule was understood and expressed across the seven hundred years or so from the Early Iron Age to the dawn of the Hellenistic period (and beyond), and throughout the whole Greek world, from Sicily and north Africa to Macedonia.

Rather than worrying about whether Greek rulers were or were not like 'our' kings, or 'proper' kings, and whether ancient Greece was a state or a stateless society, we need to re-centre the questions on rulers and rule, and to ask how and why some communities valued rulers, responded to them, and tried to limit them. By trying to change the focus of the discussion, and by looking at ruling synchronically as a phenomenon that includes *monarchoi*, *basileis* and *tyrannoi*, rulership is revealed as the location for considerable ideological negotiation and even debate. We should expect to see confrontation and contestation as a vibrant society tried to work out what ruling and being ruled meant to them, and how they needed it to adapt and change. That rulers were possible in the context of the *polis* meant that there was often tension with other political stakeholders. As a result, not only was it important for rulers to retain the legitimacy of their rule, but also there was often a political tug-of-war between rulers and ruled over the balance of political control. If we leave aside the question of whether Greek society in the archaic period (let alone the classical *polis*) was stratified or might measure up to other controversial and unconfirmed measures of statehood, it will be possible to judge the range of responsibilities of rulers and the role or roles they were imagined to fulfil in political life, how they strove to legitimate their positions, and so the extent of their political effectiveness.

# Notes

1 See also V. Parker (1998).

2 See esp. the collection of essays in Mitchell and Melville (2013).

3 Sahlins (2004), 147–8, 257 id. (1968), 24. For ranked and stratified societies: Fried (1967), 133–7.

4 Carneiro (1970), 733–8, with (1981), esp 67–71.

5 The point is neatly made in the essay by Peter Skalník (2001–2) on African chiefdoms/kingdoms.

6 Spencer (1996), 310–11.

7 See esp. the essays in Cannadine and Price (eds) (1987); Oakley (2006).

8 The 'absolutist imperative' in Islamic kingship: al-Azmeh (2001), 115–31.

9 For an important critique of the anthropological discussion of divine kingship, see Feeley-Harnik (1985).

10 O'Connor and Silverman (1995), xxv.

11 See esp. Rollinger (2011) and Root (2013); note also Kuhrt (2007), vol. 2, Ch. 11, no. 38 and fig. 11.45 with comment; and see Lincoln (2008), who hints at the possibility of divinity, even if it does not go this far. Compare also Kantorowicz (1997) for the 'king's two bodies', in medieval European thought.

12 Drews (1983).

13 Murray (1983a), 37–62.

14 Carlier (1984).

15 Starr (1961).

16 Qviller (1981); cf. Whitley (1991a) on 'unstable' systems like that on Odysseus' Ithaca. He makes the comparison with feudal kingship of Western Europe in the twelfth and thirteenth centuries, and says that because of its fragility it cannot deserve to be called kingship at all (348).

17 Service (1971); Sahlins (1958), 3–5; id. (2004), 130–48; cf. Sahlins (1968), 91–5.

18 Donlan (1981–2).

19 Sahlins (1968), 20–7.

20 Donlan (1981–2); cf. Donlan (1997), esp. 40–4.

21 Qviller (1981), quotation from 113.

22 Carneiro (1981). See also Earle (1991).

23 Whitley (1991b), 184–6 (quotation from 186).

24 Whitley (1991b), 186.

25 See Binford (1983), 220.

26 Hall (2007), 119–44.

27   He presumably rejects (or only accepts on qualified terms) Fried's model of
     evolution from egalitarian, through ranked, to a stratified society – and so to
     statehood: Fried (1967). Sahlins ([2004], 130–48) for his part is adamant that
     Big Men and chiefs can only belong to ranked societies, and that their political
     power is limited by social structures.

28   Thalmann (1998), 261–2. Cf. Sahlins (1968), 88–95.

29   Thalmann (1998), 256–68. Fried ([1967], 185) thought that stratification was
     consonant with statehood: 'Once stratification exists, the cause of stateship is
     implicit and the actual formation of the state is begun, its formal appearance
     occurring within a relative brief time.' Carneiro, however, has asserted that there
     must be a phase in which stratified societies can exist without being states, and
     that this is the place of chiefdoms in Fried's evolutionary scheme ([1981], esp.
     67–71). Kristiansen (1991) develops this point, and argues that Fried's model
     needs greater refinement, and that stratified societies are on the way to being
     states, but are not states.

30   Thalmann (1998), 246 and n. 14. Thalmann becomes very irritated by Carlier's
     claim that in Homer 'le singulier βασιλεύς équivaut exactement á notre "roi"'
     (Carlier [1984], 145).

31   Van Wees (1992), 32–6, 281–94.

32   Thorne (1993).

33   Thorne (1993), 426.

34   Weissehöfer (1996), 34–8.

35   Kuhrt (2007) vol. 1 no. 14 and n. 1.

36   Weissehöfer (1996), 13–21.

37   Lenz (1993), 10.

38   See Hansen (2002), 21; cf. Poggi (2006), 105–26.

39   Carneiro (1970).

40   Carneiro (1968).

41   Carneiro (1981), 69; cf. Carneiro (1970), 733.

42   I. Morris (1991); Hansen (2002).

43   See esp. Davies (1997); R. Osborne (2009), 128–30.

44   Runciman (1982).

45   We will return to this issue in Chapter Three.

46   Borza (1999), 11–15.

47   See, however, Carlier (2000).

48   Indeed, it is generally assumed that the Sicilian rulers of the early fifth
     century did not use titles themselves (Lewis [1994], 136), although, as noted
     above, Pindar uses both *basileus* and *tyrannos* to describe them and *tyrannoi*.
     Oost (1976), who concentrates on the rulers of Syracuse, noted that it was a

surprising, but common, assumption that 'kings' are impossible in the fifth and fourth centuries, and makes a case for the Syracusan rulers assuming the title of *basileus*. The difficulty with Oost's argument is not whether there were legitimate rulers in Syracuse, but whether they used titles such as *basileus*.

49　Decrees: restored in *SEG* 36.626, dated to 335 BC; RO no. 83 (*basileōs Alexandrō*), which Heisserer ([1980], 50–1, 91–2 with nn. 30–1) dates to 355 BC; see also Borza (1999), 11–15. Coins: Hammond (1989), 199.

50　Schofield (1986).

51　Kremydi (2011), 159–69.

52　Cf. Archibald (2000), 229.

53　Hatzopoulos (1996) with Lane Fox (2011), 377–85.

54　Hatzopoulos (1996), 1.437–9; Lane Fox (2011), 375–6.

55　Spawforth (2007).

56　See esp. Briant (1973), 326; cf. Hatzopoulos (1996), 1.422.

57　Hatzopoulos (1996), no. 4 (2.23–4).

58　We do have a description of Alexander's tent from the third century BC, Phylarchus, *FGrHist* 81 F 44 (also cited by Spawforth [2007], Appendix A.3).

59　Spawforth (2007), 97–9. Spawforth thinks that this was a tradition of responding to petitions which Alexander may have adopted from Persia. However, supplication was in Greece an acceptable and divinely sanctioned procedure for requesting assistance, and we often see rulers involved. Themistocles petitions Admetus of Molossia as a suppliant at the household altar (Th. 1.136). There are also a number of examples of the supplication of *basileis* in Greek tragedy, which of course are mythical, but seem perfectly natural – notably Aeschylus' *Suppliants*, where Pelasgus says that the decision was not his to make, but must be referred to the people, but he is still the point of contact for the suppliants. Likewise in Euripides' *Suppliants*, where, despite his willingness to refer the matter to the *dēmos*, Theseus makes the decision about whether or not the Argives' supplication will be accepted, and expects that they will accept it.

60　Carlier (1984), esp. 509–10.

61　Meiggs and Lewis (1988), 104.

62　Carlier (1986), 381–2.

63　Drews (1983), 59–63.

64　Drews (1983), 58–9; Piérart (2004). The *damiourgoi* were themselves replaced by *artynoi* by the 420s (Th. 5.47.9).

65　Carlier (1984), 382.

66　Carlier (1984), 382–4.

67　*Patrikai basileiai* is usually translated as 'hereditary kingships', but this tends to

suggest succession from father to son (which, as will be seen in Chapter Three, is inappropriate in a Greek context). A better translation is 'ancestral': cf. Th. 7.69.2 (*patrikai aretai*).

68    Barbarians will tolerate this form of kingship, Aristotle suggests, because by nature they are 'more slavish' than Greeks. In fact, Aristotle claims that this form of *basileia* is really tyranny (*Pol.* 4.1295a7–17).

69    Vansina (1985), 23–4.

70    Assmann (1992), 48–56.

71    Thomas (1991), 127.

72    Mazarakis Ainian (1997), 270.

73    I. Morris ([1991], 33–4) estimates numbers for large sites in the period between 1100–750 BC as 600–1,200 at Argos, 1,250–2,500 at Knossos, 2,500–5,000 at Athens.

74    McDonald, Coulson and Rosser (1983), 18–33; Mazarakis Ainian (1997); id. (2006).

75    Kennell and Luraghi (2009), 249.

76    Mazarakis Ainian (1997), 79–80.

77    Kennell and Luraghi (2009), 249.

78    The destruction at Nichoria seems to be too early for a connection with Sparta's activities in the region: Kennell and Luraghi (2009), 249–50; cf. Luraghi (2003); id. (2008), 70–5.

79    Crielaard (2006). On this basis, he concludes that, although there may have been a continuity of terminology between the *qa-si-re-u* of the Mycenean world and the *basileus*, there was competition among those who might hold these positions.

80    Vansina (1985), 24. It is floating '[b]ecause the limit one reaches in time reckoning moves with the passage of generations…'.

81    Although in the Bronze Age the structures of the palace societies are obscure, there is some agreement that the power of the *wanax* was based not only (or even principally) on his control of resources and economic redistribution, but also of cult, and Palaima (1995) has suggested that he was primarily a religious figure. In fact, recently Schmitt (2009; note also S. Morris [2003]) has argued that the role of the *wanax* was fundamentally religious in that he was regarded as a god, but the palaces were not the centre of political or military operations, but cult centres where the elite could also meet. Others have argued on the basis of palace architecture and the Linear B texts that rule seems to have been structured around a *wanax* and local officials, among whom were the *qa-si-re-we*: see Killian (1988); Wright (1994) (who develops the notion of a

hearth-*wanax* ideology); id. (1995). Wright has also argued that in the context of competition between the elite (both within communities and between communities) the ascendency of one family, and so lineage, was also central to the power structures of the Bronze Age communities, pointing in particular to the monumentalization of burials within defensible settlements: Wright (2006), 7–13. Further, he argues for the possibility that Mycenean society was structured around 'a series of chiefdoms and paramount lineages' ([1994], esp. 58).

82   R. Osborne (2009), 37.

83   Crielaard (2006), 282–4.

84   See the essays in Deger-Jalkotzy and Lemos (2006), and especially those by Eder, Deger-Jalkoltzy, Maran, Crielaard and (on the Mycenean elite) Wright. For the importance of the LH IIIC period in the transition from a Mycenean to a Hellenic (or Homeric) culture, see esp. Deger-Jalkotzy (1991).

85   The link between the role of the *qa-si-re-we* and the later *basileis* is elusive, if indeed there was one, and we should avoid evolutionist models which see a simple transference of power from the personnel of a centralized palace elite to a local elite, tempting though that may be. The *qa-si-re-we* seem to have been involved in the administration of metals, although they may also have had religious functions, and never exclusively or always both of these: Hooker (1980), 113–14; Carlier (1984), 108–16; Lenz (1993), 92–104; Palaima (1995), esp. 124. Cf. Deger-Jalkotzy (1991), who discusses the changes in terminology of ruling alongside continuities in the ideologies.

86   Maran (2006).

87   See Maran (2001).

88   Maran (2001); id. (2006).

89   Maran (2006), 143–4.

90   Hurwitt has suggested that in the Geometric period the elite were actively making links with a heroic and Mycenean past through mythical scenes of vases: 'Narrative art … may have been used to claim heroic pedigrees for the nobility, and to insist on its right to remain nobility in a polis society': Hurwitt (1985), 123–4 (quotation from 123).

91   Cf. Morris (2000), 231–7.

92   Antonaccio (1995), 240–1; cf. Morgan 2009, 47.

93   Morris (2000), 236–7.

94   Antonaccio (2006), 391.

95   Bérard (1972).

96   For Bérard (1982) the burial, on the one hand, marks a crisis in the political order in the movement towards a more egalitarian community, and, on the

other, in the cult the warrior receives as guardian of the city, an attempt by the aristocratic families who maintain it to justify their position in the new political mosaic. Cf. de Polignac (1995), 129–43.

97 Crielaard (1998).

98 Morgan (2009), 48–52.

99 On the Samian dynasty, see further Chapter Three.

100 Lavelle (2005), 17–29.

101 On problems with dating of the *Hymn* and the variety of opinions on its relationship to the *Hymn to Delphian Apollo*: Faulkner (2011), 11–12. Faulkner concludes: 'In the end, one can date *Apollo* with reasonable confidence between the first half of the seventh and the second half of the sixth century, but it is difficult to be more precise with any certainty.'

102 R. Parker (1996), 87–8; Constantakopoulou (2007), 47–9, 63–6; note also Munn (2006), 208–10.

103 Another tradition known only from Pausanias (2.18.8–9) has the Alcmaeonidae also as Neleids, but as Davies points out ([1971], 369) this story seems to be unknown to Herodotus (5.62.2, 6.125.1), so may have originated in the fourth century.

104 E.g. Andrewes (1974), 21–3; R. Osborne (2004), 59–60; Seaford (2004), 118, cf. 159; Kallet (2003).

105 E.g. Andrewes (1974), 23; McGlew (1993), 53; R. Osborne (2009), 180–1.

106 E.g. Seaford (1994), 231; id. (2004), 99, 214–16, 311.

107 R. Osborne (2009), 245–6.

108 Cf. Schaps (2004), 146.

109 For the statue: Scott (2010), 152.

110 Salmon (1984), 196.

111 On the issues involved here, see Rhodes (2003), 215–16.

112 Wycherley (1978), 156–9, 144–5; Camp (2001), 29–39.

113 Kallet (2003), 122–3 (quotation from 122); cf. discussion by Hodkinson about taxation in the Greek world, and especially at Sparta: (2000), 187–90.

114 Mazarakis Ainian (2006).

115 Mazarakis Ainian (1997).

116 Havelock ([1978], 58) is dismissive: 'This is no Mycenean king but a country squire among his hired hands.'

117 Mazarakis Ainian (1997), 270–6.

118 For the palace at Aegae: Kottaridi (2011a); cf. id (2011b). For the contrast between the Macedonian palaces at Aegae and Pella and the fortification on Ortygia of Dionysius of Syracuse and the palaces of the Persian King:

Hatzopoulos (2001). However, for Philip's and Alexander's imitation of some features of oriental court style, see Spawforth (2007). For Persian palaces, see Brosius (2007), 49.

119 Compare, however, the late tradition of Plutarch who claims that once Pericles became involved in politics he deliberately avoided social encounters: *Per.* 7.5.

120 Note also Maeandrius, tyrant of the Samians, who did not think it was right for one man to be master (*despozein*) over men 'similar' to himself (Hdt. 3.142.3).

121 See Funck (1996), who contextualizes Dionysius' fortification on Ortygia within the power-politics of Near Eastern palaces; cf. Hatzopoulos (2001).

122 The building which has sometimes been identified as the house of the Peisistratids in the Athenian agora may not have been a domestic structure: Shear (1994), 228–31; Camp (1986), 44–5; id. (2001), 35. On the 'palace of Polycrates', which Suetonius tells us Gaius Caligula planned to rebuild (21), see Shipley (1987), 76.

123 Periander: see also Salmon (1984), 199–200.

124 Cf. L. Mitchell (2007), 21–2.

125 See esp. Hodkinson (2000), 279–302.

126 Cartledge (1987), 331–43; Hodkinson (2000), 262–3.

127 Cartledge (1987), 340.

128 Morris (1992), 149–53.

129 We will come back to this in Chapter Four.

130 E.g. Gagarin (1986), 78.

131 Forsdyke (2005), 22–4.

132 Salmon (1984), 180.

133 As Kurke observes ([1991], 163–6, 182–94), epinician poetry is concerned with wealth that is well used for the public adornment of the city and the places where the city is represented, such as the panhellenic sanctuaries.

134 Cannadine (1987), 1.

135 See esp. Feeley-Harnik (1985).

136 B. R. O'G. Anderson (1990), 17–77.

137 Kurke (1991), 163–94; cf. Davies (1981), 99, 103–5.

138 Kurke (1991), 175–82.

139 Thomas (2007), 143, 147–8.

140 Lewis (2006), 8–9; see also Ogden (1997), 148–51.

# *Aretē* and the right to rule

The relationship between the ruler and the ruled is always symbiotic. The ruler must either rule through some kind of coercion (whether with the support of a co-opted elite or through military force), or through a process of legitimization, at least in the Weberian sense of legitimacy where there is a belief in the nature of rule and a willingness to be ruled.[1] This recognition of the two paths to ruling lies at the heart of Xenophon's *Cyropaedia*, where Cyrus rules his empire through fear (1.1.5), but also aims to achieve willing obedience, both in the army and in the empire (e.g., 1.1.3, 6.21, 2.1.23–4, 17–3.16, 8.1.4, cf. *Oec.* 13.6–12).[2] It is notable that when rulers became harsh or violent, their hold on power became weak. Thrasyboulus, the brother of Gelon and Hieron, of Syracuse ruled for ten months because the Syracusans revolted against the violence of his rule (Arist., *Pol.* 5.1315b38; Diod. 11.67.5–68.4), just as Hippias was said to have become more harsh after the assassination of Hipparchus (*Ath. Pol.* 19.1; Hdt. 5.55, 62.1–2), before he was driven out.

In the context of archaic and classical Greece, legitimacy – that is, willing obedience – was achieved through proof that the ruler had an excess of *aretē*, excellence. At the end of the sixth century, Heracleitus is reputed to have said that he would take one instead of thousands, if he was the best man (*aristos*) (DK 22 B 49), and that the best men, the *aristoi*, choose undying fame (*kleos*) above all other mortal things, but the many glut themselves like beasts (DK 22 B 29). For Xenophon's Cyrus of the *Cyropaedia*, the route to achieving willing obedience was by having more *aretē* than anyone else. Cyrus not only is better than others at enduring hardship, most competent in the arts of war (7.5.78–83), but also values the pursuit of other qualities, in particular justice, moderation and good sense – *dikaiosunē*, *sōphrosunē* and *phronēsis* (*Cyrop.* 1.2.6–8, 6.21–2), and justifies his right to rule on the basis that he is the most adorned of all with *aretē* (*Cyrop.* 8.1.21). In the *Anabasis*, Cyrus the Younger is the 'first' (*prōtos*) and strongest (*kratistos*) of all the royal children, and

the implication is that this justifies his desire to rule (Xen, *Anab.* 1.9.1–2). Aristotle also proposed that if there were to be any man of such exceptional *aretē*, it would not be possible for him to be ruled, because that would be like ruling Zeus (*Pol.* 3.1284b25–34, cf. 3.1288a15–29).

Ruling was also fundamentally heroic. Rulers not only traced their descent from heroes, but also themselves became living heroes for their communities. Heroic status was based on an intrinsic abundance of *aretē* (cf. Arist. *Nic. Eth.* 7.1145a23–4), which, as Lloyd-Jones notes, 'comes only to those fitted for it by their nature, the special aptitude that descends to those sprung from divine ancestors.'[3] To prove oneself a hero was to suggest not only that one was favoured by the gods, but also that the gods would intervene on one's behalf. Isocrates says that as a young man Euagoras of Salamis was so excelling in the attributes of soul and body, that those who ruled as *basileis* feared that he would not remain a private citizen, and that the Deity (*daimōn*) would intervene to make sure he acquired rule in a fitting manner (*Euag.* 23–5, 29).

In this chapter we will consider how the rulers of archaic and classical Greece continued to legitimize their rule through the abundance of their *aretē*. We will begin by considering the competitive nature of Greek society and the implications of that for the politics of *aretē*, and how the ideals of heroism came to define ruling ideologies. We will then turn to the specific strategies rulers used to prove their heroic qualities, through war, victory in the games, and city foundation. In these ways, rulers could show that they were more than men, and so had a right to rule.

## The politics of *aretē*

Proof of heroism was possible by proving descent from gods and heroes. In this sense, ancestry (as we saw in the last chapter) was important. Clearchus of Heracleia was said to have called himself the son of Zeus, and to have had a golden eagle carried before him (Justin 16.5.8–9). Euagoras, who refounded the dynasty on Cyprus, not only traced his family's descent to Aeacus, and so to Zeus (Isoc. *Euag.* 12–18; *Nic.* 42), but also was honoured with cult for his great deeds (Isoc. *Euag.* 1–2). As we have seen, the creation of such heroic genealogies was assisted by the fact that oral memory was short, and

genealogies served the needs of the present rather than represented a genuine memory of the past.

Yet genealogy had only so much importance. Euagoras' heroic descent was assumed once his own heroic status was assured. In this sense rulers showed themselves as being fit to rule by their actions, which in turn confirmed their true heroic descent. These were two sides of the one coin: having a *basilikos* nature was something to which one was born, but this birthright was revealed through action, so that one's deeds proved one's birth (cf. Xen. *Ages.* 1.5). For instance, in his account of the childhood of Cyrus the Great (of which Herodotus knew there were many versions: 1.95.1), Herodotus says that when playing with the village children, Cyrus (who had been brought up by a shepherd) had been elected *basileus* by the others, since, Herodotus says, he seemed the 'most fitting' (*epitēdeiotatos*) for the position (1.114). One of the children, the son of a Persian noble, refused to take orders from Cyrus as he organized his 'household', and Cyrus beat him. Cyrus was then brought before Astyages, the King of the Medes (who thought Cyrus had been exposed as a baby), and forced to defend himself, which he did robustly. At this point Astyages recognized the character of the child's face and noticed that Cyrus' answer was 'very free' (*eleutheriōtatē*), that is, not the answer of a slave. As a result, Astyages realized that Cyrus could not be the son of the shepherd (who had rescued him from death and brought him up in his own home), and must be his own grandson.[4]

Behaviour brought out the true qualities and heritage of the man. It was a common *topos* of Near Eastern stories about rulers that, although they rose to become hero-kings with great virtues endowed upon them, they had come from humble origins. We can see this in another story about Cyrus' early years preserved in Ctesias (F8d*), which seems to follow the pattern of the rise of the Assyrian Sargon, where Cyrus was born the son of a goat-herder, before becoming a lamp-bearer at the Medish court and finally overthrowing the king.[5] Indeed, there is a strange disjunction between the Near Eastern mythic stories about kings (whose origins were humble and poor) and the publicly proclaimed discourse of royal heritage. Darius, for example, declares in the trilingual inscription at Bisitun that he is an Achaemenid from a line of Achaemenids, among whom is Cyrus (Kuhrt vol. 1, 5.1 §2–§4 with n. 4; cf. vol. 1, 5.19), but Cyrus too, on the Cyrus Cylinder, is emphatic about his

pedigree (Kuhrt vol. 1, 3 no. 21.20–1). These competing discourses of kingship must meet different needs. It is interesting, however, that the Greeks liked the stories of humble beginnings disguising ruling qualities.[6] As Herodotus' story about Cyrus indicates, it was nature not nurture that mattered. A *basilikos* man could be revealed, whatever his apparent circumstances. Nevertheless, it is also probably important that although Herodotus' Cyrus was raised by a shepherd (like Oedipus) his birthright was from a ruling family (perhaps, ironically, also like Oedipus). Birth and the *basilikos* nature belong together, but the *basilikos* nature is an indication of birth, even if that is temporarily hidden. Therefore if one proved one was fit to rule, it was a only a small step further to prove that one's forebears were also heroic rulers.

This ability to show one's fitness for rule, and even the imperative of one's right to rule, seems to be how we should understand the politics of the archaic period. The eighth century, in particular, brought change, especially in settlement patterns. We have noted that the Early Iron Age communities were relatively fragile, and themselves often did not survive beyond a few generations, except at the larger sites. From the eighth century, the trend was towards agglomeration and urbanization,[7] and the growth in population was swift and brought many pressures on the community.[8] As Raaflaub notes, *polis* aristocracies grew out of the processes which made the *polis*, as 'the former elite of village heads evolved into a stratified aristocracy'.[9]

In this context, fierce competition developed for the right to rule. Greek poetry had long spoken of the fear of one man taking all. Solon in the early sixth century had written:

> From a cloud comes the force of snow or hail,
> and thunder is from bright lightening.
> But by great men the city is destroyed,
> and the *dēmos* unwittingly falls into the slavery (*doulosunē*) of a *monarchos*.
> Raised too far, it is not easy to restrain them
> later, but then it is necessary to put a positive gloss on it. (fr. 9 West *IE*²)

This fear was generated by *stasis* or tensions between competing members of the elite. Solon's near contemporary, Theognis of Megara, has similar concerns:

> Cyrnus, this city is pregnant, and I fear lest it give birth to a man,
> a corrector (*euthyntēr*) of our wicked *hybris*.

The citizens are still sensible (*saophrones*), but the leaders are inclined to fall
into great wickedness.
Cyrnus, good men (*agathoi andres*) have never yet destroyed a city.
But when it is pleasing to the wicked (*kakoi*) to commit *hybris*,
they both destroy the *dēmos* and find *dikē* ('just order') in favour of the unjust
(*adikoi*),
for the sake of private profit and power.
Do not hope that this city will not long be unshaken
not even if now it lies in a state of deep calm;
whenever these things become dear for the wicked men (*kakoi andres*),
the profits that come with public evil.
For from these things come *stasis* and intratribal murdering of men.
May a *mounarchos* never take pleasure in this city. (39–52)

While previous scholarship had thought that the politics of the archaic
*tyrannoi* was based on popular support,[10] it has become increasingly clear
that the object of elite politics was not the rest of the community but other
members of the elite.[11] Gregory Anderson has argued that, at least in the
archaic period, the so-called *tyrannoi* were in fact orthodox rulers competing
among an oligarchic elite according to the norms of archaic politics.[12] An
important element in Anderson's picture is the paradox that this oligarchic
elite considered itself to be equal. Raaflaub has argued convincingly that in
the archaic period egalitarian politics was also elite politics,[13] and that it was
from the elite that egalitarianism spread to the rest of the community.[14] In this
context, to be the best, to have the most *aretē*, was consistently the primary
ideological strategy for legitimating one's right to rule, proving one's power,
and fending off other possible contenders.

The most convincing proof of one's right to rule was to achieve heroic
status. Aristotle says that gods arise from among men because of an excess of
*aretē* (*Nic. Eth.* 5.1145a16–25). In fact, the heroism of rulers, if it resulted in
cult, gave them a continued presence after their death among the living, since
heroic cult transcended death and affected the translation from life to 'life after
death'.[15] To achieve hero-cult was to achieve immortality on two levels. Firstly,
hero-cult brought with it the immortality of remembrance through song,
monument, sacrifices and festivals. Secondly, however, to be honoured so
highly as to receive cult bound the ruler and the community to each other for

eternity. The local nature of this bond was important.[16] This was also a world where the dead could return to the world of the living (as Darius does at his tomb in Aeschylus' *Persians*), just as gods could walk among men. In fact, the heroic dead were expected to help the living, especially in war.[17] Theseus, for example, is represented on the painting of the battle of Marathon as 'coming up from the underworld' (Paus. 1.15.3). Similarly, in Simonides' *Plataea Elegy*, Homeric heroes are represented marching out to war beside the Spartan army. While the Homeric heroes were of a different kind to those heroized on death, they shared characteristics in that their chthonic cult was local and particular. In this sense, heroes (whether mythical or dead mortals) were semi-divine beings, at least after death, although their after-death existence was as shades from Hades, bound to a location and a community,[18] like Aeschylus' Darius.

Rulers, however, may have suggested by their activities that they were more than mortal, but at least while they were alive their position remained ambiguous. The epinician poets remind *basilikos* and heroic victors that they are still human, and that their achievements are the result of divine interventions (e.g. Pindar, *Ol.* 1.106–9, *Pyth.* 1.69–71, 2.88–9). Carney observes that the reason the '[l]iterature nagged Greeks to remember the distinction between human and divine' was that they needed reminding.[19]

For most, until the second half of the fifth century, heroic honours came only on death.[20] Gelon at Syracuse and Theron at Acragas, for example, received heroic honours when they died (Diod. 11.38.5, 53.1–2).[21] However, Diodorus says that Dion was elected general with full powers (*stratēgos autokratōr*) and given heroic honours, and the Syracusans honoured him as a benefactor (*euergetēs*) who alone was the saviour (*sōtēr*) of his fatherland after he resolved the crisis of 356 resulting from the struggle between Dionysius II, the Syracusans and Dion (Diod. 16.20.6), though some have doubted heroic honours during his life time.[22] Yet it became increasingly common in the fifth and fourth centuries for men to receive heroic honours while they were alive. If Currie is right, the fifth-century Olympic victor Euthymus of Locri received heroic honours in his lifetime.[23] Hagnon, the Athenian oecist of Amphipolis, also received heroic honours during his lifetime.[24]

It was also in the late fifth century that men started to claim apotheosis to a godly state in their lifetime. Empedocles of Agrigentum, the philosopher, politician, teacher of rhetoric and possibly also physician,[25] is said by Diogenes

Laertius to have been from a family of Olympic victors (8.51–2), and may himself have been an Olympic victor (8.53). He was also possibly invited to become *basileus* of Agrigentum (Xanthus, *FGrHist* 765 F 33 = D.L. 8.2.63), although it was said he declined. It seems he was honoured as a god in his lifetime with sacrifices, obeisance and prayers (D.L. 8.67–8, 70) – though, if the anecdotes about him are to be believed (and Timaeus, for one, did not believe them), these instances of divine honour were spontaneous rather than part of systematic and ritualized cult. Nevertheless, Empedocles himself also claimed he was a god (fr. 112 = D.L. 8.62)[26]

Lysander is another who seems to have received honours while alive: Douris of Samos (*FGrH* 76 F 71) says that the Samians put up an altar for him as for a god and made sacrifices, sang paeans for him, and established a festival of the Lysandreia.[27] It is also possible that the Samians erected a statue for him in the Altis at Olympia (*IvO* 652).[28] Lysander himself may well have been attempting to indicate his divinity; as well as a portrait in marble in the treasury of the Acanthians at Delphi which was said to be of Lysander and may have been dedicated by him (Plut. *Lys.* 1.1, 18.1),[29] Lysander had the statue group erected at Delphi of him being crowned by Poseidon (ML 95; Paus. 10.9.7–8; ML 95; Plut. *Lys.* 18.1, *Mor.* 397f), attended by Zeus and the Dioscouri, as well as leading members of the victorious fleet at Aegospotami.[30] It is possibly in this context that we should understand the story that Lysander may have wanted to introduce elective *basileia* at Sparta (Diod. 14.13.2–8; Plut. *Lys.* 26; cf. Nepos, *Lys.* 3). He hoped, it was said (probably by Ephorus), that he would be elected *basileus* because of the great and wonderful deeds he had already achieved, and which had led to him receiving divine honours on Samos (cf. Douris of Samos, *FGrHist* 76 F 71);[31] as Cartledge suggests, that Lysander was already receiving divine cult put him in the right position for further mortal honours and for taking on the heroic and divine aspects of *basileia*.[32]

This experimentation with panhellenic divinity was also being played out through assimilation with the cult of Zeus. It is possible that Philip's status as an Olympian was being hinted at in the cult of Zeus Philippius established at Eresus (RO 83 γ.4–5), just as Hieron's association of himself with Zeus Aetnaeus may have also been trying to obtain for himself a different kind of afterlife.[33] Philip may not have requested cult from the people of Eresus

(we have no background information about the context of its foundation), but Bosworth argues that 'Philip was deeply associated in the cult of Zeus, and the sacrifices made to Zeus were also in some sense offered to Philip'.[34] Certainly he does seem to be preparing a claim to divinity by including in the fateful procession at Vergina the image of himself as the thirteenth god (Diod. 16.92.5). While doubts have been expressed about the purpose of the Philippeium, the gilded statues of his family seem also to be suggesting a status which was more than mortal (cf. Paus. 5.20.9–10; note also 5.17.4).[35] Even if this building is not a heroön, it certainly looks like one. Schultz argues that, even if there is no evidence of cult, 'the urge to understand the Philippeium's architecture as communicating the idea of heroön is also very strong'.[36]

Claiming divine rather than merely heroic status seems to have generally been viewed as qualitatively different. As noted above, Lysander possibly intended to use such as honours as a platform for establishing a claim to rule, or at least seems to have thought himself worthy of rule, for which such honours helped him reach this conclusion. On the other hand, Agesilaus turned down the request by the Thasians that they might offer him divine honours (Plut. *Mor.* 210d).[37] It was probably not in Agesilaus' interests in Sparta for him to claim too much for himself. Alexander, on the other hand, had nothing to lose, and a lot to gain, in being declared a god.

In order to rule, one had to prove that one had an abundance of *aretē*, and to keep on proving it. One consequence was that it was the ruler, not the office of ruling, that was heroic. Gelon received cult for what he had done, not because rulers must receive cult. This too is important for his cosmic role, as it is personal and not institutional, even though his mortal person (and his immortal existence) had civic significance. In this sense, rulers were charismatic leaders of the Weberian type. In his typology of legitimate leadership, Weber argues that there are three broad types of legitimate authority: legal, traditional and charismatic.[38] The charismatic leader, in Weber's terms, is someone 'set apart from ordinary men and treated as endowed with supernatural, superhuman, or at least specifically exceptional powers or qualities'.[39]

In the sections that follow, we will consider the range of strategies rulers used for showing that they were 'set apart': firstly, rulers as warriors, but then rulers as victors in the games, and rulers as founders. All together, we will see that through these means rulers were trying to validate their position as rulers

by proving the extent of their *aretē* and showing their heroic value, so that some even received heroic cult, the ultimate proof that one was heroic and establishing an immortal relationship with the community.

## Rulers as warriors

War could make rulers. Heracleitus says: 'War is the father of all things, and *basileus* of all, and reveals some as gods and some as men, and makes some men slaves and some free' (DK 22 B 53).[40] War also showed that rulers were fit to rule. For Plato, *basileis* should be those who were best (*aristoi*) in philosophy and war (*Rep.* 8.543a). In the early sixth century Pittacus of Mytilene seems to have established his worthiness to rule on the basis of a victory in a *monomachia*, a battle of champions, with the Athenian Olympic victor, Phrynon (Hdt. 5.94.1–2; D.L. 1.74; Strabo 13.1.38).[41] Mytilene had experienced bitter factional strife, in which Pittacus himself had been involved, and which seems to have arisen out of dissatisfaction with the violence of the ruling family in Mytilene, the Penthilidae (Ar. *Pol.* 5.1311b26–30). Pittacus must have been a member of the elite himself since he was at one stage among the *hetairoi*, or associates, of the poet Alcaeus and his brothers (Alcaeus, fr. 129 Lobel and Page *PLF*). He later married into the family of the Penthilidae (switching political camps, and through his marriage to a family which could trace its roots to Orestes, bolstering his own heroic credibility: Alcaeus, fr. 70 Lobel and Page *PLF*; Paus. 3.2.1).[42] While not the first to displace the Penthilidae (Pittacus was preceded by at least one other ruler, Melanchrus),[43] he was elected by the Mytileneans to rule them,[44] which he did for ten years before going into retirement (D.L. 1.75).[45] Diogenes Laertius says he was honoured by the Mytilenians, who gave him land, which he dedicated as holy, and this land is now called Pittakeios (1.75).[46] As Kurke suggests, the name seems to indicate hero-cult, or at least to hint at it.[47]

This connection between success in war, heroism and political power has its roots in the Early Iron Age. As we have seen in the previous chapter, Early Iron Age communities, at least in the Euboean Gulf, were already expressing both the competitive and communal values that we can discern in the Homeric texts. We have also seen that these Early Iron Age communities seem to have

rulers, who become archaeologically visible through their dwellings. LH IIIC pottery also indicates an interest in warfare among other elite activities,[48] and in this period many rulers were warriors, or were represented as warriors, in their burials. In fact, Deger-Jalkotzy has argued that the relatively small number of warrior tombs in LH IIIC probably reflects the fact that *only* rulers were represented in burials as warriors,[49] bolstering the importance of warfare to ruling ideologies.

The intensity of war before the fifth century has recently been doubted – Raaflaub suggests that we can only say war was endemic from the fifth century[50] – but, as Hans van Wees has pointed out, the symbolism of war was obviously significant for the elite in the archaic period,[51] as it was also in earlier periods. The warrior tomb at Lefkandi is often regarded as the tomb of a ruler. The warrior grave at the West Gate at Eretria has also been viewed by some (Bérard in particular) as that of a ruler, perhaps even the last ruler of Eretria, though not all agree.[52] Archaic poetry also often reflects communities preoccupied by war and martial values, and Irwin suggests that Homeric epic and exhortatory martial elegiacs both work to support the heroic values of the elite.[53]

At its essence *aretē* was a Homeric value, and for the Homeric hero the most important quality was *aretē*.[54] Thus it was the duty of the hero, as the Lycian Glaucus had been instructed by his father, to always be the best and to be pre-eminent above others (*Il.* 6.207–9).[55] In Homer, *aretē* was primarily a martial virtue, and it justified one's right to rule over others. Sarpedon asks Glaucus why they, above all others, receive honours in Lycia, but gives his own reply: because the Lycians say 'our *basileis* are not without fame who rule in Lycia, and they feast on fat sheep and choice honey-sweet wine, and their strength is noble (*esthlē*), since they fight among the foremost Lycians' (Hom. *Il.* 12.310–21).[56]

Further, even though weapons suddenly disappear from graves in the eighth century,[57] dedications of panoplies and other military paraphernalia were made in sharply increasing numbers from the eighth century at sanctuaries (though more, it seems, at Olympia), and figurines of warriors were dedicated at sanctuaries at Sparta and elsewhere.[58]

One of the primary functions of the ruler was to lead the army in war. Aristotle, for example, says that the Spartan *basileia* was a permanent generalship (*Pol.* 3.1285a7–8, 1285b26–8).[59] Indeed, for Spartan *basileis*, who were

constrained by their place within a complex institution of governance, being on campaign also gave them operational freedom (Th. 8.5.3). In the fifth century, one apparently residual role of the Argive *basileus* was to lead the army in war (cf. Hdt. 7.149.2). In regard to Macedon, Hatzopoulos emphasizes the special relationship of the *basileus* as leader of the army, especially when on campaign.[60]

It was also the duty of the ruler to increase the territories of the city. Aristotle says that the success of the Spartan and Molossian *basileis* was based on foundations and acquisition of land (*Pol.* 5.1310b34–40).[61] Van Wees also argues for the importance of wars of conquest in the early archaic period, which he claims produced the class of 'serfs' in many Greek states, epitomized by the helots in Sparta.[62] In the early fifth century, Hippocrates of Gela had vigorously gone to war with the cities of eastern Sicily, and conquered Callipolis, Naxos, Zancle and Leontini (Hdt. 7.154.2). In the fourth century, Jason of Pherae took the irregular military position of *tagos* to set himself up as a warlord in northern Greece, who controlled not only Thessaly but also much of northern Greece, as far as Epirus (Xen. *Hell.* 6.1.7).[63] Jason also reputedly had an intention to undertake a war against Asia (Isoc. 5.119), which (of course) Philip II of Macedon also planned to attempt, and Alexander the Great achieved. Gabrielsen and Chaniotis argue for the ideological importance of warfare and imperialism for the Hellenistic kings, which Gabrielsen traces back to the classical period,[64] but which must surely have originated in Early Iron Age ideologies.

Here we also seem to see parallels with Near Eastern ideologies of ruling. Near Eastern rulers, like Greek rulers, were also men of war. It has been argued that the Assyrian rulers, in particular, were determined on world conquest, and were driven by the ritual and cultic need (as enunciated in their creation myth, the *Enuma Eliš*) to bring into order the chaos of the world outside Assyrian control, just as Marduk managed to overcome the chaos of Tiamat. The King was identified as the representative of god on earth, and the war over chaos among the gods was re-enacted in the terrestrial and mortal sphere.[65] Thus the ideology of neo-Assyrian kingship included the need for world domination, even if in reality kings were prepared to put limits on what could actually be achieved.[66]

In a similar way, in Hesiod's *Theogony* Zeus also conquered the forces of chaos and was made ruler (*basileus*) of the gods (881–5),[67] though despite

the importance of territorial acquisition, for the early Greek rulers the ability
to wage war successfully was linked to the ability to offer protection, to be
saviour and benefactor. That the ruler should provide security for his people,
especially in war, was axiomatic. Gelon, Hippocrates' successor at Gela, who
had been appointed *hipparchos* of Hippocrates' cavalry because of his *aretē*
and was 'most famous' (*lamprotatos*) in Hippocrates' wars (Hdt. 7.154.2),
himself finally took Syracuse (Hdt. 7.155.2). His most brilliant and audacious
victory, however, was against the Carthaginians at Himera in 480, when he
went to the assistance of Theron of Acragas (Diod. 11.20.4). For this victory,
he was acclaimed, according to Diodorus (11.26.6), as benefactor (*euergetēs*),
saviour (*sōtēr*) and *basileus*.[68]

Hieron, Gelon's brother, is praised in similar terms. In the *First Pythian*,
Pindar praises Hieron for delivering Hellas from the 'deep slavery' of the
Carthaginians on the one hand (with Gelon), and on the other Hieron's own
victory over the Etruscans at Cyme in 474, for which he made dedications
of armour at Olympia (ML 29), and at Delphi. The poet prays that they may
not return since the sons of Deinomenes have defeated them through their
valour (*aretē*) (71–80). Similarly, in the *Second Pythian* Hieron is thanked
for bringing through his power (*dynamis*) a look of security (*asphalēs*) to the
maiden of Zephyrian Locri after their war (8–20), and for this reason is called
*euergetēs*, benefactor.

For some rulers, military prowess seems to have led to cult.[69] We have
already seen that honours for Pittacus of Mytilene may be viewed in this light.
On his death, Gelon was honoured with hero-cult (Diod. 11.38.5). Herodotus,
though generally hostile to the ruler of Syracuse, says that the deeds of Gelon
were said to be the greatest, and he was by far the most important of the
Greeks in his day (7.145.2). Philip II of Macedon also claimed honours, and
perhaps even divine honours, for his martial abilities. Philip commissioned
the building of the Philippeium at Olympia to commemorate his decisive
victory against the Athenians and Thebans at Chaeronea in 388 BC. Alexander
was also so successful at making war that at Athens a statue was set up for him
as *basileus* and *anikētos theos*, unconquered god (Hyp., *Against Dem.* fr. 7 col.
31–32), and received cult in other cities as well, although there is some debate
over whether he demanded these honours or whether they were thrust upon
him.[70]

## Rulers as panhellenic victors

Participation in games was linked with war.[71] Pindar says that whoever is endowed with *kudos* ('fame') from taking part in games (*aethloi*) or making war, being spoken of well, received the loftiest profit, the best flower of speech of citizens and foreigners (*Isthm.* 1.50–1). Kurke has shown how panhellenic victors were often associated with warriors (Plutarch, for example, says the walls of cities could be pulled down for returning victors, since there were no need of walls if it had men who could fight and win: *Quaest. conv.* 2.5.2).[72]

Furthermore, games, and especially chariot racing, had long been a means of playing out elite competition and marking status. The 'hero' of Toumba was buried with his four horses,[73] and LH IIIC pottery from the Euboean Gulf depicts scenes with chariots.[74] In epic, Patroclus' funeral games are opened with chariot races (Hom. *Il.* 23.272–650). Chariot racing is said by Pausanias to have become an Olympic event in 680 BC (5.8.7), and subsequently became the most prestigious event of the games,[75] since participation in equestrian events such as the chariot races required resources which only the very wealthiest could command.[76] In *Olympian* 1, Pindar says that the horse-loving *basileus*, Hieron, 'gains the peaks of every *aretē*' (13).[77] Hieron, in *Pythian* 2, is said to excel everyone else in wealth and in honour, *timē* (59–61; cf. Bacch. 3).

Panhellenic sanctuaries in particular were important as transregional centres for the competitive display of *aretē*. It would seem to have *prima facie* importance that Olympia became a venue for elite display at a point when the nature and constitution of the elite was destabilized by the changes that were occurring in urban centres. While 776 BC as the date for the foundation of the Olympic games is mythical,[78] Catherine Morgan has shown that it was about this time that the sanctuary began to take shape as a transregional sanctuary.[79] We have already discussed in the previous chapter how, as the elite needed to compete with each other more at home, an important arena for competition became the panhellenic sanctuaries outside the city, first Olympia and then Delphi, Nemea and Isthmia, which were founded as a cluster in the first quarter of the sixth century, though the sequence is unclear.[80]

The perpetual celebration of heroism perhaps already implicit in the building of the tumulus at Lefkandi received a new form with the development

of a panhellenic context for victory and for the display and celebration of victory, as it allowed the possibility of more enduring forms of memorialization, through the celebration of their deeds in song (cf. Bacch. 3.89–96),[81] and in monuments. Thus the value of panhellenic victories resided not just in the victory itself, but also in the poems and dedications which could be commissioned to celebrate, commemorate and contextualize it within the values specific to supporting the ruling ideologies.[82] Epinician poetry itself provided a commemoration for eternity of one's status, especially a victory at Olympia. As Golden notes, commemoration in epinician song 'places a man on a continuum with the legendary heroes of the epinician myths'.[83] Furthermore, Gregory Nagy argues that Pindaric epinician not only connects the heroic past with the present, but that it also collapses the distance between the past and the present, 'in that the very activity of athletics is from the standpoint of ideology a present-day ordeal that re-enacts, in a perpetual series of seasonally recurring festivals, the primordial ordeal of the hero'.[84]

Monuments, which supplanted epinician poetry from the mid fifth century as the main vehicle for the commemoration of victories at the games,[85] also were an integral part of the drama of victory, especially those erected at the panhellenic centres, which gave the dedicatees a visible and continuing victory. As both Starn and Raschke emphasize, the very act of erecting a statue for a mortal smacks of heroization and apotheosis because of the ambiguity of *kouroi* as gods or heroized men.[86]

Victory at the games was 'heroic' in the general sense, in that the games were a place for men to strive for *aretē* (Pindar, *Ol.* 8.4–6), victory was an indication of *aretē* (Pindar, *Ol.* 3.43), and the victory garland a crown of *aretai* (Pindar, *Ol.* 3.18, cf. 5.1). Yet panhellenic victory could also lead to hero-cult, from at least the fifth century, perhaps even in the victor's lifetime. Cynisca, the sister of the Spartan kings Agis II and Agesilaus, was the first woman to win an Olympic victory with a quadriga (Paus. 3.8.1), probably in 396 and 392 BC. She had a portrait statue (*eikōn*) erected of herself in the sanctuary at Olympia (Paus. 6.1.6), as well as a statue of the horses in the sanctuary of Olympian Zeus (Paus. 5.12.5). At Sparta she also received explicit hero-cult: a heroön was built for her near the Platanistas (Paus. 3.15.1).[87] Of course, other individuals apart from rulers could participate in the games, and even become victors and be heroized. By the same token, not all rulers were panhellenic

victors, but panhellenic victories because of their associations with heroism could provide an important platform from which claims to rule could be built.

Panhellenic victories also obviously had on-going importance for rulers in maintaining the ideological basis of their rule, as a repeated expression of their *aretē*. Pausanias thinks Cleisthenes of Sicyon was the first victor of the chariot race at Delphi (Paus. 10.7.6),[88] and Herodotus thinks he also won the four-horse chariot race at Olympia (Hdt. 6.126.2). In the fifth century, Gelon of Syracuse won an Olympic victory in 488 (Paus. 6.9.4; cf. *IvO* 143).[89] Hieron of Syracuse won the single horse race at Olympia in 476 (Pindar, *Ol.* 1; Bacch. 5) and in 472,[90] the chariot race at the Pythian games in 470 (Pindar, *Pyth.* 1; Bacch. 4), and at Olympia in 468 (Bacch. 3). Polyzalus may have won a victory at Delphi in about 478 (*F. Delphes* iii.4.452), though this depends on the evidence of the bronze charioteer at Delphi, whose primary ascription to Polyzalus is now doubted.[91] Theron of Acragas won the chariot race at Olympia in 476 (Pindar, *Ol.* 2).

Participation and victories in the games were important for competitive politics with other members of the local elite as a means of affirming local superiority, especially as the extravagance of victory commemoration also escalated.[92] Barbara Mitchell has highlighted the example of Arcesilas IV of Cyrene who won victories in the four-horse chariot race at Delphi in 462 and Olympia in 460.[93] In the 460s Arcesilas seems to have been under pressure from the local elite.[94] Through these victories Arcesilas bettered Telesicrates, a member of the Cyrenean elite, who had won the foot race in the Pythian games of 474 and was celebrated by Pindar in *Pythian* 9.[95] In *Pythian* 5, which celebrates Arcesilas' victory of 462,[96] Pindar opens (1–4):

> Wealth has far extending might (*ho ploutos euresthenēs*)
> whenever, fate having given it up, mixed with pure *aretē*,
> a mortal man celebrates it
> as a companion with an abundance of friends.

From the beginning of the poem, Arcesilas is proclaimed for his wealth, and the power that wealth brings. Then the poet turns to Arcesilas' virtues as *basileus* – he is divinely blessed (*theomor' Arkesilas*: 5), he has wisdom to bear well god-given power (*hē theosdotos dunamis*: 12–13), and great prosperity accompanies him as he walks in justice (*dikē*). This is all because, on the one

hand, as *basileus* of a great city, his natural-born eye (*sungenēs opthalmos*) perceives this as a most venerable prize (*aidoiotaton geras*), and, on the other, because, the value of it being understood, Arcesilas is now blessed because the victory has been achieved (15–23). This was fighting language for the belea-guered ruler, who was using his victory in an attempt to stabilize his political position.[97] Nevertheless, despite these victories, Arcesilas' *basileia* crumbled (though it may have survived to the 440s), and he appears to have died at the city he founded, Euesperides (schol. Pindar, *Pyth.* 5.12, 34; Arist. fr. 611.17).[98]

It is significant that the panhellenic sanctuaries at an early stage also became a venue for display for the role of rulers in the city and with the city. One of the Orthagorids, Myron, was an Olympic victor and built a treasury at Olympia (Paus. 6.19.1–2, 4), although it is unclear whether this man belonged to the seventh century (as Pausanias thinks) or whether he was a brother of the sixth-century Cleisthenes.[102] The inscription on the treasury of Myron (inscribed on a bronze chamber), if it is genuinely seventh-century, says that it has been set up by Myron and the *dēmos* of the Sicyonians (Paus. 6.19.4). White thinks that an inscription – and one formulated this way – is too early for the seventh century,[103] but in the seventh century the *polis* of Dreros could make and inscribe laws, so it is not unthinkable that Myron could also have made his dedication. Yet what is significant is that Myron (whether seventh century or sixth century) was not just the representative of the *dēmos*, but also that the *dēmos* stood with Myron. It was not his dedication alone, but theirs together,[104] just as Hieron in the early fifth century made a dedication at Olympia to celebrate the victory over the Etruscans by Hieron the son of Deinomenes and the Syracusans (ML 29). This identification of ruler with city was an important means of embedding rule and making it part of a common purpose with the ruled, and in this sense eliding the distinction between the ruler and the ruled.[105]

Victory in the panhellenic games was an indication of political power.[99] The father of Cleander and Hippocrates of Gela (Hdt. 7.154.1) was an Olympic victor,[100] and erected a victory statue in the Altis for which the inscribed base has been found (*IvO* 142).[101] Miltiades, the tyrant in the Thracian Chersonese, had been an Olympic victor before the Dolonci invited him to rule them (Hdt. 6.36.1).

The political significance of panhellenic victories, and the marking of

them, also had reverberations outside the panhellenic centres. At the end of the decree in which Athens granted asylum to Arybbas of Molossia after his expulsion by Philip of Macedon in 343/2 BC, three crowns are also inscribed marking Arybbas' two Olympic victories and his victory at the Pythian games (RO 70, with plates 5a–b). There were also two reliefs on the stone, one at the top and one at the bottom, both chariot scenes, which, as Rhodes and Osborne note, must surely commemorate his victories.[106] Rhodes and Osborne also observe that the 'the incorporation of crowns unrelated to the content of the decree is most unusual'.[107] They suppose that the crowns must have been included because (they guess) they were won in competitions against Philip and also, as someone from the fringes of the Greek world, to emphasize Arybbas' Greekness.

While both these suppositions are probably fair, it is also significant that the crowns provide the commentary on the reliefs – we can probably assume that the reliefs depict Arybbas' Olympic and Pythian victories because the crowns point that way. Panhellenic victories suggested power, as we have already seen, and Arybbas (who must have contributed significantly to the cost of such a lavish stele)[108] must surely have been making a comment about the importance of this decree – not just providing a home for an exiled *basileus*, but providing a base for a powerful ruler. Even more, he is a ruler who is also an Athenian citizen, as were his descendants. Furthermore, it is significant that these signs referring so explicitly to the ideologies of personal rule carried meaning in democratic Athens. It is important, however, that the Athenians did not attempt to restore him as the decree promises (RO 70.42–7), but that he died in exile (Justin 7.6.12). Thus the stele and its relief is probably protreptic in its appeal – trying to make the point that Arybbas was worth supporting, even if the Athenians in the end decided that he was not.

## Rulers as city-founders

City-founding was also a 'heroic' activity, and city-founders received hero-cult. The idea of rulers as heroic founders of communities may have had its origins in the Early Iron Age. This seems likely to have been the ideological discourse which produced the tenth-century Toumba at Lefkandi. Antonaccio notes

that 'the Toumba's *basileus*'s burial founds the Toumba cemetery', and suggests that the 'main purpose … of the Toumba tumulus is to create a lineage with the *basileus* as *archegetes*', or founder.[109] However, she does not think that it was heroön in the sense that cult was offered.[110] In any case the Toumba appears to represent a dramatic and foundational moment for the community, even if the burying community associated with the mound did not last much more than a century.

Founders were responsible for setting in place the political and religious structures of the city defined by the *nomima*, the 'customs'.[111] The role of the oecist was to mark out the limits of the city, define the sacred land, divide up the land, and arrange the laws and the constitution (Hom. *Od.* 6.1–10; Pindar, *Pyth.* 5.89–3; Plut. *Tim.* 35.4). Oecists became part of the story-telling of settlements, and many foundation stories contain accounts of mythical founders. As a result, McGlew suggests that the provision of an oecist was a means of giving a city a story of autocratic power without affirming the validity of individual rule.[112] That may have been the case in some cities, but by no means in all.

While not all oecists retained political control in their foundations beyond the act of foundation,[113] there was a close conceptual relationship between founding and ruling. One clear example is the foundation of Cyrene in North Africa. The story of Battus' foundation of Cyrene is known in more than one version, but he was both founder of the city and founder of a ruling dynasty.[114] As oecist Battus I was buried in the agora, and honoured as a hero 'worshipped by the people', *hērōs laosebēs* (Pindar, *Pyth.* 5.93–103).[115] The story-telling of the origins of the dynasty (in all its versions) emphasized the role of Delphi,[116] whose involvement is significant, especially in giving the appointment a level of divine legitimacy, which the last of the Bacchiads, Arcesilas IV seems to have fostered energetically in order to support his struggling hold on power (Pindar, *Pyth.* 4, 5.55–63; cf. 9.51–5).[117]

Other rulers were also considered oecists, even if the act of foundation was actually a refoundation. Miltiades son of Cimon, according to Herodotus, again at the intervention of Delphi,[118] was appointed at the request of the Dolonci as oecist and *tyrannos* (Hdt. 6.34.1–36.1, cf. 6.103.4), and on his death was honoured with sacrifices, and equestrian and athletic games were established 'as was customary for an *oikistēs*' (Hdt. 6.38.1).[119] As discussed in

an earlier chapter, the fourth-century Euphron of Sicyon, though reviled by Xenophon, was honoured on his death by the people of Sicyon, who thought of him as a good man (*anēr agathos*), and buried him in the *agora* as an *archēgetēs* (Xen. *Hell.* 7.3.12).[120]

In fact, the rejuvenation of a city was often considered as a refoundation. Philip II was honoured as a hero at Philippi, the city of Crenides which he refounded (and rebuilt) in 356 BC (cf. *SEG* 38.658).[121] Timoleon, according to Plutarch, was responsible for the refounding of Syracuse, sending to Corinth for settlers (*Tim.* 22.4–23.2, 35.3–4); Diodorus gives the text of a decree which says that on his death he was honoured with musical, hippic and athletic contests because he 'brought down the tyrants, defeated the barbarians in war and resettled (*anoikisas*) the greatest of the Greek cities' (16.90.1; cf. Plut. *Tim.* 39).[122] Timoleon may not have been a ruler in a straightforward sense, and he may have deliberately tried to distance himself from claims of taking sole rule by destroying the tombs of the previous dynasty and re-establishing the courts (Plut. *Tim.* 22.1–3); yet despite Plutarch's insistence that the Syracusan constitution was a democracy, the Syracusans gave to Timoleon major responsibilities for decision-making (esp. Plut. *Tim.* 38, cf. 22.7),[123] which make him look as if he acquired ultimate power in fact, even if not in appearance.

The Spartan kings also seemed to have been considered founders, at least on some level. Isocrates says that the original Spartan dyarchs were thought of as the oecists of Sparta (4.61, 65). Ephorus, however, notes that Eurysthenes and Procles, the twins from whom the twin houses were said to descend, were *oikistai*, although they were not given the title *archegetai*, 'first leaders', 'founders' (and the implication of Ephorus' comment is that they also did not receive cult, since the point of the passage is that cult was reserved for Lycurgus, the lawgiver: *FGrHist* 70 F 118). Nevertheless, Xenophon suggests that Spartan kings received heroic honours when they died (Xen. *Lac. Pol.* 15.9), and we have already discussed the magnificence of their funerals, which Herodotus says were like those in Asia on the death of the Persian king (6.58–9), though it seems that only the hero of Thermopylae, Leonidas, received the additional honour of games (Paus. 3.14.1).

Rulers were often also founders of new cities, forming a tradition of city-founding that continued into the Hellenistic world.[124] For rulers, the act of

foundation (or refoundation) of cities would bind with strong religious and ritual bonds the dynasty and the city. This must have been the case with the many Cypselid foundations, which indeed tied these foundations, such as Corcyra and Potidaea, to Corinth with lasting bonds of obligation, even after the fall of the dynasty (Th. 1.25.3–4, 56.2).[125] Hippocrates, tyrant of Gela (Hdt. 7.154.1), also refounded Camarina as its oecist (Th. 6.5.3; Philistus, *FGrH* 556 F 15). Diodorus says that Hieron in Sicily refounded Catana as Aetna (although his son Deinomenes was given it to rule: Pindar, *Pyth.* 1.58, 60–1). Diodorus says that Hieron made the foundation in order that he would receive heroic honours (11.49.1–2). Pindar honours him as 'famous founder', *kleinos oikistēr*: *Pyth.* 1.31), and when he died received heroic honours (*timōn hērōikōn etuchen*) since he was their founder (Diod. 11.66.4),[126] although Strabo also says that Catanians later tore down his tomb (Strabo 6.2.3). In the same year as the foundation of Aetna, Theron of Acragas resettled Himera (Diod. 11.49.3), possibly also with the intention of ensuring receipt of cult.[127] In 400 BC, Dionysius I founded Adranum on the slopes of Etna (Diod. 14.37.5), as well as foundations in the Adriatic (Diod. 15.13.4; Theopompus, *FGrHist* 115 F 128c), and his son Dionysius II founded two colonies in Apulia (Diod. 16.5.2). We have already noted the refoundation by Philip II of Macedon of the Thasian community of Crenides as Philippi in 356 BC – its original foundation had been as recent as 360 (Diod. 16.3.7).

Most declarations of ruler as oecist or refounder were genuine in the sense that they were based on a real renewing of the membership community. Battus I of Cyrene was, of course, an actual oecist. Miltiades took with him to the Chersonese all who were willing from among the Athenians (Hdt. 6.36.1). Timoleon had also been responsible for bringing settlers to Greece to repopulate the cities devastated by war (Plut. *Tim.* 22.7, 23.1–2, 35.1–4); in Syracuse there was even a redistribution of land (though Plutarch says this was effected by Corinthian officials summoned from Corinth rather than Timoleon himself: *Tim.* 23.2). Plutarch also says that because he took care of the settlers in Sicily, assisting them in making laws, redistributing land and arranging the constitutions, they considered him their *oikistēs* (Plut.*Tim.* 35.1–4). In the previous century, however, Hieron had ejected the people of Naxos and Catana to resettle Catana (renamed Aetna) with a mixed population of peoples from the Peloponnese and Syracuse, resettling the

original inhabitants at Leontini, redistributing the land to the new settlers, and giving the city its constitution (Diod. 11.49.1–2; Pindar, *Pyth.* 1.60–5). Nevertheless, Hieron's act of resettlement at Aetna, though celebrated with great aplomb before a panhellenic audience (Pindar, *Pyth.* 1.29–33), had violent consequences and resulted in civil disruption in Sicily, since after the fall of the Deinomends the displaced attempted to return to their homes, and the mercenaries given citizen rights by the Deinomenids were disenfranchised (Diod. 11.72–3, 76).[128]

The act of city-founding was a display of leadership, and a demonstration of power through land acquisition (cf. Xen. *Anab.* 5.6.15). The Cypselids built an extensive and disparate empire based on foundations. Cypselus' son Gorgus was responsible for the foundation of Ambracia (though he may have commissioned the foundation rather actually been the oecist – which puts him in a relationship with the colony not unlike Timoleon's with the colonies he commissioned in fourth-century Sicily). Other Cypselids also seem to have become oecists: Nicolaus of Damascus says that Pylades and Echiades were sent as oecists of Leucas and Anactorium (*FGrHist* 90 F 57.7; cf. Strabo 10.2.8). The ultimate source for Nicolaus of Damascus' comments on these foundations is probably Ephorus, and there are inevitably doubts about the accuracy of his details for archaic foundations.[129] Nevertheless, taken together, the picture that appears to emerge from Herodotus, Nicolaus and other sources is a fairly consistent one.

The relationship between ruling and foundation was complex. At Cyrene Battus was said to be sent as *archēgetēs* and *basileus* (ML 5.25–6), or *hēgemōn* and *basileus* (Hdt. 4.153).[130] Oecists and *archēgetai*, 'leaders' and law-givers, came to be related as 'creators' and 'inventors'.[131] To refound a city was to give it a new beginning and a new identity. That Miltiades was honoured by the Dolonci as an oecist rather than as a ruler (or even an Olympic victor, as he was), suggests that honours for oecists were the primary honours. Hieron's foundation of Aetna was celebrated with vase paintings, coins and poems by Simonides, Pindar and Bacchylides (court poets according to Aelian: *VH* 4.15), and possibly even a play by the Athenian tragedian, Aeschylus (*Vit. Aesch.* 9).[132] In fact, as Dougherty points out, by drawing upon colonial traditions, Pindar in his victory odes for Hieron and Arcesilas of Cyrene is making a link between city-foundation and panhellenic victories.[133] For Dougherty,

the act of foundation raises the status of the victory, and makes the victor a founding hero.

For a ruler, becoming a city-founder ensured his heroic status, and at least from the seventh century seems to have trumped other means of displaying heroic qualities. City-founding also bound city and founder with religious bonds, and the founder became part of the narrative of identity of the city and its community. Cult in the form of sacrifices and games also ensured the memorialization of the city-founder and provided the immortality of being for perpetuity the focal point of the community. Foundation as a guarantee of one's heroism seems to have become increasingly important in the discourse and ideology of ruling, especially in a context in which others could now also prove they were heroes, and possibly compete for the right to rule. It is also not surprising that foundation as a strategy for securing cult seems to have taken hold in Sicily, an island with a history of foundation. It is perhaps also not surprising, then, that the history of the Greek cities in Sicily was also dominated by one-man rule.

Yet not all rulers were able to keep a hold on power. Despite his foundation at Euesperides and his Olympic victories, Arcesilas IV of Cyrene was assassinated, probably as the result of conflict with Cyrenean aristocrats.[134] Similarly, Dionysius II at Syracuse was evidently not the man his father was (cf. Diod.16.4.1–4; Plut. *Dion* 7.4–7) and was ousted by Dion, the husband of Dionysius' half-sister and an influential member of Dionysius' court.[135]

By the same token, not all who were able to provide proofs of their *aretē* were also able to establish their right to rule. Cylon of Athens, despite his Olympic victory, was not successful in his attempt to establish himself as ruler (Th. 1.126.3–12; cf. Hdt. 5.71). On the advice of Delphi (no less) to attack during the greatest festival of Zeus, Cylon tried to seize the acropolis at Athens with the help of his father-in-law, Theagenes of Megara. If we can trust Thucydides with this level of detail on an event so long before his own time, it is significant that in seizing the acropolis people came from their fields and laid siege to Cylon and his friends (Th. 1.126.7). Lavelle argues that Cylon's attack on the acropolis when all the people were out of the city was 'deliberate and hostile', and that his fundamental mistake was to dispense with 'any process involving persuasion or consent', and that he made use of a 'hostile alien force'

in occupying the city.[136] On the other hand, seventy years later the Athenians were more willing to accept Peisistratus, already recognized for his military achievements (Hdt. 1.59.4), especially after many years of conflict between competing factions. Although Peisistratus' third and final attempt to secure sole rule came about through a battle with people from the city, Herodotus says that Peisistratus' supporters included those from the city and the demes 'for whom *tyrannis* was more welcome than freedom' (1.62.1), and he was easily able to make the defeated disperse (Hdt. 1.63.2). The *Athenaion Politeia* says that even when he was driven out he easily took rule back again (16.9).

In the competition for superhuman honours it became increasingly important for rulers to be able to confirm heroic status, although this status could be challenged. The Peisistratids, Kurke suggests, probably saw Miltiades and the Philaids as a political threat because they also kept four-horse chariots, and could win military victories. Although Cimon, the half-brother of Miltiades, 'handed over' an Olympic victory to Peisistratus (and so secured his return from exile), when he won again he was put to death by the sons of Peisistratus (Hdt. 6.103.1–3), a mark of the political threat he had now become by virtue of his victories.[137]

For a dynasty to lose control on power could mean their complete execration as a pollution, and rejection by the city of the ruler as protector in death as well as in life.[138] Leotychidas in Sparta was caught and convicted of taking bribes; he went into exile and his house was razed (Hdt. 6.72). In Sicily, we have already noted that the tomb of Hieron at Aetna was destroyed by the displaced Catanians after he died. In the fourth century, Dion was criticized for not destroying the tomb of Dionysius I when Dionysius II lost control of the city (Plut. *Dion* 53.2). On the other hand, Timoleon did destroy the palace of the Dionysii in 343/2 (Plut. *Tim.* 22.1–3). Nicolaus of Damascus, though late (so perhaps following a literary pattern rather than having a genuine source), says that when Cypselus the son of Periander was killed, his housed was razed, and his bones were thrown beyond the borders unburied (*FGrHist* 90 F 60). The loss of legitimacy, for whatever reason, meant the loss of everything.

Charismatic ruling was known elsewhere in the ancient world, and it is apparent that the rulers of archaic and classical Greece belonged within the general thought world and value systems of the Mediterranean and Near East, ideas and values which were no doubt transferred around the Mediterranean

and reinforced by means of complex elite social and political networks.[139] We have already considered some point of contact with the Assyrian ruling ideologies. The Persian kings also maintained a combination of charismatic and dynastic rule. Darius and Xerxes declared themselves to be the best in intelligence, at self-control and in fighting.[140] Looking forward to Rome, Ando has discussed this phenomenon in relationship to the Roman imperial period.[141] He argues that Augustus 'bequeathed more than his name to the office he had created: his legacy simultaneously attached a degree of charisma to that office and demanded charismatic appeal from its occupant.'[142] Thus both successive Roman emperors acquired charismatic power from the holding of that office, and Augustus became established as the founder of that charismatic authority.

However, whatever the sources of influence, the Greeks developed their own particular take on what a ruler should be. Unlike Near Eastern rulers, Greek rulers were not ostentatious, and did not limit access to their person. Further, while heroic antecedents made the basis for a claim to heroism, successive rulers had to prove that they too were heroic, and the Greeks found their own particular strategies. This could be achieved through war, but also by victories in the panhellenic games (which Herodotus says was beyond the comprehension of the Persians: 8.26),[143] and through foundations of cities. In this way, successive rulers proved, and reaffirmed, their heroic antecedents, even as they recreated heroic credentials for themselves and their dynasty.

# Notes

1   Weber (1947), esp. 124–32; id. (1948), 78–80. Note also the comments by Fukuyama on legitimacy and authoritarianism: (1992), 15–19.

2   Compare Plut. *Dion* 10.4: 'The adamantine bonds [of rule] are not ... fear, force, a multitude of ships of a thousand-fold barbarian guard, but goodwill (*eunoia*), kindness (*prothumia*), *charis* generated by *aretē* and justice, which although softer than those of severity and harshness are stronger for the maintenance of leadership.'

3   Lloyd-Jones (1971), 51.

4   Cf. L. Mitchell (2012d).

5   Drews (1974); cf. Lenfant (2004), lix, though she notes that the origins of Ctesias' Cyrus are even more extreme than those of Sargon since his father is a thief.

6    Cf. S. Lewis (2000), 99–101, on the stories of origins of the Sicilian rulers.

7    Many settlements expanded and some centres became increasingly urbanized,
     such as those at Athens, Corinth or Argos, whether through physical synoecism
     or a more natural agglomeration: Snodgrass (1980); Morgan (2003), 47–69.
     Demand argues that synoecism was not common, and was not the normal
     route to *polis* formation: (1990), 14–27. Corinth and Athens were occupied
     continuously from the Bronze Age, but dramatic expansion occurred during
     the eighth century: Morgan (2003), 55–69. Argos only shows signs of some
     settlement from Protogeometric times, but expanded rapidly during the Late
     Geometric period (Morgan [2003], 61–2). Morris calculates that in 1000 BC
     the largest settlements had populations of about 1,500, but by 700 population
     figures had risen to about 5,000 (I. Morris [2009], 66). Expansion of this
     level may have been due in part to population growth. Tandy ([1997], 19–43)
     attributes population growth to improved nutrition, but also to population
     movements, so that as some settlements were abandoned others expanded, and
     the merging of neighbouring communities: Hall (2007), 74–8; Morgan (2009),
     *passim*; cf. R. Osborne (2009), 66–75.

8    Morgan (2003), 54–5; id. (2009), 56; I. Morris (2009), 67–8.

9    Raaflaub (1997), 55.

10   This was the view of the fourth-century theorists, especially Aristotle (*Pol.*
     5.1305a7–29, 1310b12–31), although he also says that some *tyrannoi* were
     brought down by the *dēmos* (*Pol.* 2.1274a5–7). This fourth-century interest in
     class politics was picked up by modern scholarship. For example, Andrewes
     argued that the popular base for tyrannies was important as it was expressed
     through the hoplite army (although the 'rise of the hoplite army' has also been
     considerably revised in recent years): Andrewes (1956), esp. 31–42. Mossé also
     assumed that most (if not all) the archaic tyrants at least based their rule on
     popular support, though she also notes that developments in trade and the
     military were important as well: Mossé (1969), esp. 1–89.

11   For archaic Greece, see esp. Stein-Hölkeskamp (2009). In the late fifth and
     early fourth centuries, however, the success of Dionysius I and Clearchus of
     Heracleia may have been their ability to take the side of the mob against the
     aristocracy. This seems to have been the case at Syracuse, where in the first
     part of Dionysius' reign the resistance came from the Syracusan cavalry (Diod.
     13.112.1–4, 14.7.1, 14.1, cf. 13.91.5). Diodorus says that he became 'champion'
     *prostatēs* of the mob (*ochlos*): 13.91.3 (on *prostatai tou dēmou*, especially at
     Athens, see further Chapter Five).

12   G. Anderson (2000).

13  Esp. Raaflaub (1996), 139–74. Note also I. Morris (1996), 19–48, who also talks about the Strong Principle of Equality, but sees this deriving from class pressures from below.

14  Cf. L. Mitchell (2009).

15  Cf. Sourvinou-Inwood (1995), 194–200, 216.

16  See esp. Buraselis *et al.* (2004).

17  Burkert (1985), 207; Bowden (1993). Chaniotis, however, has argued that the rulers of the Hellenistic period received divine honours in their lifetime as recognition of their role as protectors of the community, but they were not expected to extend that protective role after death: Chaniotis (2003), 432–3.

18  Buraselis *et al.* (2004).

19  Carney (2000), 210.

20  Currie (2002) argues for a date in the mid fifth century for the first realization of hero-cult for a living man in Euthymus of Locri.

21  Fischer-Hansen, Nielsen and Ampolo (2004), 187.

22  Jones ([2010], 94) doubts he could have received such honours in life. Certainly, in the extant works of Diodorus most of those who received heroic honours were awarded them at death, including Timoleon. Malkin ([1987], 239), however, accepts that Dion received these honours during his life in anticipation of Hellenistic ruler cults.

23  Currie (2002).

24  Malkin (1987), 84.

25  Kirk, Raven and Schofield (1983), 281–2.

26  See Panagiotou (1983).

27  See Flower (1988), 131–3.

28  Scott ([2010], 204–5) makes a positive identification, but without explanation. One presumes he thinks it is a statue base. The stone itself says only 'of the Samians'. Umholtz ([2002], 271 n. 41) describes the stone as a shallow block which belongs to an unknown building, and thinks the lettering is Hellenistic.

29  Palagia (2009), 39.

30  Bommelaer (1971); Palagia (2009) 36–8; cf. Scott (2010), 105–7.

31  Habicht (1970), 3–6; see also Currie (2005), 159–60.

32  Cartledge (1987), 84.

33  Cf. Dougherty (1993), 86–8.

34  Bosworth (1988), 281; cf. Fredericksmeyer (1979).

35  The statues were gilded marble rather than chryselephantine, as Pausanias claims: Müller (2010), 181.

36  Schultz (2007), 205–33. Carney, however, thinks that it cannot be a cult

building, and Philip must only be hinting at that status: (2000a), 212–13; (2000b).

37 Flower (1988), 123–34.

38 Weber (1947), 328–9.

39 Weber (1947), 358–9.

40 See Kirk ([1962], 238–44), who notes that this fragment needs to be taken together with DK 22 B 80: 'Celsus says that the ancients used to hint at some kind of divine war, Heracleitus thus saying: "It is necessary to know that war is common and right is strife and that all things are happening by strife and necessity."' Fr. 80, as Kirk observes, must be referring to the interaction between opposites, 'for all change, as Heracleitus and his contemporaries seem to have believed, could be resolved into change between opposites' (241). The general sense of fr. 53, however, in Kirk's view, is probably more concrete. Cf. Kirk, Raven and Schofield (1983), 193–4.

41 The war itself was brought to a conclusion through the arbitration of Periander of Corinth.

42 That rule could pass to the husband of the 'princess' is a *topos* of myth: e.g., Menelaus marries Helen to rule in Sparta, Oedipus marries Jocasta to rule in Thebes, Lynceus marries Hypermestra to rule in Argos, and Xouthus marries Creousa to rule in Athens. Finkelberg suggests: 'Each single case, taken alone proves nothing, but the persistence with which the same basic pattern recurs over and over again suggests that, as far as heroic Greece is concerned, kingship by marriage was envisaged as a standard pattern of succession' ([2005], 68–79, quotation from 69).

43 Strabo (13.2.3) says that there were a number of families and/or individuals who held power: Pittacus, Myrsilus, Melanchrus and the Cleanctidae. (Note the very interesting hypothesis of Dale [2011] that 'Myrsilus' was not a person, but a title for a ruler.) The clash between these families seems to have been bitter and prolonged. Pittacus helped the brothers of Alcaeus remove Melanchrus (D. L. 1.74), but this does not seem to have resulted in them holding power, or not for long. Pittacus himself also seems to have been an associate at some stage of Myrsilus, and had married into the family of the Penthilidae (D. L. 1.81; cf. Alcaeus fr. 70 Lobel and Page *PLF*). Somewhere in all this, he betrayed the family of Alcaeus (Alcaeus, fr. 129 Lobel and Page *PLF*).

44 Aristotle says that he was elected in order to deal with the problem caused by the exiles, which included Alcaeus and his brother (*Pol.* 3.1285a35–1285b1). This was election by an assembly or by the council, or more probably both together – both existed during Pittacus' rule (fr. 130.18–21 Lobel and Page *PLF*).

45  While Page ([1955], 154) may not think the causal link between Pittacus' victory in a *monomachia*, a duel between champions, could have ensured his election to rule in Mytilene, that Pittacus defeated an Olympic victor, proved that he was 'the best', and so had a right to rule.

46  For posterity, Pittacus became known as one of the seven sages, as a law-maker (though Aristotle is also certain that he was a maker of laws but not constitutions: *Pol.* 3.1274b18–23), and as being responsible for a number of sayings, among which, fascinatingly, he is said to have coined that 'It is difficult to be good (*esthlos*)', which has political as well as moral connotations, since the *esthloi* were both a moral and a social class.

47  Kurke (1994), 92.

48  Crielaard (2006), 282–4.

49  Deger-Jalkotzy (2006).

50  Raaflaub (2007), *passim* but esp. 18; cf. Alonso (2007). However, for other recent views on Spartan helotry (which see its development as organic and not related to conquest), see esp. Luraghi (2003), though in this context note also Cartledge (2003), in the same volume.

51  Van Wees (1998).

52  See further Chapter One.

53  Irwin (2005), 35–62.

54  See especially Adkins (1960), 30–60.

55  Cf. Nagy (1979), 26–41.

56  See esp. van Wees (1988), 15–22.

57  Snodgrass (1999), 37, 68; R. Osborne (2009), 163–4. Notably, however, the earliest (eighth-century) examples of Iron Age panoplies have been found at Argos: Snodgrass (1999), 41, 136.

58  Figurines from Sparta: Wace (1929), esp. 262, 274–6, 281 plates CLXXXIII, CXCI, CXCVII–III, CC; military figurines from Bassae: Kourouniotis (1910); cf. miniature military paraphernalia from Crete, Delphi, Aegina and elsewhere: Benton (1939–40); Perdrizet (1908), 106–7; series of military paraphernalia at the major sanctuaries: e.g. (Olympia) as well as *Waffenfunde* in *Bericht über die Ausgrabungen in Olympia*, see also Kunze (1950); Bol (1989); Kunze (1991); Philipp (1994); Baitings (2001); Scott (2010), 149–50; (Delphi) Perdrizet (1908), 93–106; (Dodona) Carpanos (1878), 101–2, plates LV–VIII. Morgan (1990) doubts the importance of Isthmia as a sanctuary where arms and armour were dedicated, but see Jackson (1999).

59  While Aristotle says Sparta has the best form of *basileia*, he also says it is not a constitution and is also quite dismissive of it: *Pol.* 3.1285a3–4, 1287a3–8.

60   Hatzopoulos (1996), 1.425.

61   We will return to the issue of foundations below.

62   Van Wees (2003).

63   On the Molossian Alcetas' status as Jason's *hyparchos*, see Sprawski (1999), 76. It is not clear what the status of the Molossian *koinon* would have been, since Xenophon makes the point of singling out Alcetas. It is clear that Alcetas' reign was more forceful, and Alcetas had a more strained relationship with the *koinon* than some of his predecessors. See further Chapter Four.

64   Gabrielsen (2005); Chaniotis: (2003), esp. 57–77. Note also the terms of the ephebic oath, known from the various fourth-century sources but which may have had archaic origins, in which Athenian ephebes swear that they will not hand the *patris* on diminished but greater and better: see esp; RO 88 § 1 with discussion.

65   Identification between god and king: Bedford (2009), no. 6; Hero-King who puts down chaos: Adad-nirari II: Chavalas (2006), no. 118; see Crouch (2009), 27; cf. Liverani (1979); Oded (1992).

66   See esp. Tadmoor (1999). Herodotus suggests that the Persians (and especially Xerxes) may have had similar ambitions (Hdt. 7.8β.1, γ.2: 'the sun will not see any land bordering on ours, and I will make all their lands together with ours one country, having passed through the whole of Europe'). Weisehöffer (2004); id. (2009b), however, argues for a *pax Achaemenidica* during Xerxes' rule.

67   West (1997), 280–3, 300–4 is surprisingly sceptical about direct connections between Hesiod's *Theogony* and the *Enuma Eliš*, although he does offer possibilities of a common heritage for the two traditions.

68   Hornblower ([2011], 47–8) has quite rightly made the point that this sounds 'emphatically and oddly Hellenistic', although Currie ([2005], 170) has defended the triple honorific on the grounds that these titles also already appear in Pindar. Certainly, both Theron and Hieron are called *euergetēs* (*Ol.* 2.93–5 [Theron], *Pyth.* 2.18–24 [Hieron]), but only Zeus is *sōtēr* (*Ol.* 5.17, *Pyth.* 6.8). On the other hand, Brasidas was honoured as *sōtēr* at Amphipolis in 422 (Th. 5.11.1), buried as a hero, and received as honours annual sacrifices and games, so it is clear that *sōtēr* was also already associated with hero-cult in the fifth century. Jones also highlights the link between the notion of a hero as 'benefactor' and 'saviour': (2010), 26.

69   Antonaccio observes that hero-cult (especially as opposed to tomb cult, which has its origins in the Bronze Age) does not really emerge until the eighth or seventh centuries: Antonaccio (1995), 145–97; cf. Whitley (1994). As we have seen, however, the Toumba at Lefkandi has sometimes been interpreted in this way.

70   On Alexander and divinity, see variously: Balsdon (1950); Badian (1981);
     Fredericksmeyer (1981); Cawkwell (1994); Badian (1996); Fredericksmeyer
     (2003); L. Mitchell (2013a). Greek cities of Asia Minor offer Alexander cult
     (though dates are uncertain): Salviat (1958), with transcription of stone at
     195 and commentary on the festival of Alexandreia at 244–8 (Thasos); *Syll.*³
     1014.111 (Erythrae); *OGIS* 222 (Ionian *koinon*); see also Habicht (1970), 11–28;
     Stewart (1993), 95–102 and Appendix 3. Greek cities of mainland: Athens:
     Dein., *Against Dem.* 94; Hyp., *Against Dem.* fr. 7 col. 31–32; Timaeus, *FGrHist*
     566 F 155; [Plut.], *Mor.* 842D. Sparta: Plut., *Mor.* 219E; Ael., *VH* 2.19. Note also
     Arr., *Anab.* 7.23.2 with Brunt (1983–1989) 'Appendix XXII', 495–7.
71   See esp. Kurke (1993). Note, however, Fisher, who argues that the nature of
     most events was not directly related to skills in the battlefield: (2009), 531–2.
72   Kurke (1993), 133–7.
73   Popham *et al.* (1982); Popham *et al.* (1993), esp. 18–22.
74   Crielaard (2009), 282–3.
75   On the development of mythical aetiologies to reflect this shift, see esp. Nagy (1986).
76   Golden (1998), 169–75.
77   Cf. Aesch. *PB* 465–6.
78   Esp. Beloch (1926), 148–54.
79   Morgan (1990), 47–56. For the victor lists and their problems, especially in
     sequencing victors: Christesen (2007).
80   Cf. Mosshamer (1982); Morgan (1990), 39–40, 212–23; id. (1993), 33–7;
     Gebhard (1993), 167; id. (2000); Davies (2007), 57–8.
81   See esp. Crotty (1982), esp. 108–22 (who shows how victory places the hero in
     an ambiguous relation to the community); Young (1993): 'Pindar's business is
     to capture that brief moment of the "godlike gleam" and the "brilliant light" –
     the brief moment when his athletes are "something like the gods" – and make
     it permanent, immortalize it in song' (127); Hornblower (2004), 89–95 (two
     kinds of immortality: the 'transient immortality' of the victory, and the more
     permanent immortality created through song).
82   Bonanno makes a similar point about Hieron of Sicily and court culture
     ([2010], 189).
83   Golden (1998), 80.
84   Nagy (1990), 192–7 (quotation from 193).
85   Golden (1988), 84–8.
86   Raschke (1988), 39–40; Starn (2001), 265–6.
87   For Cynisca, see L. Mitchell (2012). Xenophon tells the story that Agesilaus
     persuaded Cynisca to breed horses to show that victory in chariot racing was

the result of wealth, not the manly virtue of *andragathia* (*Ages.* 9.6–7; cf. Plut. *Ages.* 20.1, *Apoth. Lac.* 212B): see Hodkinson (2000), 327.

88 Davies, however, thinks it unlikely: (2007), 51–2; see also Gebhard (2002), 222–4 on the list of Pythian victors drawn up by Aristotle and his nephew Callisthenes.

89 Moretti (1957), no. 185.

90 For this victory, see Moretti (1957), 92 (no. 234)

91 See discussion and bibliography in Chapter Three.

92 Cf. Bell (1995), 15; Antonaccio (2007), 268–9; Thomas (2007), 148.

93 B. Mitchell (2000), 94–5.

94 See Chamoux (1953), 173–5; B. Mitchell (1966), 108–10; id. (2000); Braswell (1988), 2–6. See also Chapter Four below.

95 B. Mitchell (2000), 94; cf. Morgan (2007), 244.

96 *Pythian* 4 was also commissioned for the victory in 462, and provides the context for the return of an exile, Damophilus, which again suggests tension among the elite of Cyrene.

97 Kurke makes the point that the language of *megaloprepeia*, 'the lavish public expenditure of wealth', was different in epinician for private citizens and rulers: for the private citizen it is important to show that he does not have ruling ambition, whereas for the ruler it 'is considered the consummate *megaloprepēs*': (1991), 218–24.

98 See Chamoux (1953), 202–9; B. Mitchell (2000), 95–6.

99 See Davies (1981), 97–105.

100 Aristotle says that before Cleander there was an oligarchy at Gela: *Pol.* 5.1316a34–7.

101 There may also have been a new portico added to the Geloan treasury in celebration of Pantares' victory. That there was a new portico in about 500 BC there is no doubt; that it was to honour Pantares is only a whimsical suggestion by Dyer (1905), 54–6. See also Scott (2010), 167.

102 See White (1958), 10; Leahy (1968), 6. Scott ([2010], 147 n. 5) accepts Pausanias' account and a victory for Myron in 648 BC without question.

103 White (1958), 10.

104 Cf. esp. Kurke (1991), 189–92.

105 Andrewes takes a more negative view: (1974), 135.

106 Rhodes and Osborne (2003), 355.

107 Rhodes and Osborne (2003), 355.

108 Tod (1948), 217.

109 Antonaccio (2006), 392–4.

110 Although note Morris' comments about the visibility of cult in the tenth century: see Chapter One.

111 Malkin (2009); cf. id. (2002).

112 McGlew (1993), 24; see also Bérard (1982); de Polignac (1995), 133. Note also R. Parker (2011), 38, who accepts de Polignac's conclusion.

113 The founding of cities is usually associated with the so-called 'colonization movement', although how we should understand the phenomenon has recently been questioned. Robin Osborne (1998), for example, has argued that we should not see settlement abroad as systematically planned by states, but as more *ad hoc* and a result of private enterprise. On the other hand, Irad Malkin has relocated the pattern of settlement associated with the eighth century within a framework of extensive and long-standing exploratory travel in the Mediterranean (1998), and now also (2011). Therefore, as is becoming increasingly clear, the Greeks were a people often on the move, and we should see this pattern of movement and resettlement in the eighth century as part of a wider picture of movements, which was also a feature of earlier periods such as the Early Iron Age migrations to Asia Minor, and resulted both in long-distance travel as well as the population of the countryside. For Early Iron Age migration patterns, see, for example, Morgan (2009), 49–52. For more large-scale migrations: Lemos (2002), 193. For movements into the countryside, see, for example, Foxhall (1997), 123–7; Houby-Nielsen (2009), 208–10. However, on the variability of settlement patterns in archaic and classical Greece, see R. Osborne (1987), 53–74.

114 Pindar refers to the foundation of the city in *Pythian* 4 and 5, celebrating the victories of Arcesilas IV, the fifth-century ruler in Cyrene. Herodotus was aware of two different versions (Hdt. 4.150–8), one told by the Therans (who were said to have dispatched the colony), and another by the people of Cyrene, which distances the Cyreneans from possible Theran origins. A fourth-century reinscription of a decree purportedly from the seventh century (ML 5) also sets out details of the original act of foundation, though the authenticity of the inscription has sometimes been doubted. See generally R. Osborne (2009), 8–15. For the Cyrenean account(s) of their foundation and local history, see Giangiulio (2006).

115 See Currie (2005), 236–44, 246–7, though McGlew ([1993], 173) thinks it unlikely that Battus' descendants also received cult.

116 On the difficulties with text of the inscription, especially the alleged reinscription of the Theran decree, see Meiggs and Lewis (1988), 7–9; R. Osborne (2009), 13–14. See also Corcella (2007), 677. On Battus' stutter and

Battus as a purifying figure: Ogden (1997), 50, 53–61. On Delphi and the
colonization movement, see Malkin (1987), 17–91.

117 For the story of Delphic founding and the 'uninterrupted continuity of the
colony': Athanassaki (2003), 93–128; for Delphi as part of the 'sacred identity' of
the colony, see Giangiulio (2006). On *Pythian* 4 and Damophilus' probable role
in commissioning the ode after he had returned to Arcesilas' court, see Feens
(1999), 29–31. The more usual view is that he was attempting to secure his
return: e.g. B. Mitchell (1966), 109; cf. Carey (1980).

118 Compare Cypselus' use of Delphic oracles to give his rule legitimacy: Hdt.
5.92β.2–3, ε.2.

119 See Malkin (1987), 77–8, 190–2.

120 See sep. S. Lewis (2004); Malkin (1987), 232–3; for *archēgetēs* as founder, note
also Malkin (1987), 248–50.

121 Chaniotis (2003), 434. On Philippi, see Koukouli-Chrysanthaki (2011).

122 Malkin (1987), 239–40.

123 Cf. Talbert (1974), 130–43 (who thinks Timoleon was aiming at oligarchy,
such as he had been familiar with in Corinth); Funke (2006), 170–1 (who also
believes in Timoleon's 'anti-tyrannical' politics).

124 Chaniotis (2004), 436.

125 Cf. R. Parker (2007), 20.

126 See Malkin (1987), 238–9.

127 Cf. Asheri (1992), 151.

128 For a more positive account of these resettlements: Thatcher (2011), 130–1.

129 See Hall (2007), 102.

130 Malkin argues that while Battus' role as *basileus* concerned the constitutional
arrangements of the colony, his role as *archēgetēs/hēgemōn* was as founder :
Malkin (1987), 246–7.

131 On 'first discoverers', see Kleingünther (1933).

132 Dougherty (1993), 83–102.

133 Dougherty (1993), 83–156; see also Hornblower (2004), 103–7.

134 B. Mitchell (2000), 95–6.

135 Dion was elected as general with full powers (Diod. 16.20.6; cf. Plut. *Dion* 48.4).
Although not always popular with the lower classes (he repealed decrees made
about the redistribution of land: Plut. *Dion* 48.6), Dion retained the position
of *stratēgos autokratōr* for three years until his assassination in 354 BC, and
possibly planned a constitution in which a *basileus* ruled with a council of the
elite (Plut. *Dion* 53.4; cf. Plato, *Epistles* 8.355d–357a). Dion himself was the
object of a court plot by Philistus, another influential member of Dionysius'

inner circle (Plut. *Dion* 13.5–14.7), and was deported in 367 (cf. Plato, *Epistle* 7.329c). He returned in 357 with an army of mercenaries. Although he had initial success because Dionysius was not in the city on his return (Plutarch says he was received as if he were a god: *Dion* 29.2), the situation eventually erupted into chaos, with the mercenary army of Dion pitted against the Syracusans, who were afraid he would make himself sole ruler. However, when the mercenary army of Dionysius also made an attack against the Syracusans from the acropolis, Dion returned to the city and overpowered Dionysius' army, led by Nypsius, Dionysius' general. For Dion's career, and the turbulent years after his death (which saw the temporary return of Dionysius to Syracuse) see Westlake (1994), 695–710.

136  Lavelle (2005), 37–8.

137  Kurke (1991), 179–80; Hodkinson (2000), 324; Thomas (2007), 143–4.

138  Connor (1985). On the role of rulers as immortal protectors, see further below.

139  Cf. Gunter (2009).

140  Kuhrt 2.503–4 (11.C [17]) = DNb; XPl (note also Weisehöfer [1996], 32–3.)

141  Ando (2000), 24–41.

142  Ando (2000), 30.

143  See Nielsen (2007), 12–17, for athletic contests as a peculiarly *Hellenic* activity in the Greek imagination.

# Ruling families

It was an important element of the ideology of ruling that either one inherited heroic qualities from heroic descendants, or one was the foundational hero from whom a heroic dynasty could flourish. In this sense, ruling was dynastic. Yet there was a stronger sense in which the family was important to rule, since even from the earliest periods we can see that for most ruling houses the family also participated in rule. Even archaic burials seem to confirm the importance of family-based elite. Foxhall, for example, has argued burial plots confirm that the new communities of the archaic period were dominated by family-based or regional elite (rather than a newly powerful middle class),[1] and, likewise, Morris argues that kinship determined membership of burying groups from Homer to the fourth century.[2]

Although there may have been one person who dominated the family, the tendency seems to have been that in ruling families power belonged to the family as a whole, just as the responsibility for ruling was also shared in the family, including its female members.[3] Crielaard makes this point about 'heroic' female burials from the West Gate at Eretria dating to the ninth century and later, which were cremations and then inhumations in cauldrons, and 'stressed not only aspects of kinship loyalty but also that power and wealth were not acquired by individuals, but were confined to a group of families of inherited rank, of which the female members were equally important'.[4]

In this chapter we will explore the nature of family-based rule. We will begin by looking at *basileia* as a responsibility of the family or clan, beginning with the example of the Macedonian Argeads, who provide one of the most worked-out examples of such clan-based rule, but then consider other examples of clan- and family-based ruling houses from across the Greek world. We will then discuss how these ruling families used different kinds of marriage strategies to strengthen their position, both through consanguineous and polygamous marriages, and the pitfalls of these approaches. In the final

section we will turn to the issue of succession, and look at the different ways in which succession was determined – primogeniture being the exception rather than the norm – and see how ruling families attempted to strike the balance between dynastic and charismatic rule.

## Family-based rule

Family-based rule is well known from fourth-century Macedon. Although the rule of the Macedonians was concentrated in one man, Elizabeth Carney has argued for an important way of understanding Macedonian kingship in which the principal members of the Argead clan (including the women) had a share in rule.[5] On these terms *basileia*, or 'kingship', was not passed strictly from father to son, but through the Argead clan, succession being determined by whoever was able to create the strongest power base and maintain the greatest support.[6] Carney claims that in Macedon the role of *basileus* was not conceptualized as an office:

> Indeed, Macedonian society in general in the classical period tended to conceptualize power in terms of individual personalities rather than offices. In terms of the monarchy, it is significant that when the first non-Argeads, Alexander's Successors, began to call themselves and each other *basileus* (king), the title was still so undefined, so personal a term, that it was tied neither to the rule of a specific people nor to an area.[7]

In addition, she argues, in Macedon royal marriages were always political, polygamy was accepted practice, and the lack of a 'chief' wife encouraged women in the royal household to behave politically in positioning their sons for the succession (we will return to this below). While generally their role was played in private, at need 'royal women could become the reserve troops of the dynast – dynastic understudies who, thanks to a critical scarcity of adult male Argeads or at least of those supportive to their sons, suddenly took dynastic centre stage'.[8] Olympias and her daughter Cleopatra, for example, were involved in international diplomacy through dedications at temples (Hyper. *Eux.* 19–26), in distribution of benefactions (*SEG* 9.2 = RO no. 96), and even in interstate relations – Diodorus says that both Antipater and Olympias

demanded the extradition of Harpalus from Athens (Diod. 17.108.7).[9] As Carney argues, this *basileia* rooted in the family is best exemplified by the family statue group in the Phillipeium at Olympia.[10]

Across the Greek world, there were a number of variations on this dynastic family-based scheme, although the basic pattern was widespread. For example, Aristotle says that the Penthilidae were a *basilikē dynasteia*, a ruling power group (even if a violent one), in seventh-century Mytilene (*Pol.* 5.1311b23–30), and that the Basilidae ('Rulers') were in control in Erythrae 'in ancient times' (*Pol.* 5.1305b18–19).[11] Herodotus suggests that the Bacchiads in seventh-century Corinth also ruled as a clan (called *mounarchoi* in Herodotus' Delphic oracle), and that they intermarried among themselves (Hdt. 5.92β).[12]

We see a similar pattern emerging in Thessaly. Herodotus describes the Larissan Aleuadae as the *basileis* of Thessaly in the early fifth century (7.6.2), although one member of the family seems to have acted as the chief official of a Thessalian coalition at need. So for example, when the Peisistratids sought Thessalian help against the Spartans, the Thessalians despatched an army under the command of their *basileus,* Cineas (Hdt. 5.63.3), who Helly and Sordi think must have been the supreme commander of the Thessalian army (though the sixth century is too early for a federal army),[12] and in the Persian Wars the Thessalians seem to have been led by one of the Aleuadae, Thorax (possibly collegially with his brothers: Hdt. 9.58; cf. 7.6).

Often, however, the ruling family was a more nucleated group, even if the group included husbands of sisters and daughters. In fact, a particularly interesting case study of familial rule is provided by the Cypselids, who followed the Bacchiads at Corinth. In the first instance, it was the Bacchiad clan which held control of Corinth as a family unit, as we have already noted. There may have been one man who had already achieved dominance over the rest of the family, as Diodorus and Nicolaus suggest (Diod. 7 fr. 9; *FGrHist* 90 F 57.1, 6), though that is not supported by Herodotus' account. Cypselus, probably himself a Bacchiad,[13] was, however, able to assert himself – whether as Herodotus tells the story or as Nicolaus of Damascus has it (both accounts contain folkloric elements which reappear elsewhere in stories about kings and rulers),[14] though it is probably important that in both accounts Cypselus' claim to rule is legitimized by an oracle (Hdt. 5.92β; Nicolaus of Damascus, *FGrHist* 90 F 57.4, 6).[15] Cypselus then used his immediate family to extend

and maintain control not only of Corinth, but also through foundations in the north Aegean and north-west Greece.[17] That the Cypselids were rulers and 'founders' has its own significance, as we have seen.

Cypselus was succeeded by his son Periander, who has a mixed reputation as one of Diogenes Laertius' 'Wise Men' (Prologue 13), as well as a cruel and ruthless ruler, whose worst crime (in the tradition) was the murder of his wife (Hdt. 3.50.1) and having sex with her dead body (Hdt.5.92ζ.3).[18] Cypselus' other son, Gorgus, who was involved in the foundation of Ambracia, seems to have shared responsibility for this north-west region (Ps-Scymnus 454–5; Strabo 7.7.6, 10.2.8). Gorgus was succeeded in Ambracia by his son, Periander (though Aristotle says that he was overthrown: *Pol.* 5.1304a31–3). On the other hand, Lycophron, the son of Periander son of Cypselus, was sent by his father to the Bacchiad foundation of Corcyra (Hdt. 3.52.6, 53.7), which Herodotus says was under Periander's control, and where Lycophron may have ruled (Nicolaus of Damascus, *FGrHist* 90 F 59). Nicolaus of Damascus also says that Periander (son of Cypselus), before his death, himself went to Corcyra, perhaps giving Corinth to his other son Nicolaus to rule in his absence (*FGrHist* 90 F 59), though Herodotus gives a slightly different account which has Lycophron killed by the Corcyraeans to prevent Periander coming (Hdt. 5.63.6–7).[19] Psammetichus (whose name suggests contacts with Egypt), another son of Gorgus, succeeded Periander (son of Cypselus) at Corinth on his death (Arist. *Pol.* 5.1315b25–6).

Family-based rule also occurred elsewhere in Greece. In Sicily, Gelon, a distinguished cavalry commander in Hippocrates' army, acquired the rule by election on Hippocrates' death (Hippocrates was the son of Pantares, the Olympic victor)[20], and, having taken Syracuse (Hdt. 7.155.2), transferred the rule of Gela to his brother Hieron (Hdt. 7.156.1). On Gelon's death the rule of Syracuse passed to Hieron (Pindar, *Ol.* 1.24; Diod. 11.38.3, 48.3). It has been thought previously that Gela passed to another brother, Polyzalus, based on an erased inscription on the base of the famous bronze statue of the chari-oteer at Delphi (*F. Delphes* iii.4.452), though more recently this assessment of the inscription and its significance has been questioned. Certainly someone inscribed himself as 'The one who rules over Gela' (*Gelas anassōn*) on the base, and Polyzalus certainly rededicated the statue group, as is attested by the reinscription in his name. However, some scholars now think it unlikely

that the original inscription could have been made by Polyzalus, or that he could have been ruler in Gela.[21] Yet the fact that the wife of Gelon, Demarete, was passed to Polyzalus on Gelon's death, not Hieron, does seem to suggest that Gelon was also trying to pass legitimate rule at Gela to Polyzalus.[22] Demarete was closely associated both with Gelon and Syracuse, and when she died was buried with her first husband on her estate where he had been buried (Diod. 14.63.3, cf. 11.38.4).[23] Nevertheless, Polyzalus seems to have been given control over the army (and expected to use it on Hieron's behalf) (Timaeus, *FGrHist* 566 F 93b; Diod. 11.48.3–7; schol. Pindar, *Ol.* 2.29c–d), so was certainly subordinate to Hieron (though that is not to say that he did not rule in Gela).[24]

On the other hand, Aetna (Hieron's foundation) was certainly given to Hieron's son, Deinomenes, during Hieron's lifetime (Pindar, *Pyth.* 1.58, 60–1),[25] though possibly with an *epitropos*, or guardian (schol. Pindar, *Nem.* 9), while Deinomenes was a minor. On Hieron's death, Syracuse went to yet another brother, Thrasyboulus (Arist. *Pol.* 5.1312b10–12; cf. Diod. 11.72.2), though Aristotle suggests that it should have gone to the son of Gelon, and it was because of these family problems that the tyranny collapsed. As we saw in an earlier chapter, Thrasyboulus' rule was known for its violence, which was probably the actual reason for the collapse of the dynasty.

The same pattern may also be evident in Libya where the Battiads controlled Cyrene, and probably also had influence in Barce, which Herodotus says was founded by the brothers of Arcesilas II who left Cyrene after Herodotus says they had a quarrel with their brother (Hdt. 4.160.1).[26] On the other hand, Arcesilas III withdrew to Barce to the court of Alazeir when pressure was mounting in Cyrene (Hdt. 4.164.4).

From these examples, it seems clear that rule across Greece and over a number of centuries was predominantly family-based. It was often (although not always) the case that one man dominated the clan or family unit. Especially in the more tightly knit families, other members of the family could then hold specific responsibilities. Among the Cypselids in Corinth and their colonies, or among the Deinomenids in Sicily, members of the family were given specific locations for which they held local responsibility, and the same was possibly also the case in Cyrene under the Battiads. At the court of Dionysius I, on the other hand, members of Dionysius' inner family held posts

of significant responsibility. One brother, Leptines, was admiral of Dionysius' fleet (e.g. Diod. 14.48.3, 53.5, 54.2, 59.7–60.), until Dionysius deposed him and replaced him with another brother, Thearides (Diod. 14.102.4). Thearides also accompanied the ill-fated contingent at the Olympic games of 386 (Diod. 14.109). Dion, brother of Dionysius' Syracusan wife and husband of Dionysius' daughter, was also an important member of Dionysius' inner circle, and was deployed as an ambassador to the Carthaginians (Plut. *Dion* 5.4).

Even the women could be included. At Cyrene, Pheretime not only ruled in her son's place during a period when he was in exile (Hdt. 4.165.1), but also accompanied a Persian army against the city of Barce to avenge his death (mutilating the wives of the women of the conspirators of Barce as well as impaling them on pikes around the city: Hdt. 4.165–7).[27] Another clear example of a woman playing an important part in local politics is Gelon's wife, Demarate, who (laying aside the issues surrounding the coin struck from the reward money) was involved in the peace negotiations after the battle of Himera, and secured favourable terms for the Carthaginians (Diod. 11.26.2–3).[28] In this way, the clan or family could hold rule as more or less closed oligarchy (which perhaps accounts for Herodotus' description of the Bacchiads as *mounarchoi* in Corinth).

## Political marriage

In these families, marriage – whether endogamous or exogamous – was often strategic as a resolution to conflict, or to mark the end of a conflict. For example, the disputed succession in Molossia between Neoptolemus and Arybbas was finalized with the marriage of Neoptolemus' daughter Troas to her uncle Arybbas (Plut. *Pyrrhus* 1.5; Justin 7.6.13). The marriage sealed the relationship and secured the cessation of conflict between Neoptolemus and Arybbas (who then ruled jointly). Extra-familial conflicts could also be resolved through marriage, such as the marriage between Hieron of Syracuse and the daughter of Anaxilas the ruler of Rhegium (Timaeus, *FGrHist* 566 F 97),[29] or the marriage of the sister of the Macedonian Perdiccas to the Thracian Seuthes, nephew of the king, in the 420s to subvert the impending Thracian attack on Macedon (Th. 2.101.5–6). These marriages worked by

bringing non-kin within kinship networks, and the expectations and respon-sibilities of kinship relationships.

In ruling families, however, endogamy and even closely consanguineous marriages were common. We have already noted that the Bacchiads married endogamously (although the marriage of Labda to Eetion suggests that this rule was not strictly observed: Hdt. 5.92.2β). At Cyrene, Arcesilas III was married to Alazeir's daughter, who Herodotus says was also Arcesilas' kinswoman; Corcella supposes that although Alazeir was a Libyan name his daughter must have been the descendant of the brothers of Arcesilas II.[30] The remarkable Pheretime, who Herodotus (4.205) seems to suggest was the daughter of Battus II, was also married to Battus III, and so the mother of Arcesilas III (as well as his great-aunt).[31]

In fact, consanguineous marriages were not uncommon as a means of keeping power and wealth in the family. Certainly, while in Athens incest between parent and child was prohibited, the acceptability of other kinds of close familial relationships was less clear,[32] and endogamous marriages were familiar among the elite.[33] Pericles son of Xanthippus of Athens, for example, was reputed to have married a kinswoman (Plut. *Per.* 24.8).[34] Also at Athens, there may have been a law that half-siblings could marry if they shared the same father, but not the same mother,[35] though the law itself (said to be a law of Solon) only appears in late sources (Philo of Alexandria, *De spec. leg.* 3.22; Nepos, *Cimon* 1.2; schol. Aristoph. *Clouds* 1371).[36] Philo also says there was a Spartan law which allowed marriage between half-siblings with the same mother, but this is more doubtful, because it is otherwise unsupported.[37] Elsewhere in ruling families, as we shall see, marriages between uncle and niece were possible. These could be marriages between a man and his sister's daughter, or his brother's daughter. It was even possible for a woman to marry her brother's son. Marriages between half-brother and half-sister (with the same father) do not seem to have been problematic.

Such consanguineous marriages were part of the marriage strategies of the early fourth-century Dionysius I of Syracuse in order to tighten and consolidate his hold on power. He married one of his daughters, Arete, to his brother Thearides (cf. Diod. 14.102.3, 103.2–3, 109.2), and when Thearides died she was married to his nephew Dion (Plut. *Dion* 6.1), the brother of Dionysius' Syracusan wife, Aristomache (Plut. *Dion* 4.1). Another

of Dionysius' daughters, Sophrosyne, was married to her half-brother (Plut. *Dion* 6.1), who was to become Dionysius II. Dionysius himself married the daughter of the prominent fifth-century general and politician, Hermocrates, and married his sister to Hermocrates' brother, Polyxenus (Diod. 13.96.3; RO 10).

In the Spartan royal families not only was endogamy the norm, so that Spartan kings married only members of the Heracleidae (Plato, *Alc. I* 121b–c),[38] but also marriages were also often consanguineous, which Hodkinson identifies as a means of concentrating wealth and keeping it in the family.[39] In the Agiad royal house, the first marriage of Anaxandridas, son of Leon was to his sister's daughter (Hdt. 5.39.1). Later, Gorgo, daughter of Cleomenes (the son of Anaxandridas' second wife who died without leaving a son and heir) was married to Leonidas, Cleomenes' half-brother (a son of Anaxandridas' first wife: Hdt. 7.205.1, 239.4), which Hodkinson argues was a strategy to rectify the financial problems caused by the division of Anaxandridas' property.[40]

**Figure 3.1** Section of the Spartan Agiad stemma

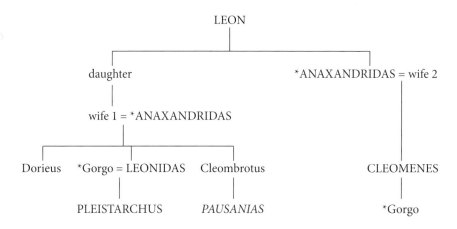

\* Indicates individuals who appear more than once
Names of rulers are capitalized.

Among the Eurypontids, the marital arrangements were also complicated. Ariston, who ruled in the second half of the sixth century, having married twice without issue, was married a third time (after divorcing his second

wife) to the wife of his best friend Agetus. She bore him a son, Demaratus (Hdt. 6.61–3). Demaratus, in the event, was deposed and eventually exiled in favour of a kinsman, Leotychidas (II) (we will return to the circumstances of the deposition and exile below). Leotychidas (who himself was also forced into exile: Hdt. 6.72)[41] had a son, Zeuxidamas, by his first wife. However, Zeuxidamas died, and so Leotychidas married again, to Eurydame (Hdt. 6.71). He then married his daughter by his second marriage, Lampito, to his grandson, Archidamus, who was the son of Zeuxidamas. Hodkinson notes that as a result of this marriage Leotychidas ensured that Archidamus' and Lampito's children would inherit all his property and that of his wives.[42]

**Figure 3.2** Section of the Spartan Eurypontid stemma

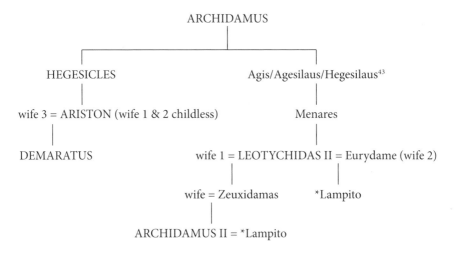

* Indicates individuals who appear more than once
Names of rulers are capitalized.

Nevertheless, it was also common for rulers in different families to make connections through exogamous marriage alliances in order to strengthen their rule across regions. For instance, Cylon of Athens (though only an attempted ruler) was married to the daughter of Theagenes of Megara, who at the end of the seventh century supported Cylon in his bid to hold the Athenian acropolis (Th. 1.126.3, 5), and Periander of Corinth married the daughter of Procles, tyrant of Epidaurus (3.50.2).

Furthermore, in order to extend the potential of such extra-familial marriages, while the normal marital practice in Greek society was monogamy (even if other forms of cohabitation were accepted within the household),[44] many ruling families were polygamous. Amyntas III of Macedon had two wives (Justin 7.4.5). Philip of Macedon had seven wives (Satyrus apud Athenaeus 13.577b–e) whose marriages were almost certainly politically motivated,[45] and whose intention was to cement his control of the north, even replacing Arybbas of Molossia with Olympias' brother Alexander (Arybbas' nephew).[46] In the early fifth century, Hieron of Syracuse had three wives: one was the daughter of a Syracusan, the second the daughter of Anaxilas, the ruler of Rhegium, and the third the niece of Theron, ruler of Acragas (Timaeus, *FGrHist* 566 F 97). At the end of the fifth century, Dionysius I of Syracuse certainly had two wives concurrently (Diod. 14.44.5–8; Plut. *Dion* 21.4; cf. Diod. 13.96.3), whom he married on the same day.[47] The first of these was Doris, the daughter of the most distinguished citizen of Locri, and the assembly of the Locrians (significantly) had voted on the connection (the assembly at Rhegium had refused Dionysius' offer of a marriage connection: Diod. 14.44.5 – a decision they probably later regretted). Doris' son became Dionysius II. Dionysius' second wife, Aristomache, was a Syracusan.

The Molossian ruling family may also have been polygamous, since in the mid fourth century Neoptolemus and his brother Arybbas quarrelled over the succession, and eventually ruled jointly (Paus. 1.11.3; Plut. *Pyrrhus* 1.5).[48] One way of understanding their disagreement may be to assume that Neoptolemus and Arybbas were half-brothers in a polygamous family, and that it was not clear to which brother rule should pass. The dispute, however, makes the point that succession itself was not straightforward, and we will return to that below.

Even at Athens, Peisistratus had at least three wives, and possibly four, if a late scholion on Aristophanes' *Clouds* can be believed: the mother of Hippias and Hipparchus, and probably also Thessalus (although the *Athenaion Poiteia* thinks that Thessalus was Hegisistratus' nickname);[49] an Argive wife, Timonassa (*Ath. Pol.* 17.3–4), who was the mother of Iophon and Hegesistratus; the rather less successful liaison with the daughter of Megacles (Hdt. 1.61.1–2; *Ath. Pol.* 15.1); and possibly also an Eretrian woman, Coesyra (schol. *Clouds* 48).[50] Timonassa, at least, was probably concurrent with the wife of Megacles, though this is not inevitable.[51] Thucydides says that Hippias, Hipparchus and

Thessalus were legitimate sons (*gnēsioi*), implying that any other sons were not (Th. 6.55.1). Herodotus, on the other hand, says that Hegesistratus was a *nothos*, an 'illegitimate' son, of Peisistratus (5.94.1), though this may mean no more than that he was the son of a non-Athenian mother.[52] Hegesistratus was given Sigeum by Peisistratus to rule (Hdt. 5.94.1–2), providing a role for this second branch of the family.

It perhaps needs to be considered, however, why polygamy was acceptable in ruling families, but was generally viewed with distaste in non-ruling households. In comments which are clearly meant to mark differences between Greeks and Persians, Herodotus said that the Persians were habitually polygamous, with everyone having many wives and even more concubines (1.135).[53] Nevertheless, in Greek society various forms of cohabitation were possible. Polyandry at Sparta was not unknown, but as Pomeroy points out, the practice of wife-lending was based on the premise of monogamous households.[54] Polygyny was also common practice. At Athens, concubinage was legally permissible for the production of 'free' children (e.g. Dem. 23.53; Isaeus 3.39).[55] There is also a late tradition which refers to a law at the end of the Peloponnesian War allowing men to take a citizen wife and then another for the production of children (D.L. 2.26; cf. Plut. *Arist.* 27.3), and there is reference to Socrates' two 'wives', Xanthippe and Myrto. MacDowell thinks, given the context of late fifth-century Athens where the numbers of men must have been depleted by war and plague, we should probably accept the existence of this law, even though he thinks it also must have been rescinded by the end of the fifth century.[56]

Nevertheless, polygamy as we see it in ruling families is of a rather different order. Possibly the key to why polygamy was possible in ruling families is its 'heroic' nature. Gernet, who links polygamy specifically to tyranny, makes the point that several mythical heroes have simultaneous marriages, and many of their children are legitimate.[57] Lewis, more recently, has argued that the polygamous marriages of Dionysius I of Syracuse were an indication of his uniqueness, and marked him out 'as beyond normal expectations and behaviour'.[58] We have seen on more than one occasion how special distinctions were made between ruling families and other families, in the ways they behaved and were treated, in order to underline and reinforce their special nature. Polygamy seems to have belonged to

this pattern of thinking, even if from an Athenian perspective it looked irregular.

Polygamy, however, was not unproblematic. A good example is the ruling house of Pherae in Thessaly, which was polygamous. Jason of Pherae (who had reinvented the Thessalian *tageia* as personal rule in the middle of the fourth century: Xen. *Hell.* 6.4.34),[59] probably had at least two wives. After his death (probably some time after it), Alexander of Pherae, who seems to have been Jason's nephew (cf. Plut. *Pelop.* 29.8), wanted to marry one of Jason's wives (Xen. *Hell.* 6.4.37). However, Thebe, Jason's daughter, who was also a wife of Alexander (Plut. *Pelop.* 28.5), murdered him with the help of at least two of her brothers, Tisiphonus and Lycophron, and perhaps also a third, Peitholaus (Xen. *Hell.* 6.4.35–7; Diod. 16.14.1; Plut. *Pelop.* 35.5–12). Xenophon says that at least one of the reasons she wanted him dead was because he wanted to marry Jason's Theban wife (Xen. *Hell.* 6.4.37).[60] Beloch recognized long ago that this woman could not have been Thebe's mother, since the reason Alexander wanted another wife was because Thebe was childless, and Thebe's mother would have been too old.[61] This Theban woman (Xenophon says she returned to Thebes on Jason's death, presumably to her natal family)[62] then must have been a much younger woman. On this basis, Daniel Ogden has pointed out that Thebe's anger was probably motivated by a 'double-dose of amphimetric strife' (that is, strife between the children of different wives) created by tensions between competing branches of Jason's family (that is, between Thebe and her brothers on the one hand, and the Theban wife of Jason), and also competition with another wife in her own household.[63]

It is significant, however, that Alexander tried to bolster his position and secure legitimacy for his *tageia* by marrying more than once into Jason's family. Jason had secured the *tageia* by election, even if he had also applied persuasion through military force (Xen. *Hell.* 6.1.2–18). Alexander's position, however, was far less secure, and it is likely that, although he may have held the *tageia* of all Thessaly also, his legitimacy was seriously under threat. It is not clear whether he also had to be elected to the position as Jason had been, but that seems unlikely.[64] Plutarch (*Pelop.* 26–1–3) says that the *koinon* of the Thessalians invited the Theban Pelopidas to intervene, and that he tried to persuade Alexander to give up the *tageia* for the 'constitutional' (that is, elected) one of *archon* of the federation, though Alexander refused.[65] Sprawski

argues, in fact, that once Pelopidas had overthrown Alexander, his control over all Thessaly was broken, and his power base limited to Pherae. Jason's regime, on the other hand, had been a successful one, and so it was in Alexander's interest to associate himself with it as closely as possible. Unfortunately for him, however, Thebe's ire had been stirred.

Thebe's anger against Alexander may also have motivated her to act because of rivalries over the *tageia* itself. On his death Jason had been succeeded by his brothers, Polyphron and Polydorus (Xen. *Hell.* 6.4.33), although Polydorus was later assassinated by Polyphron. Alexander then killed Polyphron in revenge for the death of Polydorus, who was probably his father (Alexander was the nephew of Polyphron: Plut. *Pelop.* 29.8, so must have been the son of either Polydorus, or perhaps even Jason himself).[66] In any case, Thebe's brothers were rivals with Alexander for the succession (they were all sons of *tagoi*), and so all must have had an equal right to rule.

**Figure 3.3**  House of Pherae

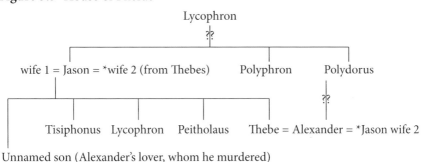

Unnamed son (Alexander's lover, whom he murdered)

* Indicates individuals who appear more than once

Nevertheless, while Thebe planned the murder, her brothers reaped the rewards. Alexander was succeeded by Thebe's brothers, Tisiphonus and Lycophron, who seem to have held the rule jointly (Xenophon says they held the *archē*), though with Tisiphonus as the senior partner (Xen. *Hell.* 6.4.37; Diod. 16.14.1, 37.3). Diodorus says that initially they were popular, but later were compelled to hold their position by force, so the Aleuadae who were not strong enough on their own brought in Philip of Macedon to help them against the Pheraeans (Diod. 16.14.1–2). It is possible then that the brothers also styled themselves as *tagoi* of Thessaly. By 353, Tisiphonus seems to

have died, and Lycophron was taking the lead in the war against Philip II of Macedon (and the Thessalian *koinon*) (Diod. 16.35), although he seems to have held some kind of joint rule with another brother, Peitholaus (Diod, 16.37.3; cf. 39.3). In 352 Philip II of Macedon, summoned by the *koinon*, ejected the brothers from Thessaly (Diod. 16.35, 37.1–6), and was, as it seems, elected *archōn* of the Thessalian *koinon*.[67]

Difficulties in polygamous families were common, and there was always the potential for conflict and factionalization, especially in the battle for succession between the children of different wives. Certainly, Olympias and Alexander had felt under pressure by Philip II's last marriage to Cleopatra. Despite the fact that Philip had marked out Alexander in various ways,[68] Alexander had good reason to worry about his prospects in Macedon, since Attalus, a powerful figure in the Macedonian court, was the uncle (or brother) of Philip's last wife, Cleopatra, and, as Muller points out, seemed to have felt himself strong enough to influence the succession (cf. Plut. *Alex.* 9.6–11);[69] indeed Diodorus (or his source) thought Alexander had good reason to be insecure (Diod. 17.3–4; cf. 16.91.2, 93.9).

This was not just an issue at the Macedonian court. Even at Sparta, where polygamy was not the norm, the sons of the Spartan Anaxandridas by his two wives also disagreed over who had the greater right to rule. Although it was not customary for Spartan *basileis* to take more than one wife (Hdt. 5.40.2), Anaxandridas took a second wife (though this was deliberately polygamous) because he did not want to divorce his first wife when the ephors told him he must because she was childless (Hdt. 5.39–41). His first wife, who had been childless, fell pregnant after he married his second wife, who also bore him a son, Cleomenes (see figure 1 above). Cleomenes was the eldest of the two, but, even though Spartan custom was for the eldest son to rule (Hdt. 5.42.2), Dorieus (the eldest son of the first wife – she had at least three sons, Dorieus, Leonidas and Cleombrotus: Hdt. 7.205), although junior to Cleomenes, was sure he would succeed his father both because of his *andragathia*, his 'manly courage', and the fact that he was the 'first' (*prōtos*) among his peers, while Cleomenes (it was said) was not mentally stable and was on the verge of madness (Hdt. 5.42.2; cf. 39.1). On their father's death, Cleomenes as eldest did succeed to the *basileia*, and so Dorieus left Sparta bent on founding a colony (although he and most of his companions died in Sicily: Hdt. 5.42.2–46.1).

It is notable that, despite Dorieus' claims and the stories about Cleomenes' madness, Cleomenes was one of the most colourful, politically successful and charismatic of the Spartan dynasts – perhaps to the point where genius tipped into insanity (cf. Hdt. 6.75.1), although he may (as Griffiths suggests) simply be the victim of a tradition of 'wicked kings'.[70] Yet as we shall see further below (and as Aristotle claimed), it was the tightness of the structures around the Spartan dyarchy which did not prevent problems in the succession, but did allow them to be resolved without breaking the institution.

Polygamous families, on one level, could extend the political range of the ruler by increasing his political connections with other ruling families. The *Athenaion Politeia* says that it was on account of Peisistratus' marriage to the Argive Timonassa that he had an alliance with the Argives, who supplied significant troops, led by Hegesistratus, for the battle of Pallene (*Ath. Pol.* 17.4 – though Herodotus calls them mercenaries: 1.61.4).[71] Yet polygamous families could also be divisive as different factions fought to control the succession. In the power struggles that followed Dionysius I's death (which eventually saw Dionysius II ousted by Dion) Aristomache held a key role on the one hand as the mother of potential rival interests to Dionysius II (Plut. *Dion* 7.2–3, 14.1), though one of her daughters was also married to him. On the other hand, as the sister of Dion and mother of Dion's wife, Arete (Plut. *Dion* 6.1), she also became instrumental in creating Dion's court after he returned to Syracuse from exile (Plut. *Dion.* 51.1–5), at which point it broke from its alliance with the household of Dionysius to form its own ruling unit.

## The problems of succession

As is already clear, the issue of succession in ruling families was often fraught. Even in ordinary Greek families inheritance was divided between all sons, with no son necessarily being given priority over the others, but the shares not necessarily equally divided (sometimes it could even be decided by lot) – as Hesiod's bitterness demonstrates, settlement was not always easily reached or amicable (*W&D* 35–9).[72] In some dynasties, succession passed from father to son, possibly on the basis of primogeniture. At Sparta, the succession, according to law, passed in the first instance from father to son

(Xen. *Hell.* 3.3.1–4). Herodotus also claims that the legitimate successor was the son born while his father held the *basileia* (Hdt. 7.3.3), although Cartledge notes that this rule, if accurate, never seems to have been observed.[73] The *basileia* at Cyrene, a colony of Thera, also seems to have passed from father to son through eight generations,[74] when the final *basileus*, Arcesilas IV, was murdered (Hdt. 4.159–65; Arist. fr. 611 [Rose]; schol. Pindar, *Pyth.* 4; cf. Pindar, *Pyth.* 4, 5),[75] although whether succession was necessarily based strictly on primogeniture is less clear, since the reigning *basileus* seems to have adopted the traditional regnal names on his succession.[76]

A more common pattern, however, was rule shared between brothers or succession passed between brothers. Examples of succession passing between brothers or between uncles and nephews can be found in Corinth among the Cypselids and in Sicily among the Deinomenids. Succession 'through' the family, rather than 'down' it, has, of course, Homeric antecedents. In Homer's *Iliad*, in a story which has no hint of the fratricide of other versions, after Pelops received the sceptre from Hermes (commissioned by Zeus and made by Hephaestus), he gave it to his son Atreus, who left it for his brother Thyestes, who then gave it to his nephew, Agamemnon, 'so that he might rule many islands and all Argos' (Hom. *Il.* 2.100–8).[77]

In historic time, however, succession between brothers was common. We have noted in passing that when Cleander, the tyrant of Gela, died (he was murdered, according to Herodotus), the *mounarchiē* went to his brother Hippocrates (Hdt. 1.154). The fact that in the fourth century the Spartan Leotychidas felt the need to insist that at Sparta rule passed to the son and not the brother suggests how prevalent the alternative pattern of inheritance was elsewhere (Xen. *Hell.* 3.3.2).[78] Nevertheless, Leotychidas was also unsuccessful in repelling the claims of Agis' half-brother, Agesilaus (see further below).

There was a tendency for the oldest member of the family to predominate, but especially in polygamous families, where there was competition between different family groupings for dominance, often based around mothers, this was not necessarily the case. Alexander the Great was not Philip's eldest son, though Arrhidaeus seems to have an impairment that made him incapable of ruling. In fact, at the Macedonian court, although the reigning king seems to have been able to nominate his successor, it seems he did not always choose the eldest son. While in the alliance between Athens and Amyntas III dating to

the mid 370s Amyntas and his eldest son, Alexander, are named as signatories
(Tod 129.2, 21), other evidence suggests that sons did not always have prece-
dence.[79] In particular, in the alliance between Athens and Perdiccas II dating
possibly to the 420s, the Macedonian oath-takers are set out in what appears
to be their hierarchical order at court (*IG* i³ 89): Perdiccas is followed in order
by his brother Alcetas, his son Archelaus, and then (after a break in the stone)
by another brother of Perdiccas, Menelaus, followed by the sons of Alcetas.
As Borza notes, it appears, at least at this stage, that Alcetas is heir-apparent,
although Alcetas did not in the event succeed Perdiccas and (as Borza also
notes) Perdiccas appointed Iolaus as *archōn* in his place at Potidaea in 432.[80]
Alcetas is said to have had an *archē* (a 'principality') in Macedon (Plato,
*Gorgias* 471a–b), as did his brother Philip (Th. 2.100.3), though Philip had
lost control of his by 432. Plato's story about Archelaus is clearly scurrilous,
but he does say that Perdiccas took Alcetas' *archē* from him, so it is possible
that Alcetas may have fallen from favour. On the other hand, it is not unlikely
that Archelaus may have done away with his uncle, as Plato claims, though the
story of Archelaus' origins must also belong to the 'wicked king' syndrome.

As is evident from examples already discussed, an easy transition of rule
was not always achieved. Fragmentation of rule was always a possibility.[81]
Even where the rules of succession were clear, such as at Sparta, acquiring
rule and keeping it was not always an easy matter. The Agiad Pausanias seems
to have made a bid for control (not just of Sparta but of Greece) when he
was appointed regent for Pleistarchus, the under-age son of Leonidas and
Gorgo (Hdt. 9.10; Th. 1.132.1). Pausanias was the son of Cleombrotus, who
was the third son born to Anaxandridas' first wife (Hdt. 7.205.1). Pausanias'
behaviour appears very much as if he was preparing himself to hold on to
rule at the cost of Pleistarchus, and may well have had higher ambitions: one
thinks of the couplet he had inscribed on the monument at Delphi, and which
was later erased by the Spartans, in which he declared himself the *archēgos*
('leader') of the Hellenes (Th. 1.132.2–3). It has also been suggested that it was
Pausanias who commissioned Simonides' *Plataea Elegy*, which describes the
Greek army, and especially the Spartans, marching out to war beside Homeric
heroes.[82] The implicit comparison is inescapable, and pointed.

Succession in the other Spartan royal family, the Eurypontids, proved
also to be particularly problematic. The problems begin in the mid sixth

century when Ariston married for the third time (above). His son by the third marriage, Demaratus, was said to be born early, so that Ariston declared at the baby's birth that he could not be his son, though he later came to regret the remark (Hdt. 6.63). Later, however, after Demaratus succeeded Ariston, the Agiad Cleomenes, who himself had to fight for his accession against the claims of his half-brother Dorieus (above), managed to have Demaratus deposed. He was working together with the Eurypontid Leotychidas (II), perhaps a second cousin of Demaratus (Herodotus says he was the son of Menares, son of Agis/ Agesilaus/Hegesilaus: 6.65.1, 8.131),[83] and their claim was that Demaratus was not the true son of Ariston (Hdt. 6.65). In order to resolve the issue, the ephors sent to the Delphic oracle, who was persuaded by one of Cleomenes' friends to answer in his favour (Hdt. 6.66). Demaratus later went into exile in Persia (Hdt. 6.67–70).

Agesilaus successfully attempted the same strategy a few generations later to disrupt the succession. As we have already seen, Leotychidas II was succeeded by his grandson, Archidamus, who was in turn succeeded by his son Agis. Yet rule did not pass to his son Leotychidas (III), since Agesilaus, who was Agis' half-brother, made the case (supported by Lysander) that Leotychidas was also not the son of his father because he also was born early (Xen. *Hell.* 3.3.2). There were rumours in antiquity that Leotychidas was in fact the son of Alcibiades (Plut. *Alc.* 23.7).

What is so interesting about these Spartan cases is that actual instability in the transitions from one ruler to the next was masked by the strength of the institutions of Spartan governance. That the structures in which the dyarchy was situated were so clear, and so enshrined in law, makes it significant that the matter of who ruled was not important for the stability of the Spartan state. That there were dyarchs was important, but controversy over who would hold the office did not produce constitutional crises, although they were obviously problematic for the families.[84]

One solution to the problem of family tension, as we have already noted in passing, was joint rule. The Spartan dyarchy was effectively joint rule. In fact, although it is unlikely to be true, Herodotus (6.53) says that the Spartans explained their dyarchy as originating in the joint rule of the twin sons of Aristodemus (since they were identical no one could decide which was the eldest, and their mother would not say).[85] Co-ruling, or joint-rule, was of

course well known in the Hellenistic period, at least between father and sons, and we may well see the beginnings of that in the fourth century, if not in Macedon itself then at least in the northern neighbours with whom they were closely concerned.

In fourth-century Thessaly, in particular, we certainly see the pattern of joint rule by members of the family persisting in the fourth-century recreation of the *tageia*:[86] Polyphron and Polydorus (Xen. *Hell.* 6.4.33); Tisiphonus and his brother Lycophron, as a junior partner (Xen. *Hell.* 6.4.35–8; Diod. 16.14.1, 37.3); Lycophron possibly with another brother, Peitholaus (Diod. 16.37.3; cf. 16.35, 37.1–3, 39.3) after Tisiphonus' death. We have already seen that in fourth-century Molossia Neoptolemus and Arybbas ruled jointly, although Arybbas ruled on his own after Neoptolemus' death (Diod. 16.72.1; cf. RO 70).

At Athens, the sons of Peisistratus, Hippias and Hipparchus, may also have shared rule (cf. *Ath. Pol.* 18.1); the younger brother, Thessalus, does not seem to have been involved. The logic of the tradition of the tyrannicide suggests Hippias and Hipparchus were co-rulers, although both Herodotus and Thucydides argue against more than one of the brothers holding rule (so that the assassination of Hipparchus could not have been tyrannicide: Th. 1.20.2, cf. 6.54.2; Hdt. 5.55–6, 62, 6.121). Herodotus, on the other hand, later tells another story about the Peisistratids which suggests that Hipparchus did have political power on some level, since he was said to have personally exiled the chrysmologist, Onomacritus (7.6.3–4).

Individual rule, embedded in the family, was a phenomenon across the Greek world. The family, closely bound together by the responsibilities of ruling, brought strength and power, but it also brought inherent weaknesses and considerable instability, both because ruling families were polygamous, and – competition between polygamous branches of the family notwithstanding – there were often no clear rules for succession or even how to share power.

Quarrels between full brothers (not just half-brothers) were common. Arcesilas II quarrelled with his brothers, apparently over who should rule, since they went to found their own cities. In sixth-century Samos Herodotus says Polycrates, together with his brothers, had seized control of the island by force (Hdt. 3.39). We know that members of Polycrates' family had ruled in Samos before him (cf. ML 16).[87] Forsdyke argues Polycrates and his brothers

must have deposed their father, Aeaces (I), though Shipley would rather see a hiatus in the Aeacid dynasty which Polycrates then restored.[88] In any case Polycrates' family was not a happy one. Herodotus also says Polycrates killed one of his brothers and drove out the other, Syloson, who was later returned to Samos with the support of the Persians (3.39.2, 139–49).[89]

However affairs were arranged at Gela, there was trouble between Hieron and Polyzalus. Timaeus says that Gelon arranged his affairs as he did so that on his death Gelon's marriage connection with Theron would transfer to Polyzalus (Timaeus, *FGrHist* 566 F 93a–b; Diod. 11.48.3–6). Both Timaeus, the scholiast (schol. Pindar, *Ol.* 2.29c–d) and Diodorus also refer to the fact that Polyzalus had 'fame' and a good reputation in Sicily, and that Hieron was envious. With his role as head of the army (if this is all he was),[90] backed by his high reputation and military success, *and* his connections with the Emmenids in Acragas, Polyzalus was in a strong position to challenge Hieron with the help of Theron and his son, although the crisis was eventually resolved (with the help of the poet Simonides). At some stage a further marriage seems to have been made between Hieron and the niece of Theron, which may have taken place after Hieron gave him information about a plot against Theron by some discontents in Himera (Diod. 11.48.8). Bonnano, in an excellent analysis of the *contretemps* between the brothers, argues that through this marriage into Theron's family Hieron both neutralized the threat of Polyzalus and effected a diplomatically sophisticated reconfiguration of his relations with Theron and the Emmenids.[91]

Competition, not surprisingly, was central to issues of who was to rule. As we have seen, it was thought fitting that the best people ruled and this was the grounds on which rule was legitimated. In Macedon, despite – or because of – the family involvement in the *basileia*, regicide was an occupational hazard of the Macedonian kings.[92] On his accession, one of the first tasks of Philip II was to dispose of any possible rivals from within the Argeadae; his half-brothers, in particular, were not spared (Justin 7.4.5, 8.3.10), one of whom may have attempted to supplant him.[93] On his deathbed, with no Argead available to take up the succession, Alexander said (in one of the few traditions about Alexander that is consistent among our sources) that his rule should pass to the 'best' person (*kratistos*) (Diod. 17.117.4 [cf. 18.1.4]; Arrian, *Anab.* 7.26.3).

Competition for the right to rule readily arose when succession was

dependent on defining who was 'the best'. The Spartan Dorieus, the son of the polygamous Anaxandridas, evidently thought that he had the right to rule over his brother, Cleomenes, because he was the 'first' of his peers. When that competition was lost, it is of course significant that he set out to found a colony, both proving his heroic worth and creating a context in which he could demonstrate that he *was* a ruler.

It is significant that for Weber charismatic leaders cannot be dynastic, since for him charismatic authority is by its nature unstable, and with the 'routinization' of charisma, the emphasis moves away from the individual to the office.[94] As Aristotle was aware, this was the problem with succession in the family (Ar. *Pol.* 3.1286b22–7). However, the combination of charismatic leadership and hereditary structure was possible to achieve when there was no insistence on primogeniture. The best and most charismatic member of the family was also likely to be the one who could gather together sufficient support to gain control. On the other hand, individual rulers became weaker, though the office more stable, when it was institutionalized and primogeniture enforced. It was still up to individuals to make something of their position, but the role of *basileus* was generally less strong, because there was no guarantee that a strong man would rule. It is not surprising that the strongest of the historical kings of Sparta, Cleomenes and Agesilaus, emerged in the context of competition.

Yet it was not only tensions in families which put ruling families under pressure. The development of the *polis*, with the maturation of political structures and the rise of a community and civic identity, also brought new demands and constraints upon ruling families. It is the place of the ruler within the *polis* that we will consider in the next chapter.

## Notes

1    Foxhall (1997), 119; cf. I. Morris (1999), 66.
2    I. Morris (1989), 90–6. Morgan, however, more cautiously notes that few such 'family' plots are known before the eighth century, and the interpretation of groupings, when they occur, is controversial: Morgan (2009), 46.
3    This point has also been made independently by Sian Lewis (2011).

4    Crielaard (1998), 48. Crielaard makes the same point about the apparent sacrifice of the woman in the Toumba at Lefkandi: (2006), 288.

5    Carney (1995).

6    Carney (2000), 4–8; cf. L. Mitchell (2007a).

7    Carney (2000), 7.

8    Carney (2000), 8–37 (quotation from 37). See also the important chapter by Sian Lewis (2011) on women in 'tyrant' households.

9    Carney (2006), 49–52.

10    Carney (2006), 49–51. Schultz argues persuasively that the building and the statues were one commission: (2007), 208–13.

11    They may also have been a family who called themselves Basilidae ruling Ephesus in the sixth century (Baton of Sinope, *FGrHist* 268 F 3).

12    Diodorus (7 fr. 9) gives the Corinthians a dynasty descended through Aletes, one of the Heracleidae until the time of Cypselus. Pausanias (2.4.3–4), on the other hand, tells a rather more elaborate story which ends the Bacchiad *basileia* with the death of the final *basileus*, Telestes (a name which Salmon [1984], 47, finds immediately suspicious since he is the *last* of the dynasty), when Corinth was ruled annually by *prytaneis* appointed from among the Bacchiads, until the tyranny of Cypselus. Carlier ([1984], 395–400) accepts this tradition. Nicolaus of Damascus says that the last of the Bacchiads before Cypselus was Hippocleides/Patrocleides: FGrHist 90 F 57.1, 6.

13    Helly (1995), 13–68; Sordi (1997).

14    Herodotus suggests Cypselus may have himself been a member of the ruling Bacchiad family (Hdt. 5.92β.1), and Nicolaus of Damascus says that he was (*FGrHist* 90 F 57.1), but, whether or not they were connected to the Bacchiads, the Cypselids also seem to have ruled through the family. Herodotus says that he killed and forced his political opponents into exile (Hdt. 5.92ε.2, η.1), but this was by way of introducing the story of Thrasyboulus' advice to Periander to kill the most outstanding citizens, which is produced as an example of the stereotype of what tyrants are like and why they must be resisted (5.92η.2–5). For this reason Salmon is not inclined to believe the stories about killings: Salmon (1984), 195. Sara Forsdyke argues that since the scattered references to Corinthian exiles at this time refer to Bacchiads, it is likely that Cypselus and Periander may have exiled members of this family, but thinks it likely that the rest of the Corinthians remained contentedly in Corinth: Forsdyke (2005), 73. Forsdyke also seems to think that civic disturbances in Corinth surrounding the Cypselids may have resulted in a number of colonies, especially the foundation of Syracuse. The date of the foundation of Syracuse is usually taken as 733 on

the basis of Thucydides' relative dating at 6.3.2, but it might be earlier (Fischer-Hansen, Nielsen and Ampolo [2004], 225). Corcyra had been founded by Chersicrates, a Bacchiad (Strabo 6.2.4; Timaeus, *FGrHist* 566 F 80), probably in the late eighth century (Gehrke and Wirbelauer [2004], 361). Nicolaus says that the Bacchiads exiled by Cypselus went to Corcyra (Nicolaus of Damascus, *FGrHist* 90 F 57.7), and that is a likely enough possibility. Cypselus is otherwise generally known in the tradition as a moderate ruler (Arist. *Pol.* 5.1315b27–8; Nicolaus of Damascus, *FGrHist* 90 F 57.8).

15    Nicolaus of Damascus has Cypselus brought up as a suppliant at the sanctuary at Olympia, until a oracle reveals his destiny (*FGrHist* 90 F 57.3). A close parallel is Ion in Euripides' *Ion*, though he of course is also the son of Apollo. Broader parallels of rulers who had childhoods in impoverishment and obscurity, only to be uncovered as ruling material, are well known from the Near East. The story of Cyrus' childhood with the shepherd from Herodotus probably had its roots in Near Eastern story cycles about rulers' humble origins: see Chapter Two.

16    Compare Cylon's attempted coup at Athens, esp. Chapter Two.

17    Graham, however, makes the important point that these north/north-western acquisitions were not just seen as belonging to the Cypselids but to Corinth itself, since the connection between colonies and mother city continued after the end of the dynasty: (1964), 31.

18    Atrocities against woman were all standard for tyrannical types (compare Cambyses' murder of his sister/wife: Hdt. 3.31–2). It is significant, as a counter to the horror stories surrounding Periander, that he was apparently a statesman of some note and trust since he was the arbitrator appointed to make a judgement on the conflict between Athens and Mytilene over Sigeum (Hdt. 5.95.2).

19    Nicolaus of Damascus says that Nicolaus (son of Periander) was *basileus* in Corcyra, but that Periander was going to give him Corinth. However, the Corcyraeans got wind of what was happening and Nicolaus was treacherously killed by them: Nicolaus of Damascus, *FGrHist* 90 F 59. Nicolaus Damascenes' account of the exchange of cities, however, is a doublet with Herodotus' story about Lycophron (Hdt. 3.53), and it is difficult to confirm which has the right version – probabilities should lie with Herodotus, but his account is moralizing and elaborately folkloric.

20    Pantares' victory: Moretti (1957), no. 151.

21    See esp. Adornato (2008). On the inscription and the statue group, see also Rolley (1990). Scott ([2010], 89–90 and n. 76) accepts the interpretation of

Rolley (favoured by Adornato) that the statue group was originally dedicated by Hieron in the 470s, and then rededicated by Polyzalus (in the 470s); cf. Maehler (2002). Both Scott and Adornato see in the reinscription an attempt to rewrite history (though not necessarily a sinister one), since the dedication at Delphi, like Hieron's at Olympia, 'were altered over time to reflect the current political reality' (Scott, 90). Adornato thinks that Polyzalus is deliberately trying to appropriate and change the function of the monument to a votive offering. See now also Bonanno (2010) 56–61, who thinks that Polyzalus was ruler in Gela, but that (once Polyzalus was in exile and neutralized) Hieron changed the inscription to fit his propagandist needs of rejuvenating the image of Deinomenids.

22   Compare, on the one hand, Brosius (1996), 38–9, on the Elamite kings and the passing-on of wives to pass on legitimacy, and, on the other, the Seleucid Laodice IV, who may have been married to each of her three brothers (Brill's *NP* s.v. Laodike II 8), although it may be that we have more than one woman (see Boiy [2004], 159).

23   On Demarete and the Demareteion, see further L. Mitchell (2012).

24   Luraghi (1994), 322–5, argues for succession at Gela from Gelon to Polyzalus.

25   Hieron had refounded Catane as Aetna: Diod. 11.49.1–2; Pindar, *Pyth.* 1.60; Strabo 6.2.3.

26   See Corcella (2007), 689.

27   See esp. L. Mitchell (2012).

28   See esp. L. Mitchell (2012).

29   See further below.

30   Corcella (2007), 692.

31   B. Mitchell (2000), 92; see also Corcella ([2007], 721) who suggests Herodotus' *Battou* may be a genitive of possession (rather than a patronymic), and so simply indicating Pheretime was the wife of Battus III. See also L. Mitchell (2012).

32   Just (1989), 76–9; cf. Pomeroy (1975), 64. See also Humphreys (1988), 479–81; Cox (1989).

33   Cf. Cox (2011), 240–2.

34   See *APF*, 18 and n. 1.

35   The Athenian Cimon is said to have married his sister, Elpinice: Plut. *Cimon* 4.7; see also *APF* 302–3.

36   See esp. Wilgaux (2011) on women as 'the place where male bodily substances meet, and mix and take effect'.

37   See Mélèze Mordzejewski (2005), 351.

38   Finkelberg (2005), 93.

39  Hodkinson (2000), 410–13. Pomeroy (2002), 74.

40  Hodkinson (2000), 410–11.

41  See further Chapter Two.

42  Hodkinson (2000), 412,

43  Cartledge (2002), 294

44  Pomeroy (1997), 35; Scheidel (2011).

45  Fol and Marazov, however, suggest there was also a religious dimension to these marriages as Orphic hierogamies, completing the ritual of war: (1977), 53–4. One difficulty here is that the Orphic hierogamy was incestual (Theodossiev [1994]), which was clearly not the case for Philip.

46  Diodorus says that Arybbas ruled for ten years (Diod. 16.72.1). He had close connections with Athens (RO 70), where he fled after he had been expelled from Epirus by Philip II of Macedon (possibly in 343/2); Philip put Alexander (I), the brother of Olympias on the throne (Justin 7.6.12, 8.6.4–8; cf. Diod. 16.72.1). Plutarch (*Alex.* 2.3) says Arybbas also arranged the marriage between Philip and Olympias, but calls him Olympias' brother. Since, according to Carney (2006, 147 n. 13), Philip married Olympias between 342 and 339, Plutarch seems to have mistaken Arybbas for Alexander.

47  Finkelberg ([2005], 91–9), builds on Gernet (1981), 289–302, to argue that the patterning of Dionysius' marriages found its origins in Bronze Age practices, and that his Locrian wife was an *endogamous* marriage, while the Syracusan was *exogamous* (which gave Dionysius sovereignty over the land). Although the argument is ingenious, it assumes that his Syracusan wife was indigenous. There is nothing in the Sicilian evidence to suggest this, and it is based upon a comparison with Herodotus' comments on the colonization of Ionia.

48  Rhodes and Osborne (2003), 352; Carney (2006), 9–11 *passim* and 143 n. 41.

49  See *APF* 448–9.

50  On Coesyra, see Lavelle (2005), esp. 134–6.

51  Lavelle inclines towards a polygamous arrangement, but also discusses the possibility of Peisistratus renouncing the marriage with Timonassa as a political strategy when he married Megacles' daughter: (2005), 203–9.

52  On the wives of Peisistratus and the status of their children, see Gernet (1981), 291–2; Ogden (1996), 45–6; cf. Rhodes (2003), 225–6. For an important discussion of marriage in ancient Greece, see Vernant (1980), 45–70.

53  Brosius ([1996], 35) thinks that this comment is meant to show distaste and lacks understanding of Persian customs (though she also concedes that the Persian kings *were* polygamous).

54  Pomeroy (1997), 55. Cf. Ogden (1996), 238–45.

55  See esp. MacDowell (1978), 89–90.

56  MacDowell (1978), 90.

57  Gernet (1981), 289–302. On the other hand, he argues that polygamy had no place within the egalitarian and abstracted structures of the *polis*. Instead he sees tyranny as an archaizing phenomenon which 'reintroduced or kept alive concepts and practices that within the complex of the city had lost their meaning' (301).

58  Lewis (2009), 64.

59  On Jason and the *tageia*, see Sprawski (1999), 23; id. (2006), 138–9. On the *tageia* and its relationship to the Thessalian archonship more generally, see Helly (1995), 13–68, 329–58 with Sordi (1997), 177–82; Rhodes and Osborne (2003), 222–5.

60  The other reason given by Xenophon was that Alexander had killed his young lover whom he had imprisoned (who may have been Thebe's brother: cf. Plut. *Pelop.* 28.10).

61  Beloch (1923), 81–3.

62  Cf. Westlake (1935), 155.

63  Ogden (1999), xxix–xxx. On amphimetric families, see also Ogden (1996), 19–21, cf. 196–9 (on amphimetric tensions in Greek tragedy).

64  See Sprawski (2006), 139.

65  See Helly (1995), 352–3; Sprawksi (2004), 499–50. Compare Sordi (1958), 191–234, esp, 205–7, who thinks that Pelopidas was trying to establish a Thessalian confederation on an entirely new basis.

66  It is just possible that Jason was Alexander's son from a third marriage, although if this was the case it is surprising that none of our sources tell us so. Thebe could conceivably have married a half-brother, especially since the relationship was homopatrial.

67  That Philip was elected either or *tagos* or *archōn* (almost certainly the latter rather than the former) seems evident from Diod. 17.4.1, where Alexander prevails on the Thessalian assembly to confer on him by common decree of the Thessalians *hēgemonia* inherited from his father (*patroparadotōn hēgemonia*). For Philip's election: Hammond and Griffith (1979), 220–4.

68  Philip did single out Alexander as his heir, at least by the time the boy was sixteen (Plut. *Alex.* 9.1), and his statue, significantly, was included together with his mother's in the Philippeium (Paus. 5.20.9–10; cf. 17.4).

69  Müller (2010), 179–82.

70  On Cleomenes, note the comments of Ogden (1997), 124–5. On Cleomenes' madness, see Griffiths (1989).

71 On chrological issues, see Rhodes (2003), 199, 227.

72 Lane Fox (1985).

73 Cartledge (1987), 100.

74 There was also a dynastic monarchy on Thera, descendants of the probably mythical Theras who was said to have settled there from Sparta (Hdt. 4.150.2). Theras, according to Herodotus, was a Cadmeian (so Theban), but also, as the maternal uncle of Eurystheus and Procles, the twin brothers who founded the Spartan dyarchy, he had held the *basileia* in Sparta as their guardian when they were children (4.147.1–2).

75 In the fragment of Aristotle the name of the last king is given as Battus. See esp. B. Mitchell (2000), esp. 95–6.

76 Battus I is called Aristoteles at Pindar, *Pyth.* 5.87.

77 In the *Iliad*, the story of Pelopid succession is simple and matter-of-fact, and there are no hints of the dark, troubled and bloody story that was to become widely known in the fifth-century story: Kirk (1985), 126–7. In this alternative version, which was known to epic but not used in the *Iliad*, brothers quarrel over who has the right to rule, which results in multiple murders which must be avenged through the generations (Aesch. *Agam.* esp. 1243–6, 1577–611; cf., e.g. Apollodorus, *Epitome* 2.10–14). It is telling, however, that such stories came to be told about tensions over succession, even ending in regicide.

78 Brosius ([1996], 38–9) produces Near Eastern parallels for succession between brothers.

79 L. Mitchell (2007b); cf. Anson (2009).

80 Borza (1990), 161

81 Similarly, in Thrace the unity of the kingdom of the Odryssian Thracians was always precarious (Herodotus says of the Thracians generally that if they were ruled by one man or could follow a single purpose they would be unbeatable: 5.3.1). In the fourth century, it was held together by the personal forcefulness of individual kings, but easily collapsed into individual *archai* (e.g. Dem. 23.8, 170).

82 Aloni (1997); id. (2001); Jung (2006), 237–41.

83 See especially Cartledge (2002), 293–8 (noting that he retains the reading of the MSS at Hdt. 8.131.3, which say that all the list given at 8.131.1–2 except the *two* generations after Leotychidas were kings, whereas Hude, the editor of OCT, accepts the emendation of Paulmier to seven generations).

84 A comparable situation existed in medieval England where the office of 'kingship' encoded in law was more significant than individual rulers, and allowed difficult transitions between rulers without bringing down the state: see Ashe (2013) and Musson (2013) with Mitchell and Melville (2013).

85    More likely, the dyarchy arose out of two tribes gaining ascendancy over the others.

86    In the fourth century our sources also indicate there was some kind of partnership between Daochus, Thrasydaeus and Cineas (Dem. 19.295; Marysas, *FGrHist* 135 F 20; Polyb. 18.14.4), although it is not clear which position(s) they held. Sordi (1997, 178) guesses that Daochus was an *archōn* of the *koinon* on the grounds that the *tageia* was reserved for emergencies, comparing the role of *tagos* with *stratēgos autokratōr*.

87    See esp. Shipley (1987), 68–72.

88    Forsdyke (2005), 66–7. Shipley (1987), 72.

89    See, however, R. Osborne (2009), 258–65.

90    That he was not ruler of Gela, at least for a time, may be suggested by the fact that he seems to have been forced into exile in Acragas (Diod. 11.48.5).

91    Bonanno (2010), 103–24.

92    Cf. Carney (1983).

93    Hammond and Griffith (1979), 208; Ellis (1973); id. (1976).

94    Weber (1947), 364–6.

# Rulers in the *polis*

It is often assumed that the apparent republicanism of the *polis* excludes a ruler, and where a ruler existed in a *polis* he was extra-constitutional.[1] For Aristotle, in particular, the *polis* was a community of equals, who ruled and were ruled in turn (e.g. *Pol.* 1.1259b4–6, 3.1279a8–13),[2] and, although he could imagine contexts where a ruler might be possible, it did not fit very happily with his model. In fact, from the very beginnings of the *polis* there was obvious tension between the needs of one-man rule and the rule of all or the rule of the few. As we have already discussed in an earlier chapter, this tension resulted from the egalitarianism which was fundamental to elite politics of the archaic period coupled with the intensely agonistic nature of Greek society which pulled in the other direction to privilege one man above all the rest. As the best man in the community, rulers were placed at some level in an isolated position, which sometimes has been compared to the vulnerable space occupied by the scapegoat.[3] To rule alone brought the envy of one's peers. In a fragmentary poem, the seventh-century Archilochus congratulates an unknown conqueror:

> this city … you turned about …
> these men have never yet been pillaged, but now
> you have taken them in battle and have won fame.
> Rule (*anasse*) this place and hold the tyranny (*tyranniē*):
> For surely you will be envied by many among men. (fr. 23 West *IE*)

Resolving this tension between ruler and ruled involved constant negotiation in order to create and maintain civic harmony.

This chapter will comprise two main sections. In this first part we will look at two areas, both of which had cosmic significance, where rulers' roles were put under pressure and rulers were forced to change their strategies for ruling as a result of the development of the *polis*: that is, in the relationship between the ruler and the religious life of the *polis*, and the ruler and the rule of law.

We will see that ideas about how rule should be shaped and how competition should be played out changed as a result of new ideas about religious space and abstract law, but that rulers and ruling ideologies were adapted so that rulers could continue to have a place in the *polis*, and both ruler and *polis* could be accommodated. In the second half of the chapter, we will put this discussion into a constitutional focus and consider specific case studies where rulers existed alongside other bodies with which the ruler shared sovereign power. In this way we will be able to see the ways in which the political needs of the community and the ruler could both be met in the context of the *polis*, and the challenges that faced both ruler and the community.

## Ruling prerogatives

Fierce competitiveness and envy of those who were successful in proving their heroic qualities meant that just as rulers had to prove continuously by their heroic activities that they had the right to rule, there were also other political stakeholders, such as other members of the elite in councils or assemblies, that were trying to place limits on the powers of the rulers in order to maximize their own political positions. Of course, the battles that resulted did in some cities end in the degeneration of the position of the ruler, especially when the ruler was weak. However, we have also seen that a number of ruling families were able to resist this pressure for a number of generations. The most successful of all were the Spartan dyarchs, who by working with the pressures from other institutional bodies survived down to the third century BC.

One area where it is often assumed that rulers were supplanted in the *polis* or became irrelevant was in cult. In an earlier chapter we saw how in the Early Iron Age rulers' houses were the religious centres of the community, and rulers seem to have been the officiators at the sacrifice and in the ritual dining.[4] In fact, Mazarakis Ainian says that the control of cult was one way that 'chiefs' 'could maintain their leading position, which aspirants for power were ready to challenge.'[5] Further, it has often been said that the move towards communal sanctuaries and monumental temple-building reflects a new emphasis on the communal nature of religious organization.[6] Snodgrass assumed that the building of a temple dedicated to the patron god of the city

was the defining moment when a community became a *polis*.[7] Together with this view it is also said that this was the moment when rulers disappeared from the political landscape of the *polis*.[8] As Snodgrass puts it, 'the god has taken over the monarchy.'[9]

However, the building of temples does not mean that rulers' religious responsibilities were curtailed, only that they changed. Indeed, the shift from ruler's house to temple was not necessarily clear-cut, and did not necessarily mean that the rulers' responsibilities in this area were undermined. Morgan, for example, argues that the motivation for temple-building was often more complicated than a change from houses of men to houses of gods might suggest, but that there were other considerations, especially economic ones, to explain the beginnings of temple construction.[10] Jonathan Hall also makes the point that it is not always easy to tell whether the building of a temple sprang from the collective effort of the community or 'the ability of a powerful individual to mobilize labour and resources.'[11]

Indeed, despite the expense (or perhaps because of it),[12] like their Near Eastern counterparts many rulers were temple-builders:[13] for example, Cypselus and Periander both probably built temples at Corinth and Isthmia, the Peisistratids built temples and altars at Athens (including the incomplete Olympieium), as did Gelon and Hieron in Sicily. For the most part it seems that rulers retained the responsibility for cult, and in many communities the ruler retained the role of the primary cult officiator. When the sixth-century Cyreneans limited the role of Battus III with the assistance of the lawgiver Demonax of Mantineia, Herodotus says that only the *temenea* ('royal lands') and the priesthoods were preserved for the *basileus* (Hdt. 4.161.3). It is also significant that Gelon of Syracuse held the hereditary priesthood of Demeter and Kore, who were the principle deities for Sicily (Diod. 5.2.3),[14] to which priesthood Hieron succeeded on Gelon's death (Hdt. 7.153–4; Pindar, *Ol.* 6.94–6).[15] It is also significant that, as well as their involvement in temple-building, the sons of Peisistratus organised the Panathenaea, which provided the context for the assassination of Hipparchus. At Macedon, Briant argues that if the role of the *basileus* could be reduced to one function, it would be that of 'chief priest' (cf. Arrian, *Succ.* 38 on Philip Arrhidaeus),[16] and at Sparta, as we shall see, it was important that the dyarchs were true descendants of Heracles in order to complete the sacrifices satisfactorily.[17]

The maintenance of civic order was another traditional area of *basileia* that came under pressure, forcing rulers to adapt their roles and their ideological positioning. In Hesiod's world, the authority of the *basileus* derives in the first instance from Zeus. For Hesiod, Zeus is *basileus* (*W&D* 169, 668, *Theog.* 886), and father by Themis (Divine-Ordinance) of Eunomia (Good-order), Dike (Justice), and Eirene (Peace) (*Theog.* 901–2; cf. *W&D* 256), who distributed the laws (*nomoi*) (Hesiod, *Theog.* 73–4). Zeus not only was the arbiter of justice (*dikē*) (Hesiod, *W&D* 238–47, 256–85), but also the provider of a framework of order where the weak should not be oppressed by the strong (Hesiod, *W&D* 202–47, 267–73).[18] In fact, Hesiod says that *basileis* are from Zeus (*Theog.* 96), and in Homeric epic the authority of the *basileis* is drawn from the fact that it is Zeus who gives them the sceptre and the *themistes* (*Il.* 2.205–6, 9.98–9).[19]

Thus the ruler as a leader of the people should provide straight judgements. In the *Theogony* (75–94) Hesiod says that at the birth of *basileis* the Muses pour sweet dew on their tongues so that soothing words might flow from their mouths. As a result, the *basileus* settles causes with straight judgements (*itheiai dikai*), and speaking without faltering, he at once makes an end skilfully to even a great argument. Therefore, *basileis* are prudent (*echephrones*), wherefore they can easily turn everything around when the people in the assembly are misled, encouraging them with soft words. And when he goes through a gathering they propitiate him as a god with soothing reverence, and he is distinguished among those assembled.[20]

As upholders of *dikē*, that is, the right order of things (e.g. Pindar, *Pyth.* 1.86, Eur. *Electra* 876–8; Isoc. *To Nic.* 18),[21] part of the ideological importance of rulers had traditionally been to provide the conditions for political well-being and good order, *eunomia*, within the city.[22] Malcolm Schofield has demonstrated clearly the importance of *euboulia*, 'excellence in judgement', as an element in the Homeric heroic code, where good leaders both gave good counsel and were also prepared to receive it.[23] The good ruler, through his good government, also brought prosperity. Odysseus says to Penelope that her fame reaches to broad heaven:

> as does [the fame] of a blameless *basileus*, who, being god-fearing and
> ruling over many stout men,
> upholds good order (*eudikia*), and the black earth bears
> wheat and barley, and the trees are heavy with fruit,

and his sheep give birth without fail, and the sea provides fish
because of his good government (*euēgesiē*), and the people prosper under him.
(Hom. *Od.* 19.109–14)

However, during the course of the archaic period there developed an
abstract sense of law and of constitutional order which stood apart from the
judgements delivered by rulers. It was around the seventh and sixth centuries
that the laws of the *polis* were physically recorded, probably as a consequence
of the need to codify norms and to regulate the activities of magistrates in the
context of the developing *polis*.[24] On one level, the need to write down laws
was a reflection of the disaffection created by those who, like Hesiod's *basileis*
(*W&D* 248–64), transgressed norms of acceptable behaviour and exploited
relationships, were 'gift-devouring' (*dōrophagoi*), and, through their violence
devoid of justice, lay themselves open to the punishment of Zeus (*W&D* 38–9,
202–64).

Law-making, on the other hand, was about creating an objective standard
for behaviour which reflected and was in line with a god-given order. So for
Hesiod the judgements of men are monitored by Zeus, and Solon, for whom
Good Law (*Eunomia*) makes everything orderly and fitting (fr. 4.32 West *IE²*),
calls on Black Earth, the mother of the gods, to bear witness that he wrote laws
(*thesmoi*) for both the bad and the good, having fixed straight justice to each (fr.
32 West *IE²*). Further, as part of the developments in the rationalizing and critical
understanding of knowledge and the cosmos, some cosmologists had come to
view law, *nomos*, as integral to an external cosmic harmony, which was available
to be rationally understood and diagnosed.[25] Heracleitus makes the connection
between divine law and the laws of the city explicit when he says:

> It is necessary for those who speak with sense to use all their strength for the
> common cause of all, just as even a city is strengthened by law. For all human
> laws are nourished by one law, the divine law; for it rules as much as it wishes,
> is sufficient for all, and is superior (DK 22 114).[26]

Abstract law had precedence over the mortal purveyors of law. In the Orphic
tradition cosmic justice followed closely upon Zeus, for *Nomos* is Zeus'
co-adjudicator, his *paredros* (fr. 247 Bernabé), and for Pindar *nomos* had
become *basileus* (fr. 169).

So it became axiomatic that law should rule, since only an external and objective law would provide equal justice for the rich and the poor, and rulers themselves had to be subject to law, although that did not necessarily mean the rulers were not or could not be lawgivers. Pittacus we know wrote laws, as also it seems did Periander of Corinth, especially concerned with civic order and the constraint of excess.[27] However, as we have seen, rulers such as Peisistratus were also known for not disturbing the existing laws. The Orthagorids likewise had a reputation for being 'slaves to the law in many respects' (Arist. *Pol.* 5.1315b15–16).

Nevertheless, leadership and the provision of order were also locations for considerable contestation. This tension between *basileus* and law is most evident from about the seventh century in the appointment of external lawgivers, who could stand in place of *basileis*. The situation at Cyrene provides one of the best examples of the depth of the tension between *basileus* and *nomos*, and the right to rule. The *basileia* seems to have weakened under Arcesilas II, who (according to Herodotus) quarrelled with some of his brothers (who went off to found Barce),[28] was defeated by the Libyans and was murdered by another brother, who was in turn murdered by Arcesilas' wife (Hdt. 4.160). In the reign of his successor, Battus III, who Herodotus says was lame (although Herodotus' story suggests that his rule was lame),[29] the citizenry (which Chamoux and Mitchell think must have been dominated by the old Theran aristocracy)[30] imposed controls upon his authority. The Cyreneans (on the advice of Delphi) were able to insist on the interventions of Demonax from Mantineia as a 'mediator' (*katartistēr*) to restructure the constitution, and limit the sovereignty of the *basileus* to priestly functions; 'everything else which had formerly had been the prerogatives of the king, Demonax gave to the *dēmos* for all' (Hdt. 4.161).[31] Battus' successor, Arcesilas III, who was married to the daughter of Alazeir, the *basileus* of Barce, attempted to forcibly regain some of these lost powers, and first went into exile after a period of civil war, returned to Cyrene with Samian support, went into exile again, and then was assassinated in Barce (Hdt. 4.162–4). His mother Pheretime, with Persian assistance, re-secured the *basileia*, which survived for another two generations, though eventually collapsed under pressure from the Cyrenean aristocracy.

The interference of Demonax of Mantineia represents a particularly important element in the negotiations at Cyrene over who should rule and

in what way. In the first instance it is important that the Cyreneans were able to impose their will over that of their *basileus*. It is also significant that they chose to do that through a lawgiver brought into the city from outside. The use of external 'lawgivers' such as Demonax was not unusual in archaic Greece.[32] These men were appointed to come into communities temporarily with full powers, and then left (notably Solon left Athens rather than stay to become *tyrannos*). As McGlew has shown, it was important for the autonomy of the law that the lawgiver did not remain in the community and so was separated from the laws.[33] In this way the fiction could be maintained that law was eternal and divine, while at the same time recognizing its human and mortal nature, along with its essential rationality.

As in the tradition of the *basileis*, the lawgivers' role was concerned with political order and arbitration to find political solutions within communities. Just as Lycurgus restructured the political order at Sparta, so did Demonax at Cyrene, creating new divisions and systems within the political body (Hdt. 4.161.3), although Demonax did not seem to be concerned with introducing a law code such as those attributed to Solon and Lycurgus. But in bringing Demonax to Cyrene to restructure and effectively refound the city, the *basileus* and his responsibilities were fundamentally undermined.

On this level, lawgivers were aligned with city-founders, as we have already seen in an earlier chapter. Their law, while formulated by mortals, created an order which, while local to the city, in some sense still reflected the divine order of Zeus – Lycurgus' laws were thought to have been the basis of Eunomia in Sparta, and Solon says in his poetry that his laws brought Eunomia and put an end to disorder. As a lawgiver – a refounder – Lycurgus received cult at Sparta (Ephorus, *FGrHist* 70 F 118). At the end of the fifth century, Diocles of Syracuse, one of the elected lawgivers to revise the laws of the city, was also honoured not only with heroic honours on his death, but also a temple built at public expense (Diod. 13.35.1–2).[34] On this same basis, lawgivers were also like rulers, and importantly some rulers were lawgivers, especially when they were also city-founders.

Yet the abstraction of law (*nomos*) became central to the legitimacy of rule. By the late fifth century the Persian Cambyses, who invented laws to suit himself (Hdt. 3.31.1–5), became the stereotype of the *monarchos* who ruled only to please himself (Hdt. 3.80.2–5). It was to become central that authority

was based on the spontaneous and willing acceptance of the rule of law (e.g. Plato, *Laws* 690b–c). The complaint that Pheidon of Argos was a *basileus* who became a *tyrannos* seems to be based on the idea that he overstepped this mark (Arist. *Pol.* 5.1310b23–27; cf. Hdt. 6.127.3 – though at this point we are dealing with someone around whom an invented tradition, even multiple traditions, has arisen, and the real Pheidon has been lost in the tyrannical stereotype).[35] The Spartan Agesilaus realized that it was important that he was, and was seen to be, a ruler under law, by which he meant be answerable to other constitutional magistrates – or at least Xenophon could see he needed to be represented that way.[36] Even Alexander the Great had to make an appearance that he was willing to respect law in his dealings with the Greeks, at least in the earlier years of his reign. It is significant that Agesilaus turned down the possibility of being deified in his own lifetime, while Alexander took a different route.[37] Currie has argued that the dangers of tyranny were thought to lurk behind the deification of living men, which ran the risk of placing them above law.[38] The issue of ruler and his relationship to law, already prefigured in the fourth century,[39] was to become a predominant concern of Hellenistic political thought.[40]

## Constitutional rulers

To rule under law meant for the most part to be answerable to other offices of state, as opposed to holding power absolutely. In practice, this meant that for rulers to be successful and effective, they had to come to terms with other groups within the community that wanted a share in power. In some cities, this resulted in magistrates sharing power in turn, as at Athens or Dreros, or responsibility for creating order being devolved to different agencies. This may be what we see has happened on the Shield of Achilles, where a disagreement between two disputants is being settled by the elders (*hoi gerontes*) rather than a *basileus*, although there is very little agreement among commentators about how this scene should be interpreted.[41] As Stephen Todd writes: 'all we know is it represents one way in which one dispute could be settled in one community which one poet was able to create in his imagination.'[42] Certainly, as we have seen above, Hesiod's *basileus* also 'settles claims with straight judgements'

(*Theog.* 85–6), so in the Shield of Achilles we are unlikely to be seeing a general evolutionary shift from ruler to council.

In fact, even when there was a ruler in place, arbitration could be devolved onto other bodies and officials. At Athens, during Peisistratus' period of rule, the Areopagus tried cases of homicide (*Ath. Pol.* 16.8), and it is likely that other cases could be tried by the archons, as seems to have happened in Solon's time (*Ath. Pol.*3.5), since Peisistratus probably maintained most of Solon's institutions (Hdt. 1.59.6; Th. 6.54.6).[43] Peisistratus himself created the position of *dikastai* for the demes (*Ath. Pol.* 16.5), who may have replaced local arbitration provided by the nobility with magistrates from the central administration.[44] Also at Sparta, the ephors, rather than the dyarchs, had responsibility for 'great judgements' 'on their own discretion' (*autognōmenes*) – though it would be better, Aristotle says, if they had made their judgements according to written law since the ephors were only ordinary men (*hoi tychontes*) (*Pol.* 2.1270b27–31).[45]

It is often said that *basileis*, with their traditional prerogatives, were 'constitutional', at least in the sense that their positions were embedded in the systems of governance, whereas *tyrannoi* held power unconstitutionally, or extra-constitutionally. On the basis of a stereotype of 'Asiatic' rulers, of whom Herodotus' Cambyses was the most extreme example, unconstitutional rule is also often equated with absolute rule. Absolute and unconstitutional rule are then often produced in our sources as defining features of rule by one man, a prejudice which has filtered into modern discussion of individual rule in the Greek world, and of tyranny in particular. In the second part of this chapter, we need to think about why there was such suspicion in our sources that one-man rule would be unconstitutional, and probe the issue of absolute rule in order to question how absolute it really was, before turning to consider the constitutional structures within which and alongside which rule in archaic and classical Greece could be situated.

## Absolute and unconstitutional rule?

It is certainly the case that some Greeks had deep concerns about the possibilities of a sole ruler who might hold uncontained power without regulation.

To some degree this concern about individual rulers was probably reinforced by the charismatic, but erratic, rule of Zeus. In Hesiod, Zeus has the right to distribute honours because of his in role in the gods' victory over the Titans (*Theog.* 881–5), but in Homer's *Iliad*, the sovereignty of Zeus is represented more as omnipotent and unavoidable than positive. Zeus is Lord (*anax*: e.g. *Iliad* 1.502, 2.102, 7.194), he rules the gods on Olympus (*Iliad* 1.494–5), and oversees all mortal things, but with his arbitrary scales weighs not justice but the turn of events (*Iliad* 8.68–72, 16.657–8). He is unpredictable. He hands out good and evil to all men from jars upon his floor (*Iliad* 24.257; cf. 10.71), determines how men will behave (e.g., *Iliad* 6.234), and can give men courage or take it away (*Iliad* 20.242–3).[46]

The ambivalence of Zeus as an erratic *basileus* is probably reflected in the concern in a number of our ancient texts about what might happen when one man rules alone. Lack of restraint, the excesses of unbridled passions and the inability to control them, was something to be feared. Particularly at Athens, in the intellectual mood of the second half of the fifth century, there was pessimism about the possibilities and dangers of human nature when left to its own devices. Herodotus, in the fifth century, characterized the rule of one man in the Constitution Debate in terms which were to echo around fourth-century political thought. The Persian Otanes argues:

> It seems to me that the Persians ought not have one monarch (*monarchos*); it is neither good nor desirable. For you have seen the extent to which Cambyses went in violence (*hybris*), and you have shared in the violence of the Magian. How could monarchy be suitable, when it is possible for him, unaudited (*aneuthynos*), to do whatever he wishes? For it would place even the best of all men who was in this position outside his accustomed thoughts. For violence grows in him on account of his advantages, and envy is ingrained in men from the beginning. In having these two things he has every evil. For glutted with these things, he does many reckless deeds out of both violence and envy. (Hdt. 3.80.2–4)

Sole and unregulated rule (which was therefore outside law), it was thought, could only lead to excess. Phalaris of Acragas, who was said to have burned men in a bronze bull, was a byword for violent tyranny (e.g. Pindar, *Pyth.* 1.95–8). Dionysius I was accused of many atrocities, particularly against the cities which he captured in war (e.g. Diod. 14.40.1, 65–9). It was also supposed

sole rulers would suppress or eliminate opposition: the story of Thrasyboulos'
advice to Periander to cut off the heads of corn was notorious in antiquity (e.g.
Hdt. 5.92ζ; Arist. *Pol.* 3.1284a26–33; note also Eur. *Suppl.* 447–449; compare
Xen. *Hieron* 2.17–18). For Aristotle the worst kind of tyranny was rule for
the advantage of the monarch, who ruled the unwilling without regulation
(*Pol.* 3.1279b5–6, 1285a14–28 at 18–20, 4.1295a17–23, 5.1311a2–4). While
Aristotle concedes that *basileis* need bodyguards in order to make sure law
is enforceable (Arist. *Pol.* 3.1286b27–40), he says a *basileus* was protected
by citizens and the law, but a tyrant needed a *foreign* bodyguard (Arist. *Pol.*
3.1285a24–9, 5.1311a7–8; cf. Arist. *Rhet.* 1.1357b30–36; Xen. *Hieron* 6.10;
Plato, *Rep.* 8, 566b, 567d).[47]

Criticism of these ancient sources has not been helped by modern preoc-
cupations with totalitarianism, and late medieval/early renaissance theories
of absolutism,[48] and many modern commentators have tended to assume
that this ancient preoccupation with the excess of sole rule reflects a political
reality in which many ancient rulers ruled absolutely and unconstitutionally.
Yet it has now long been understood by sociologists and medieval historians
that even the rule of the seventeenth-century Sun King himself, Louis XIV,
who proclaimed himself an absolute ruler, was not uncontested, or was not as
absolute as he and his propagandists claimed.[49]

In the ancient world also, we need to take care about assuming that sole
rule was absolute. In his important study of Hellenistic courts, Gabriel
Herman, argues that the Hellenistic monarchs, like Louis XIV, did not have
absolute power. He writes:

> If one shortsightedly regards the Hellenistic king's position as entirely defined
> by his formal rights, he indeed appears absolute: possessed of unlimited means
> of action, he was subject to no control, and his decisions could not be appealed
> against to any other person or body. There was, however, a striking contrast
> between this legal definition of his position, and his standing within his
> immediate milieu. In his social existence, his freedom of action was curtailed in
> more than one respect. He was enmeshed in a network of dependencies centred
> on the court, and could preserve his position only by skillfully outmaneuvering
> the factions and coalitions that were constantly coalescing with the intention of
> bringing him down. To succeed in this, he was constrained to resort to a series
> of long-term strategies and to some improvised, short-term ones.[50]

Ruling for the Hellenistic kings comprised a series of negotiations of power, where something was given and something received. In the Hellenistic world, Herman set these sequences of negotiations within the networks of friends, *philoi*, and makes the important point that the Hellenistic kings may not legally have been answerable to anyone, but they were still accountable within a network of connections that could carry political weight.

The same was true for Alexander the Great, who pushed at the boundaries of what he could get away with. Although there was increasing concern, at least in our sources, that he was becoming too much like an absolutist Persian King,[51] even his will could be resisted, as the 'mutinies' at the Hyphasis and Opis make clear. Alexander's Companions, the *Hetairoi*, acted as his advisers, but also represented a serious check on his actions. Because of their resistance, he was not able to introduce *proskynesis*, obeisance, as he had wished (e.g. Arrian, *Anab.* 4.10.5–12.5; Plut., *Alex.* 54.3–6). Alexander may have killed one of his Companions, Cleitus, but he also had to make an elaborate and public show of grief and regret in order to live it down (Arrian, *Anab.* 4.8.1–9.8; Plut. *Alex.* 50.1–52.7). As his career progressed, it is quite clear that Alexander did try to extend what he could get away with without complaint. However, as the attempts at assassination show, as well as the mutinies, there were limits to what he could do without constraint.[52]

Elsewhere we can also detect similar patterns of court-communities which could offer a base of support for a ruler, on the one hand, but also acted to restrain. In Homeric epic, Alcinous' Phaeacia is ruled by twelve *basileis*, with Alcinous as the thirteenth (*Od.* 8.390–1). However, he is also answerable to them, and they have the right to summon him to meetings of the council (*Od.* 6.53–5).[53] In historical time, the Spartan Agesilaus was also sent on campaign with thirty Spartiates (Xen. *Hell.* 3.4.2), who acted as his advisers (Diod. 15.33.1) and who were replaced on an annual basis (Xen. *Hell.* 3.4.20), presumably so that they could not become a power base for the king. As we have considered in earlier chapters, the very nature of ruling, based as it was on the family (so that the inner family were often responsible for rule) also acted to restrain individuals, and could result in co-ruling, especially where there were jealousies and tensions over which members of the family should predominate. Dionysius of Syracuse had a circle of *philoi*, friends, who acted as his council (Diod. 13.111.1, 14.8.4, 61.2), much as did Alexander the Great,

even if membership of this group was reasonably precarious (Diod. 14.101.2, cf. 13.91.4 [Philistus; cf. Plut. *Dion* 11.4–12.1], 15.7.3–4, 17.1 [Leptines]). Dion was almost certainly a member of this inner circle, as he probably was at the court of Dionysius II (Plut. *Dion* 6.3–4), although he was later exiled and returned to supplant the younger Dionysius.

In fact, despite the stereotype of sole rule, rulers generally were accountable to or ruled in conjunction with assemblies and councils, even if the councils were drawn from the elite. Even in epic councils of 'elders' supported Hector and Alcinous (Hom. *Il.* 3.146–53; *Od.* 8.390–1), and assemblies could be summoned, if only at the behest of the *basileus*.[54] In the historic period Cyrene is a good example of a council or assembly acting as a counter-balance to the ruler, since it must have been either an assembly or a council which summoned Demonax of Mantineia to reform the powers of the dynast (cf. Hdt. 4.161.1), and even after Arcesilas III was able to reject these reforms he still ruled together with a *boulē* (Hdt. 4.165.1; note also [late fourth century] *SEG* 9.1.16–19). This also seems to have been the case at late seventh-/early sixth-century Mytilene, where there is evidence of a council and an assembly (fr. 130.18–21, 306 Lobel and Page *PLF*) which presumably elected Pittacus to office. It is not clear how much power the assembly may have had, although Kurke makes the point that even the assembly in the *Iliad* could vote with its feet if nothing else.[55]

Indeed, rule by one man seems to have been made more acceptable if it was balanced by an assembly, even if only of limited function. Even Dionysius I was elected by the Syracusans as *stratēgos autokratōr* on the grounds that Gelon had also been elected with full power to deal with the Carthaginians (Diod. 13.95.1–3; cf. Plut. *Dion* 5.5). On his death, his son Dionysius II also summoned the assembly to ratify his position (Diod. 15.74.5).[56]

Further, although Diodorus says that Dionsyius openly declared himself as tyrant (13.96.2), this is probably unlikely as he was very careful to present himself as a constitutional ruler in official documents, styling himself as *archōn* of Sicily (RO 10, 33, 34), even if he was also willing to employ Eastern opulence to give a sense of his power.[57] Nevertheless, during Dionysius' long reign there is evidence of a functioning assembly and other constitutional machinery (Diod. 13.95.1, 96.3, 14.45.2–5, 65.4; cf. RO 35–7), even if he retained a tight hold on the decision-making processes.[58] Despite revolts

and resistance during his reign, especially from the Syracusan nobility (that is, especially the cavalry), it is wrong to assume that Dionysius ruled the completely unwilling. Although he had enemies put to death, he seems to have done that through the assembly (Diod. 13.96.3), and, although Diodorus says that there were a number of plots against him, as a result of which he was said to wear an iron breastplate (Diod, 14.1.2), it is also evident that he was able to 'work the crowd' on various levels, winning the majority of Syracusans over by rewarding achievements and hard work (Diod. 14.53.4, 70.3), and being willing himself to be generous in his treatment of those who opposed him (e.g. Diod. 14.105.3–4). In many ways, Dionysius' style of rule resembles that of Alexander the Great, and also Xenophon's Cyrus in the *Cyropaedia* – a telling comparison perhaps.[59]

If rulers were to find a place in the *polis*, then they needed to be constitutional in this sense, at least, that they found an accommodation with other mechanisms of rule. In the context of constitutional development, the division of rule between different locations of sovereign power seems from an early stage to have been a key feature of the Greek constitutional mentality, although it was not as joined-up or as successful in some constitutional formations as in others. In this way, individual rule might be limited, but it also needed to find a way to coexist with other, often more (or less) clearly defined, offices of governance.[60]

In the final part of this chapter we will consider two different case studies in order to highlight the vicissitudes and strengths of individual rule in a constitutional, or quasi-constitutional, *polis*. One case study will look at the Molossian *basileia* (which we have already seen could also tolerate co-ruling), and the other the Spartan dyarchy. These two systems are sometimes thought to be related in some ways (because of certain probably superficial similarities), but they also provide good examples to consider in detail, since one comes from the Greek heartlands, and the other from what is often regarded to be the edges of the Greek world. Both, at least in the classical period, putatively limited the power of the *basileis* (Aristotle gives this as the reason for their longevity: *Pol.* 5.1313a20–33), but the way this limitation was interpreted, and exercised, tells us a great deal about the nature of rulers and ruling in general, and how the Greek state could tolerate individual rule.

## *Molossia:* basileus *and* koinon

Our first case study comes from the fringes of the Greek world, Molossia. The Molossians were a tribe in north-western Greece. Thucydides regards the Molossians in the 420s as one of the northern barbarian tribes (2.80.6). Euripides, on the other hand, makes the Molossian royal house descendants of Neoptolemus and the Trojan Andromache (Eur., *Androm.* 1243–6).[61] By the fourth century, however, the Molossians presented themselves as Greeks and were generally (although not necessarily overwhelmingly) accepted as such.[62]

The Molossians had an ancestral *basileia* (Th. 1.136.2, 2.80.6; Cabanes e.g. 1.1–19 [= D 1], 1.20–32 [= D2]),[63] which they for their part traced back to Pyrrhus son of Achilles (Justin 17.3). Later traditions attributed Tharyps/ Tharybas/Arybbas with an Athenian education and said he brought Greek laws and institutions to the Epirote cities in the early fourth century (Justin 17.3.10, 12; Plut. *Pyrrhus* 1.4), although Davies thinks the use of the peculiarly west-Greek *damiourgoi* points to a more organic and indigenous development of the machinery of state, and that we should not take this tradition too seriously.[64] There must be something in the story, however, since later Arybbas was able to claim Athenian citizenship, which he inherited from his grandfather.

However, by the mid fourth century, decrees attest to the workings of an institutionalized *koinon*, and the Molossians, for their part, seem to have had an independent political personality. They issued coins from the early fourth century bearing the inscription ΜΟΛΟΣΣΩΝ ('of the Molossians'), although Alexander I issued coins in his own name for a short period while he was in Italy.[65] The bronze coins, at least, bear the head of Athena Parthenos, and Hammond thinks that they must have been issued as a compliment to Athens, probably in 375 BC.[66] In decrees dating from the 360s at Dodona, the *basileus* is named alongside officials, of which the *prostatēs* (leader) seems to have been the most important (Cabanes 1 = D1),[67] but also a *grammateus* (secretary), and other officials – in the first instance *damiourgoi* (Cabanes 1 = D1, D 2),[68] who seem to have been replaced by *synarchontes* (Cabanes 2 = D 4). In the earliest of these decrees (Cabanes 1 = D1, D2), the award is expressed in the passive (e.g. 'Philista the wife of Antimachus from Arrhonus was granted citizenship'), there is no mention of an assembly of the Molossians, and only

officials are named. Later decrees, however, (perhaps from the 350s–340s) are awarded by the *koinon* of the Molossians (Cabanes 2 = D4), the 'Molossoi' (Cabanes 3 = D6), and even the assembly of the Molossians (Cabanes 5 = D13). The *koinon* was apparently able to make grants of citizenship in its own name without reference to the *basileus* (e.g. Cabanes 2 = D4, *SGDI* 1334 = D12; Cabanes 5 = D13), as well as grants of *proxenia* and tax exemptions (Cabanes 6 = D9; cf. Cabanes 3 = D6).

It is probably significant that the earliest decrees we have do not mention an assembly. While it is likely that there was a federated structure at this point (the coinage would seem to indicate this; there must also have been a political mechanism for deciding and enacting the exile of the dynast, as was the case some time before 385 BC), it may be that there was only a representative council and not an assembly at this stage, as Davies suggests was the case during the reign of Neoptolemus.[69] The earliest clear evidence of an assembly enacting decrees does not appear before the reign of Alexander, who was himself put in power by Philip II of Macedon (see below), which itself raises questions about the relationship between dynast and *koinon*, and also seems to indicate that the role of the dynast was significant enough for Philip to interfere.

The relationship between the Molossian *koinon* and the *basileus* was reputed to have been close and respectful. Plutarch says that it was customary for Molossian *basileis* to swear each year that they would rule according to the laws, and for the people to swear in return that they would preserve the *basileia* according to the laws (Plut. *Pyrrhus* 5.5), though it is difficult to know when this oath was first introduced. Aristotle, on the other hand, as we have seen, attributes the long life of the Molossian dynasty to the moderation of the *basileia*, and limitations placed on its sovereignty (*Pol.* 5.1313a18–24). He also says that the Molossian *basileia* was based on the aristocratic ideal of private or family honour, since the Molossian rulers, like their Spartan and Macedonian counterparts, made foundations and acquired territory (*Pol.* 5.1310b31–40).

Nevertheless, it is also clear that the relationship between the *basileus* and his people was not always harmonious, as the rule of Alcetas I demonstrates. In 385, Alcetas was in exile in Syracuse, but was restored by Illyrians (Diod. 15.13.2–3), who had been armed by Dionysius I of Syracuse and who were

acting on his orders.[70] The Illyrians then turned against the Molossians and ravaged the country, killing 15,000 (which Hammond guesses must have included other Epirotes as well), before they were driven out by the Spartans, acting on the basis of an alliance that Hammond thinks was probably made in 386 at the time of the Peace of Antalcidas (and during the period when Alcetas was in exile), although at the time the Spartans were probably also allies of Dionysius.[71] Dakaris supposes that Alcetas had originally been expelled by a pro-Spartan group among the Molossians, and it seems reasonable to assume that the exile was enacted by decree of the *koinon*.[72]

It also seems that Alcetas was strong enough to develop an independent foreign policy, since in 375 (so after his restoration) he was both named as the subject ally of Jason of Pherae (Xen. *Hell.* 6.1.7), and appears with Neoptolemus (his son) as the only individuals named among the allies in the second Athenian naval alliance enlisted in 375 by Timotheus (RO 22).[73] In 373 he assisted the Athenians in making a crossing to Corcyra (Xen. *Hell.* 6.2.10–11), and along with Jason of Pherae supported Timotheus' defence at Athens ([Dem.] 49.10, 22–4). That Jason and Alcetas arrived together at Timotheus' house looking for accommodation suggests that the relationship between Jason and Alcetas may not have been as simple as master and 'subject', but that Alcetas retained significant status in his own right, and the relationship between Jason and Alcetas may have been more co-dependent, or that at least Alcetas ruled with Jason's backing. In any case, Alcetas seems also to have been recognized as a citizen at Athens, as had his father Tharyps (RO 70.3–4).[74] It is difficult to see where and how the *koinon* figures in Alcetas' activities either with Jason or in Athens.

The relationship between *basileus* and *koinon* was clearly a complicated one, and not always easy, and Molossian kings were willing and able to use their extensive personal relationships. Yet while it is likely that Alcetas was exiled by decree of the *koinon* at some point before 385, he was not returned by the will of the *koinon* but rather was foisted on it by Dionysius of Syracuse, who found a secure ally in the western coastal region of the mainland useful, as did the Athenians and Jason of Pherae in the 370s. Alcetas also seems to have been able to force his pro-Athenian policy on the Molossians, despite their debts to the Spartans. Nevertheless, as leader of the army Alcetas seems to have extended Molossian territories to include other Epirote tribes

(Xenophon describes him as the *hyparchos* of Jason in Epirus: *Hell.* 6.1.7),[75] whether or not he was technically holding them for Jason, or whether he was holding them with Jason's support. It is possible that control of the army was key, although it was probably an army levied, at least in part, by the *koinon*. Alcetas does seem to have been an agile politician in the wider circles of Greek politics, with influential friends in Sicily, Athens and Thessaly. But this worked both for and against the interests of the *koinon* (although always, it would seem, in the interests of Alcetas).

What we seem to see in Molossia are two separate locations of sovereignty, which at once had a level of dependence on each other, but also had enough independence that they could compete with each other for dominance. Just as the fourth-century Pheraean *tagoi* attempted with varying degrees of success to operate irrespective of the Thessalian *koinon*, and to assert their will despite it, so also we see at least Alcetas trying either to be independent of the *koinon* of the Molossians, or to assert his will over it. One of the primary roles of the dynast seems to have been to lead the army, but control of the army effectively also brought with it the ability to direct foreign policy. It is also worth noting that Alcetas and Neoptolemus are named (not the Molossoi) among the allies of the Second Athenian Naval confederacy (above), just as Olympias and her daughter and wife of Alexander Cleopatra (not the Molossoi) are named as the recipients of grain from Cyrene, possibly in the 330s (RO 96). Despite the existence of the *koinon*, and the limitations it may have placed upon the ruler, it was the ruling household that remained the focus and representative of ruling power.

In any case, in the years to come, the Aeacid dynasty was by no means stable, despite Aristotle's assertions to the contrary. Alcetas I was succeeded by his son Neoptolemus. Alcetas also had another son, Arybbas, who, as we have seen, challenged the succession. To resolve the issue Arybbas married Neoptolemus' daughter Troas and joined Neoptolemus as co-ruler in the 350s until Neoptolemus' death (Paus. 1.11.3; Plut. *Pyrrhus* 1.5; Justin 7.6.11).[76] Diodorus says that Arybbas ruled for ten years (Diod. 16.72.1). He was prepared to work on the family connections with Athens (RO 70), where he fled after he had been expelled from Epirus by Philip II of Macedon (possibly in 343/2); Philip put Alexander (I), the brother of Olympias on the throne (Justin 7.6.12, 8.6.4–8; cf. Diod. 16.72.1).[77]

Relations with the later Epirote confederacy (established in about 330 BC) also showed continuing signs of strain. Alexander I was probably succeeded by Arybbas' second son, Aeacides (Paus. 1.11.3; cf. Diod. 16.72.1, 19.35.5, 36.2), who Pausanias says was under Olympias' thumb, and who may have been co-ruler with Neoptolemus, the child-son of Alexander and Cleopatra.[78] He was later deposed by decree of the Epirotes (Diod. 19.36.3; cf. Paus. 1.11.4), because, Pausanias says, the Epirotes hated Olympias. He later made this up with them and tried to regain his position (Diod. 19.74.3), but was taken by Philip, the brother of Cassander, and died (Diod. 19.74.5; Paus. 1.11.4). He was succeeded by Alcetas (II), Aeacides' elder brother, who had been exiled by Arybbas, although Alcetas himself was soon put to death by the Epirotes and replaced by Pyrrhus, the son of Aeacides (Diod. 19.88.1; Paus. 1.11.5), perhaps ruling jointly with Neoptolemus, the son of Cleopatra, before Pyrrhus murdered him (Plut. *Pyrrhus* 4.1–3, 5.1–14). Thereafter the confederacy often had significant influence in matters relating to succession, although strictly the Aeacids remained rulers of the Molossians alone, and not the Epirotes.[79]

## *The Spartan dyarchy*

The Molossians may have had a 'constitutional' monarchy of a sort, but Sparta provides the chief example of the successful negotiation of the division of sovereignty. The Spartan dyarchy is often viewed as an oddity in the context of Greek politics, but, as we have seen, co-ruling was not an unfamiliar phenomenon. In fact, Ellen Millender has discussed how the dyarchs at Sparta could act as a check on each other, seen most clearly in the wrangling between Cleomenes I and Demaratus, which led to Demaratus' deposition in favour of Leotychidas.[80]

The two royal houses held an institutionalized position within the structures of rule from an early date. By about the seventh century, constitutions started to become more defined, at least in broad terms. The detail of the 'Lycurgan' constitution at Sparta was probably largely an invention of the fifth and fourth centuries, but the seventh-century Great Rhetra laid down the general structures of governance (Plut. *Lyc.* 6).[81] It seems that by at least the mid sixth century the Spartan dyarchs were answerable to the annually

elected ephors, who could only be selected once,[82] but who by the fifth century at least had probably become the most important officials at Sparta, even if their tenure was only annual.[83] The two *basileis* swore an oath to the ephors once a month to rule according to law, and the ephors responded in turn that they would preserve the *basileia* (Xen. *Lac. Pol.* 15.7).[84] Aristotle dismisses the Spartan *basileia* as only a permanent generalship, because the kings had to court the favour of the ephors (*Pol.* 2.1270b13–16).

On one level, Aristotle is right. The *basileis* led the army in war, although as Carlier notes this was on campaigns decided by the machinery of state, rather than the *basileis* as Herodotus claims (Hdt. 6.56).[85] Yet as Cleomenes demonstrated through his interventions in Athens in the late sixth century (Hdt. 5.64–5, 72, 74–6), and Agesilaus showed through the Asian campaign in 396–4 (Xen. *Hell.* 3.4, 4.1–2), command of the army could itself be an effective vehicle for political power, especially in the control it could give over foreign policy, since once abroad the *basileus* had full control over his itinerary, just as he also had a significant diplomatic role to play while on campaign.[86] On his campaign in Asia, Agesilaus also made use of his international connections to open negotiations with the Persian Pharnabazus, in an attempt to bring him over to Agesilaus' (and the Spartan) side (Xen. *Hell.* 4.1.29–38).

In the field, Spartan *basileis* were liberated from many of the normal constitutional constraints (cf. Th. 8.5.3) and could act independently, although at their own risk, since they remained answerable for their actions once they were home. The Spartan Pausanias in 403 supported the Athenian democrats because of a supplication from his *xenos* Diognetus, the brother of the Athenian general Nicias (Lys. 18.10). On his return, however, Pausanias was tried by the *gerousia* for his conduct and acquitted (Paus. 3.5.2), but tried again on the same charge in 395 (although the immediate incentive for the second trial was failing to intercept Lysander in time at Haliartus: Xen. *Hell.* 3.5.25).[87] He went into exile and was condemned to death in his absence. Even Agesilaus left Asia and went home when he was summoned by the ephors in 394 (Xen. *Hell.* 4.2.1–4; *Ages.* 1.36).[88]

An area where the dyarchs certainly had priority was in religion. A significant function of the *basileis* was to conduct the sacrifices on behalf of the state; Xenophon says that this was on the basis of their divine descent (Xen. *Lac. Pol.* 15.2). In this connection it is important that not all Spartans were

considered to be descended from Heracles (Hdt. 8.114.2).[89] It is also of note that, in the succession dispute of 397 BC, Lysander provided the argument that it was Heraclid descent that mattered (the implication was that Leotychidas was not the son of Agis).[90] This coalescence of religion and politics seems to indicate a strong conceptual overlap between the mortal and political world and the cosmos. That one of the functions of the dyarchs was cosmic seems to be confirmed, as we have already seen, by Herodotus' description of the death-ritual of the *basileis* (Hdt. 6.58–9). We have also already noted that Xenophon says that on their death the Spartan *basileis* were honoured, not as mere men, but as heroes (*Lac. Pol.* 15.9). Herodotus indicates that a *basileus* must be buried in Sparta (highlighting his local cultic significance), since if the body itself was not available (if he died abroad), then a statue of the *basileus* was buried (Hdt. 6.58.3).

However, it is also significant that the religious functions of the king were public and civic, and that the death-ritual was formal, civic and compulsory for all sections of Spartan society; Herodotus labours the compulsory nature of the ritual (with fines issued for non-compliance: 6.58.1–2). While on the one hand the formalized and communal nature of the ritual surrounding the dyarchs highlights the importance of the dyarchs to the state as a whole, it also indicates the level of state regulation of the functions of the *basileus*. On one level, it is easy to argue (as Aristotle does) that the role of the Spartan *basileis* had been progressively limited and the *basileia* had declined in importance; on another level, however, the formalization of death in this way indicates the institutionalization of the dyarchy, and the need for the state to control even the divine aspects of their position.[91]

The dyarchs also had other important privileges and responsibilities in the community. They received tribute from the Lacedaemonians ([Plato], *Alc. I* 123a–b), which Hodkinson takes to mean from the *perioikoi*.[92] They also had responsibility for legal arbitration in cases relating to marriage and adoption, and, as with their other residual responsibility for roads (Hdt. 6.57.4), the regulation of the disposition of wealth in and between families had serious economic consequences.

Among their prerogatives, Herodotus says that the dyarchs appointed from the citizen body the Spartan *proxenoi* and the representatives who, at need, were sent to Delphi (6.57.2; cf. Xen. *Lac. Pol.* 15.5). That they appointed the

Pythii fits easily with their other religious duties; however their responsibility for appointing *proxenoi* seems unusual, since Greek states usually appointed their own *proxenoi* generally on the basis of benefactions already received.[93] Mosley argues that the Spartan king did not appoint all *proxenoi* but simply supplemented those contacts that already existed through his own network of *xenoi*.[94] Cartledge, on the other hand, thinks that they probably did have this responsibility, and that it is in line with the general Spartan desire for the state to control all relations with outsiders.[95] Even more to the point, the dyarchs were the right men for the job. There are a number of examples showing that the dyarchs did have active and important *xenia* connections (e.g. Archidamus and Pericles: Th. 2.13.1; Pausanias and the family of Nicias: Lys. 18.10;[96] Agesilaus and the son of Pharnabazus: Xen. *Hell.* 4.1.39–40).[97] However, it is also important that at Sparta the awarding of *proxenia* was not left as a general expectation of what the dyarchs might do, but this duty had become a formal and institutionalized part of their role.

In fact, unlike in other *poleis* where by the fifth century the role of the *basileis* tended to be defined more loosely on the basis of custom and tradition, at Sparta the *basilikos* functions of the dyarchs were formal, regulated and institutional, which for the most part created stable relations between *basileia* and state. The Spartan *basileis* had no absolute right to create policy without reference to other bodies of governance, and Lewis is sceptical whether most of the dyarchs had any substantial influence on policy or events.[98] Yet their friendship networks alone were important for the extent of their political influence. Cartledge has shown how Agesilaus was able to boost his position at Sparta through the strength of his friendship networks, and was even able to draw the other (and competing) *basileus* into his network of reciprocal obligation, to Agesilaus' advantage.[99] Hodkinson, also, has emphasized the power of the patronage connections that could be exercised by the kings in influencing the courts and political decisions.[100]

The institutionalization of the *basileia* at Sparta was its strength as well as its weakness.[101] Although the substance of the power of the dyarchs was based on their personal charisma, Cartledge rightly argues that ensuring the two *basileis* were included in the Great Rhetra was a political masterstroke which preserved their office, and gave them a political role as part of the machinery of government as members of the *gerousia* (Hdt. 6.57.5).[102] Aristotle, as we

have seen, says that it was the limitations on the Spartan *basileia* which gave it longevity. Although Aristotle also considers the Spartan dyarchs no more than permanent generals, it was their permanence that gave them political strength. As Cartledge points out, Lysander allegedly chose the *basileia* as the focus for his political ambitions by opening it up as an elective position, because as a man of his age (he was too young for the *gerousia*) the *basileia* was permanent, while the ephorate was annual, collegiate, and non-renewable.[103]

In both these Molossian and Spartan examples there are features in common: the kings' role as leader of the army is striking, as is the way in which they were able to deploy to great effect different kinds of friendship networks. However, there was a balance to be struck between personal charisma and the stability of the state. As a ruler the Molossian Alcetas was obviously a loose canon, even though probably a brilliant military commander, and someone who was willing to exploit all his personal connections. Though the Molossians made territorial gains under Alcetas, as his period of exile and the violence of his reinstatement shows, Molossian political structures struggled to contain and manage him. Yet they were able to control him to the extent that he could be exiled, as the later Epirote confederacy was able to depose and replace successors to the Molossian kingship. At Sparta, on the other hand, while there was for the most part fierce competition between the two ruling houses and control by the state also entailed playing the games of friends and enemies among the ephorate and on the *gerousia* (as the acquittal and subsequent condemnation of Pausanias appears to indicate),[104] the dyarchs themselves were not pitted against the other institutions of governance *per se*, but the very constitutional structures meant that the 'office' of the dyarchy was preserved, whatever games the dyarchs themselves chose to play. As we saw in an earlier chapter, this was also evident in matters of succession, where crises in the succession were not crises for the stability of the state. Nevertheless, while ruling at Sparta was closer to 'office-holding' than in many of the other cities we have considered, that some Spartan rulers were able to shine so brightly is indicative of its essentially charismatic conception.

Here we reach one of the central paradoxes of rulers and ruling in archaic and classical Greece. In order to rule the willing, one was expected to be a charismatic leader, who drove the city forward and kept it politically energized

and focused through the abundance of one's *aretē*. However, for a truly stable political system charismatic leadership had to be balanced by other officers of governance, who could hold the ruler accountable and endorse, and even limit, his rule. Assemblies and councils were important – even the Phaeacian Alcinous was answerable to his council. Sometimes these other agencies could become so strong that the ruler's hold on power collapsed – the Cyrenean aristocracy brought down the Battiads, probably through the council.

The task of the ruler was to present his rule in such a way that he demonstrated that he was restrained. In order to maintain legitimacy, and belief in his rule, he had to present his rule as upholding certain values and completing certain functions, and to show that he ruled under law, at least in the sense that his rule was at some level constrained and audited. As Hammer has pointed out in relation to the assemblies described in Homeric epic,[105] charismatic rule involved a negotiation between ruler and ruled, and rule itself was a public concern in the *polis*, in which the people participated actively in the legitimacy of rule.

In previous chapters, we have considered the personal nature of ruling, which seems to have been significant in a number of ways. Herodotus reports the violence of the tyranny of Cypselus and his son Periander (5.92ε–η), and Aristotle also repeats the stories of Periander's ruthlessness (*Pol.* 3.1284a26–33, 5.1311a20–2, 1313a36–41), but then notes that the Cypselid dynasty was one of the longest tyrannies because Cypselus did not have a bodyguard, but instead made himself approachable to the people (*Pol.* 5.1315b22–9). Rulers relied on their personal qualities, their charisma, and their personal relationships in order to retain their position of rulership, but for political stability they also had to allow the ruled to have some control over how rule was managed, so that the relationship between the ruler and the ruled was balanced and consensual. Diodorus says that Gelon spoke in the assembly at Syracuse, without his armour or even his *chitōn*, and made a defence of his life and all the things that had been done by him in regard to the Syracusans (Diod. 11.26.5).[106]

As we have seen, it has sometimes been easy to assume that a pattern of decline of the *basileia* in the face of increasing power of the citizenry was the norm, and this evolutionist pattern which sees the simple society moving towards the abstract and bureaucratized state has long been fashionable.

However, in Greek society political developments did not necessarily follow this linear trajectory, and constitutional movement did not necessarily or straightforwardly tend away from *basileia* towards rule by the few or the many. The story of Cyrene tells us as much about contestation between the one and the few as it does about decline. Battus III may have ceded powers, but Arcesilas III demanded that they be restored. With the support of his mother (and the Persians) to a certain extent they were. The acceptance of the place of *basileia* in the structures of government tells us much about the conceptualization of sovereignty as a general phenomenon in the Greek world, the way that it developed, and the preference for multiple locations of power and authority which could be balanced against each other and could hold each other accountable, whether or not this was always successful or peaceful.

# Notes

1   For Hansen (2006) a ruler and the *polis* are not a good match. While Hansen concedes that the *polis* was imagined in terms of three constitutions (the rule of the one, the few and the many), for him (arguing from Aristotle) the essence of *polis* life was exercising political rights, so that (in Hansen's view) 'the *polis par excellence* is the democratic city-state' (111–12), though it is arguable whether Aristotle would agree, since he also excluded large sections of the community as unfit to rule (*Pol.* 7.1328b2–1329a2). Hansen goes on to say that oligarchies, and especially monarchies, cannot be *poleis* in the same sense, and that 'in a monarchy the monarch is the *only* citizen in the political meaning of the word'.

2   On the problems and issues in defining equality, see L. Mitchell (2009).

3   Kurke (1994), 86–92; see also Gernet (1981), 161; Bremmer (1987), 303–4; Ogden (1997).

4   Sarah Hitch (2009) talks about the importance of sacrifice for reflecting and establishing hierarchy in Homeric epic: esp. 141–203; see also essays, esp. those by Detienne and Vernant, on sacrifice and the *polis*: (1989).

5   Mazarakis Ainian (1997), 393; cf. Morgan (1990), 73–9.

6   See, e.g., Snodgrass (1980), 33–4, 58–64; Mazarakis Ainian (1997), 384; R. Osborne (2009), 94–6.

7   Snodgrass (2006), 212; cf. Coldstream (2003), 317–27; R. Osborne (2009), 83–4.

8   E.g., Mazarakis Ainian (1997), 384.

9   Snodgrass (2006), 212. Claims such as those made by Snodgrass also seem to be

based on the further assumption that urbanization and the development of the *polis* went hand in hand with political synoecism and the building of fortification walls. Demand has shown (now supported by Morgan) that synoecism was not a common element in *polis* development, and the importance of city walls in *polis* development, especially for the earlier periods, is currently a matter of debate. Synoecism: Demand (1990), 14–27; cf. Morgan (2003), 171–6. Walls as sign of *polis*: Hansen (2004), 135–7; importance of walls for a city: Crielaard (2009), 354, 355, 363–5. Walls not common in mainland Greece before fifth century: Winter (1971) 61–4, 289–99; Lawrence (1979), 30–8.

10   Morgan (2003), 142–55.

11   Hall (2007), 86–7.

12   It is true that temple-building was expensive, and there was often the need for a collective effort to put together sufficient resources – Croesus dedicated three columns of the Artemisium at Ephesus (Tod 1.6), and a number of groups and individuals contributed towards the rebuilding of the temple of Apollo, to which the Athenian Alcmaeonidae, as the contractors, made a significant contribution (Hdt. 1.62.2–3; Pindar, *Pyth.* 7.10–12), as did Amasis of Egypt (Hdt. 2.180). It was common for temple-building to be let out to contractors, who were not paid until the building was complete: Burford (1969), 109–14.

13   On temple-building as a ruler's prerogative in the Near East, see the essays in Boda and Novotny (eds) (2010).

14   See Thatcher on the ways that the Deinomenids used this pan-Sicilian cult to forge an identity that supported their rule: (2011), 144–8.

15   Note, however, Parker (2011), 48: 'Herodotus … seems to see the power of Gelon, tyrant of Gela and Syracuse, as partly resting on his family's hereditary role as "hierophants of the chthonian gods". But the claim is enigmatic, and isolated.'

16   Briant (1973), 326–7 n. 2.

17   Even at Athens, where the most important religious magistracy was the office of *basileus*, it was said that, although like most other magistracies at Athens it became an annually appointed office, the *basileus* was originally elected from the *prokritoi*, the elite, on account of his *andragathia*, which was a civic equivalent of *aretē* (*Ath. Pol.* 3.1–3, 5, 57; [Dem.] 59.73–8). Even in the fourth century, the role was specialized enough that the wife of the *basileus*, who administered the oaths to the priestesses, made sacrifices on behalf of the city and performed the 'sacred marriage' with the god Dionysus (see Seaford [2012], 85–8), by law had to be an *astē*, that is, the legitimate daughter of Athenian parents, and a virgin before she was married ([Dem.] 59.75). In a community

where all citizens, at least theoretically, were *kaloi k'agathoi* and could claim autochthonous descent, these strictures were to ensure that she would have the appropriate purity to enact religious duties for the city.

18   See also Lloyd-Jones (1971), 87.

19   Cf. MacDowell (1978), 13–16.

20   Cf. Gagarin (1986), 24–5.

21   See, e.g., Dodds (1951), 1–27; Adkins (1960), 61–85; Lloyd-Jones (1971), 1–54; Humphreys (1988), 466–8.

22   For *eunomia* as a local rather than a universal phenomenon: see Ostwald (1969), 62–85. Order was often dependent on a proactive (rather than reactive) use of force and even violence. McGlew and Irwin see the collocation of justice and force as part of the discourse of tyranny, and as a feature which differentiated it from *basileia* (McGlew [1993], 52–86; Irwin [2005], 221–30). As Irwin points out, Hesiod is explicit that force (*biē*) is the antithesis of order, *dikē* (*W&D* 274–85); Solon, on the other hand, declares that he has yoked force (*biē*) and justice (*dikē*) (fr. 36.16 West *IE²*). However, Solon was not a tyrant, and indeed rejected autocracy. Furthermore, despite Hesiod's rejection of force in the implementation of *dikē*, in Homer there is a swirling discourse of violence, order and justice. It is the Zeus-given sceptre of Agamemnon which Odysseus as a *basileus* uses forcefully and even violently to maintain order (*Il.* 2.185–206, 265–8). Likewise, Zeus also responds very violently (*labrotatos*) and is angered (*kotessamenos*) by those who with violence (*biē*) deliver crooked judgements (*skoliai themistes*) and drive out order (*dikē*) (*Il.* 16.384–8). Violence and order are part of a discourse of ruling, which could also question the need for force. In Pindar, when 'Law is King of all' (*Nomos pantōn Basileus*) (fr. 169), the gnome is illustrated by the violence of Hercules. On Pindar fr. 169: Ostwald (1965); Pavese (1968); Lloyd-Jones (1972); Crotty (1982), 104–6; Pavese (1993); Kyriakou (2002). Havelock (1969) is also useful here for understanding the non-moral loading of *dikē* and its cognates before the second half of the fifth century (compare also Gagarin [1974], but his economic basis for *dikē* is not convincing). Note also the way Agamben ([1998], 30–5) explores this idea of the violence of *nomos*.

23   Schofield (1986), revising the position put forth by Finley that heroic honour was only realized in battle: (1977), 113–18.

24   See esp. Hölkeskamp (1992a); id. (1992b).

25   On the new sixth-century empiricism, see for example: Most (1999); Bertelli (2001).

26   See Kirk, Raven and Schofield (1983), 181–212, esp. 211–12.

27   See further Chapter One. On Periander, see Salmon (1997), 65.

28   Corcella observes (rather oddly) that dynastic conflicts were not uncommon among tyrannies ([2007], 689). Dynastic conflicts were common wherever there was power and wealth at stake.

29   Cf. Ogden (1997), 60–1.

30   Chamoux (1953), 137, 139–41; B. Mitchell (2000), 88.

31   Barbara Mitchell ([2000], 89), however, makes the point that control of the *temenea* provided the *basileus* with great wealth. Note also that Corcella ([2007], 690) warns against seeing Demonax's reforms as particularly 'democratic' (commenting on Arist. *Pol.* 4.1319b19–23). Demonax himself is called *basileus* of Mantineia by Hermippus of Smyrna (*FGrHist* 1026 F3), concerning which Bollansée (1995) concludes that Hermippus must have been referring to a magistracy like the *basileus* at Athens.

32   Gagarin (1986), 58–61; Raaflaub (2005), 42–3.

33   McGlew (1993), 106–8.

34   Diocles, however, had also been exiled as a result of a political scuffle with the influential politician Hermocrates (Diod. 13.75.2–5)

35   For the impossibility of untangling the confused traditions regarding Pheidon, see esp. Hall (2007), 145–54.

36   See Humble (forthcoming). I am very grateful to have been allowed to see this essay ahead of publication.

37   See L. Mitchell (2013a).

38   Currie (2005), 195.

39   See esp. Chapter Five.

40   Balot (2006), 269–76.

41   E.g., Wolff (1946); Sealey (1976), 24–5; id. (1994), 113–15; Thüer (1996); Carawan (1998), 49–68; Nagy (2003), 75–87; Farenga (2006), 109–73. Farenga, following Cantarella (2002), equates the *gerontes* with *basileis*. Cantarella argues that there were two separate usages for *basileus* in Homer ([2002], 125–6, 135–7), the sceptre-bearing *basileus*, and the other *basileis*, such as the twelve *basileis* who ruled the Phaeacians, and who formed Alcinous' council, for whom Alcinous was 'thirteenth' (Hom. *Od.* 8.390–1; cf. 6.54–5). She notes that members of Homeric councils can also be called *gerontes* (not necessarily an indication of age) (cf. *Il.* 3.146–53, 22.117–21), and describes them as 'des chefs des divers *oikoi* de la cité …'.

42   Todd (1993), 33.

43   Rhodes (1993), 106 with 219.

44   Rhodes (1993), 215–16.

45  The Spartans were reputed not to have written laws, not even the 'laws' of Lycurgus (Plut. *Lyc.* 13.1–3); see further Gagarin (1986), 56–8.

46  See Duffy (1947).

47  It is often assumed that a bodyguard is a defining feature of tyrants in particular. However, it was a commonplace that rulers needed bodyguards. In this context it is significant that both Peisistratus (*Ath. Pol.* 14.1) and Dionysius (Ar. *Pol.* 3.1286b39–40) had bodyguards from among the citizen body, and Cypselus was known for not having a bodyguard at all (Ar. *Pol.* 5.1315b27–8; Nicolaus of Damascus, *FGrHist* 90 57.8).

48  The notion of Absolute Rule, at least as developed in the political thought in the Christian West, is itself problematic. The idea of Absolute Rule took shape in sixteenth- and seventeenth-century Europe: Fox (1960). The late sixteenth-century French political philosopher, Jean Bodin, developed the theory of the divine right of kings in order to justify the King's absolute authority: while a sovereign is not bound by law as such, he is limited by divine law and natural law (see esp. Franklin [1992]). Developing this thought, in the seventeenth century, Thomas Hobbes in *Leviathan* said strikingly that, although not based on a divine right to rule, a monarch's power rested on the consent of his subjects (and that this was a joint contract), but that his power and his honour was absolute (*Leviathan* 18); it was for the sovereign to be the final judge and arbiter of what was morally right, and so to be the absolute legislative power in the state (*Leviathan* 20.16) (see Bobbio [1993], 94). On the other hand, the enthusiasm of James (VI and I) for the divine right of kingship was a reaction to the vigour with which, in the sixteenth century, the Scottish theorist George Buchanan compared a king to a physician, whose role was to heal the ills of the commonwealth. As a result, he should not be above law, and was in actuality elective, and therefore could be resisted (Mason and Smith [2006], esp. 124; cf. Clarke [2003], 64–72). In France, in the seventeenth century, Louis XIV's extravagant claims to absolutism were supported by the French homilist and theoretician Jacques-Bénigne Bossuet, who made the case for absolute rule in his text *Politics Drawn from the Very Words of Scripture*, drawing parallels with the kingdoms of David and Solomon, thus sacralizing the state and the role of the king within it (on Louis XIV, absolutism and the divine right of kings, see Fox [1960]; on Bossuet, see Perreau-Saussine [1996]). As a result, the theoretically unregulated rule of Hobbes' *Leviathan* has often been assumed to be the political reality of the 'tyrannical' age of archaic and classical Greece.

49  E.g. Elias (1983); Mettam (1988); Kettering (1993).

50  Herman (1997), 212.

51   This picture of supposed Persian absolutism is also a figment of the Greek
     imagination: see Brosius (2007).

52   That does not mean, however, that there were not concerns about the
     possibilities of Alexander's absolutism, and later stories about his life wanted to
     emphasize what they could see as a decline into absolute rule. Both Arrian and
     Plutarch include a story about Anaxarchus, who was summoned to Alexander
     to help the ruler through his grief after the murder of Cleitus. Anaxarchus,
     they say, laughed at Alexander, and said that the ancient wise man made Dike
     (Justice) the companion (*paredros*) of Zeus, since whatever Zeus ordained,
     that would be just. Consequently, Anaxarchus said, the things done by a great
     *basileus* must be considered just, both by himself and others. Alexander was
     very pleased with this view of things, since both Arrian and Plutarch are using
     the story to mark an important change in his manner of ruling. Invective
     against rulers, as we have seen, was not new. Alcaeus vilified Pittacus, his
     competitor. Stories told about Alexander during the second sophistic reflect
     not only a more general concern about absolutism but also Greek and Roman
     concerns about the possible absolutism of their own emperors.

53   Cantarella (2003), 135.

54   See esp. Cantarella (2003), 130–43.

55   Kurke (1994), 76–7.

56   By appealing to 'the multitude' (*to plēthos*), Agathocles later also had himself
     proclaimed *stratēgos autokratōr* by the Syracusan assembly so that he would
     'rule alone' (*monarchein*): Diod. 19.9.4.

57   Cf. S. Lewis (1994), 137–8.

58   S. Lewis (1994), 135–6.

59   This is a 'chicken and egg' issue, perhaps, about theory and practice: see further
     Chapter Five.

60   Foxhall ([1997], 119, 120 and 134 n. 58) makes the important point that even
     in Athens in the fifth century it is difficult to differentiate between offices and
     office-holders, who shaped 'the duties and privileges of the offices they held'.

61   Allan suggests the play may have first been performed in Molossia: Allan 2000.

62   On the 'Greekness' of the Molossians: Malkin (2001); Hall (2002), 165–6;
     L. Mitchell (2007), 205–6.

63   Cabanes = Cabanes (1976); D = Davies (2000). Philip replaced Arybbas with
     Alexander (see below).

64   Davies (2000), 252–4. On the west-Greek nature of the *damiourgoi*, see below
     n. 68.

65   Hammond (1967), 549.

66 Hammond (1967), 541–4.

67 Cabanes (2010), 128.

68 On *damiourgoi* as a particularly west-Greek phenomenon, see Murakawa (1953); cf. Jeffery (1973–4).

69 Davies (2000), 254.

70 It is unclear how or why he was exiled. Diodorus also tells the story of the exile of Aeacides (who was attempting to help Olympias against Cassander) by decree of the Epirotes, but also says that this was the first time such a decree had been passed since Neoptolemus son of Achilles was *basileus*: Diod. 19.36.4; cf. Plut. *Pyrrhus* 4.1.

71 Hammond (1967), 533; id. (1994), 428. For the Spartan alliance with Dionysius, see further Chapter Two. Athens had been interested in wooing Dionysius away from his support of Sparta as early as the 390s (RO 10; cf. Diod. 14.62.1, 63.4, 70.1–3, 72.1; Lys. 19.19–20; Xen. *Hell.* 5.1.26), although an alliance was not formed with Dionysius until the 360s (RO 34, cf. 33). Dionysius also won first prize at the Lenaea of 367 (see Introduction); Diodorus says he drank himself to death in the celebrations for his victory: 15.74.1–4; cf. Plut. *Dion* 6.2). For a concise and clear account of Dionysius' reign, see Rhodes (2010), 314–24.

72 Dakaris (1964), 64; cf. Cabanes (2010), 127.

73 For the date that these names were inscribed: Cawkwell (1963), 91 n. 61; id. (1981), 42–5. See also Seager (1994), 174.

74 See also M. Osborne (1981), T37.

75 Cf. Hammond (1967), 524.

76 Rhodes and Osborne (2003), 352; Carney (2006), 9–11 *passim* and 143 n. 41.

77 On Diodorus' record of Arybbas' death and the date of the decree, see Rhodes and Osborne (2003), 353.

78 See Carney (2006), 67–9 and 169 n. 29.

79 See Carney (2006), 10–11, 66–8, 169 n. 25. On the relationship between the Epirote Alliance and the Aeacids, see Hammond (1967), 561–2; id. (1994), 441–2. On the status of the Aeacids: Hammond (1967), 562; Carney (2006), 52–3.

80 Millender (2009), 11–12.

81 For the detail of 'Lycurgan' laws, see Flower (2002) together with Hodkinson (1997).

82 Westlake (1976).

83 D. Lewis (1977), 40–2; cf. Andrewes (1966), 8–14.

84 It is significant that this oath was made with the ephors, since it might mean that the oath can date no earlier than the mid sixth century, if Diogenes Laertius

is right in claiming that it was the ephor Chilon who first 'yoked the ephors to the *basileis*' (1.68.6): cf. Cartledge (1987), 106–7. On the other hand, Hodkinson is uncertain about the importance of Chilon for reform, although he does think that the ephorate itself must date to earliest period of Lycurgan reforms. On Chilon and the ephorate: Hodkinson (1997), 84–5, 87. See also Cartledge (2002), 120 (who accepts the ancient tradition on Chilon).

85  Carlier (1984), 257–60.

86  See also Carlier (1984), 263–4.

87  For these two trials, see esp. Cartledge (1987), 133–5.

88  In the *Agesilaus*, Xenophon says Agesilaus chose not to be the greatest man in Asia, but to rule at home according to the laws, and to be ruled in respect of them (2.16).

89  Cartledge (2002), 295.

90  While an oracle was consulted, it was the *polis* (although as Cartledge notes this must have actually meant the officials – probably the ephors together with the *gerousia*) that made the final decision (Xen. *Hell.* 3.3.4): Cartledge (1987), 111.

91  Cf. Price (1984), 29; Woolf (2008); Rhodes (2009), who seeks in different ways to de-emphasize the distinction between religion and politics.

92  Hodkinson (2002), 188, 352.

93  L. Mitchell (1997), 28–37.

94  Mosley (1971), 433–5; Hodkinson (2000), 340; cf. Wallace (1970), 198; Cartledge (1982), 251.

95  Carteldge (1985), 108.

96  See also L. Mitchell (1997), 59.

97  Pindar – who at least for the most part presents his dedicatees in ways that they would find supportive – emphasizes the role of *basileis* more generally as *xenoi* and their duties of hospitality. For example, he praises Theron of Acragas for being 'just (*dikaios*) in his reverence for *xenoi*' (*Ol.* 2.6), and in his ode for the boy-victor Hagesidamus tells the story of Heracles' founding of the Olympic games in revenge on the *xenos*-cheating (*xenapatas*) *basileus* of the Epeians (*Ol.* 10.24–59). *Basileis*, as any member of the elite, were bound by the codes of ritualized friendship (cf., e.g. Pindar, *Ol.* 9.66–85, 13.1–3, *Pyth.* 10.63–6, *Nem.* 4.11–13, 7.65–6, 10.49–54, *Isthm.* 6.66–71). However, as the wealthiest and most important members of the society, the *basileus* in any city seems to have had a special role in this regard on behalf of the whole community (see esp. Pindar, *Pyth.* 3.68–71, 5.55–7, *Isthm.* 2.37–42).

98  D. Lewis (1977), 43–9.

99  Cartledge (1987), 139–59.

100  Hodkinson (2000), 359–65.

101  See esp. Millender (2009), 10–15.

102  Cartledge (1985), 103–4.

103  Cartledge (1987), 94–6; cf. Hamilton (1979), 92–6.

104  See esp. Cartledge(1987), 134–5.

105  Hammer (2002), esp. 153–60; see also id. (2005).

106  Hornblower (2011), 47.

# Epilogue: Athens, ruling and *aretē*

Paul Cartledge has said: 'Monarchy runs like a red thread through Greek political history and thought ... It was never normal or normative, though.'[1] To a certain extent this is true, since there were not really any political structures that were all either normative or normal in archaic and classical Greece, though there were some trends and variations on some themes. Further, Greek political thought generally means Athenian political thought, since we have little from any other city, and it is true that after the failure of the Peisistratids, Athens did reject rule by one man.

Yet it remains important that personal and charismatic rule did not disappear entirely from all of the Greek world by the end of the archaic period as many have claimed, but remained a significant alternative to either rule by the few or rule by the many, and there were occasions and times when communities decided that they needed the rule of one rather than the rule of many or the few, and this was a legitimate political option. Indeed, by about the first quarter of the fifth century, the first attempts seem to have been made to set one-man rule into a theoretical framework. Although a poet rather than a political theoretician, Pindar in the *Second Pythian*, a poem addressed to Hieron of Syracuse, seems to reflect current trends in political thought. He says that a man of honesty and worth who does not offer flattery will prosper under any type of constitution, whether at the court of a *tyrannis*, the rowdy crowd, or the wise (86–8). This poem, which probably dates to 477/6,[2] represents the earliest extant formulation of rule by the one, the few and the many that was to dominate Greek constitutional thought, although it looks as if it is an easy *topos* to reach for, and so probably had a certain familiarity by the time Pindar was able to use it in his poetry. In the first instance it is interesting that the rule of one man is a *tyrannis* which, at least superficially, has no negative edge to it.[3] Yet it was in its negative form that rule by one man was initially most clearly theorized and enunciated.

# The rule of the tyrant

It is at Athens that we see the greatest resistance to autocracy, so much so that Parker has suggested that Athens invented the negative idea of tyranny.[4] There was a law against tyranny possibly since the pre-Solonian period (*Ath. Pol.* 8.4),[5] ostracism was established at the end of the sixth century to counter the threat of tyranny (*Ath. Pol.* 22.3–4), the so-called tyrannicides received cult by the very end of the sixth century or beginning of the fifth century,[6] proclamations and prayers were said in the assembly and the *boulē* against tyrants (Ar. *Birds* 1072–4, *Thesm.* 338–9), in 410/09 BC a law was passed against anyone who might overthrow democracy, install himself as tyrant, or support a tyrant (Andoc. 1.96–8), and in 337/6 BC a further law was passed against anyone who might rise up against the *dēmos* for a tyranny or join in setting up a tyranny (RO 79).[7] Democracy was consistently theorized as the opposite of tyranny because it brought freedom in opposition to the slavery of tyranny.[8]

As we have touched on many times throughout this book, by the end of the fifth century the theoretical notion of the rule of the tyrant was well developed. The tyrant who ruled alone was, by nature, wanton and cruel, raped women, and killed off any rivals (cf. Hdt. 3.80.2–4). He ruled outside law, since he held all law in his own hands (e.g., Eur. *Supp.* 429–55), and also ruled in his own interests rather than in the interests of the ruled (e.g. Th. 1.17; Arist. *Pol.* 5.1311a4–5). Tyranny was rule of the unwilling (e.g. Arist. *Pol.* 3.1285a27–8, 4.1295a22–3), and those who allowed themselves to be ruled by tyrants were slaves (e.g., Hdt. 7.135), or slavish by nature (e.g. *Airs, Waters, Places*, 16, cf. 23; Arist. *Pol.* 3.1285a19–23).

Especially at Athens, part of the fear of one-man rule was based on the Greek experience of the Persian *basileus*. The Athenians saw themselves as the saviours of Greece both because of the victory at Marathon and the abandonment of the city when Xerxes' army came (e.g. Th. 1.73.2–74.5). The victory over the Persians at Plataea was celebrated at Delphi with a golden tripod inscribed in terms of rescue from slavery:

> The saviours of spacious Hellas dedicated this,
> Having delivered their cities from hateful slavery (*doulosunē stugeras rhusamenoi polias*). (Diod. 11.33.2 = [Simonides] XVII (b) Page)

Yet by the end of the fifth century it was also possible to associate Athens herself with the slavery of Persian tyranny (Th. 3.10.3).

In Athens the laws against tyranny were generated by an ongoing fear not just of a tyranny that might be imposed from without but also a tyranny that might arise from within. Political action at Athens (as elsewhere) was based upon political groups which clustered around political leaders.[9] As a result, one man could dominate the political scene, as happened in the 440s and 430s, when Pericles held the generalship for fifteen years in succession (Plut. *Per.* 16). Indeed, Thucydides says that what in theory was democracy was in fact rule by the first (*prōtos*) man (Th. 2.65.9),[10] and there were some who called Pericles a tyrant (Cratinus fr. 258 Kassel and Austin *PCG*; fr. 240 Kock; Com. Adespot. 60 Kock).[11] Alcibiades, who raced chariots and lived a life that was thought to be beyond what was legal, was also thought to be aiming at tyranny (Th. 6.15.4); Thucydides has him say that one cannot reasonably demand both brilliance (*lamprotēs*) and equality (Th. 6. 16).[12]

The symbolism of the East as an expression of autocracy was also ambiguous. In the early fifth century, it was said that Pausanias, the Spartan regent, who Herodotus says 'had a desire to become *tyrannos* of Hellas' (5.32), was not only charged with medizing, but also with going about Byzantium dressed in Medish costume (Douris says he wore a Persian robe: *FGrHist* 76 F 14), having a Persian and Egyptian escort, throwing Persian parties, and restricting access to himself (Th. 1.130). Likewise, Dionysius of Syracuse used exotica to express his power: a chariot drawn by four white horses (Diod. 14.44.8), a boat furnished in silver and gold (Diod. 14.44.7), Persian-style clothing (Douris *FGrHist* 76 F 14) and diadem (Baton of Sinope, *FGrHist* 268 F 4).[13] Xenophon's Cyrus may also have adopted Medish finery (which created an illusion of grandeur and power: *Cyrop.* 8.1.40.1; cf. 3.1), but Xenophon did not approve. It was said to be Alexander's decision to adopt oriental fashions that first started to cause the rift between him and his men (e.g. Arrian, *Anab.* 4.7.4, 8.4; Plut. *Alex.* 45.2–4). Taking on the accoutrements of Persian royal theatre was one way of creating a sense of power, but it also brought with it charges of tyranny.

Yet there were also more positive images of monarchy, even oriental monarchy.[14] Theseus was celebrated as the hero-*basileus* who synoecized the city, and, as we have seen in the opening chapter, in Euripides' *Suppliants*

of the 420s established the *dēmos* in a *monarchia* (352).[15] In Aristophanes'
*Knights* the *dēmos* is hailed as *monarchos* (1330) and *basileus* (1333).[16] We
have already discussed how, when Demos is rejuvenated in Aristophanes'
*Knights*, he is represented as an 'oriental' monarch (1329–33). The Athenian
empire also used the structures and symbols of the Persians both as a model
for and an indication of their imperial might.[17] The Athenians were willing to
embrace the image of Athens as the tyrant city (e.g. Th. 2.63.2, 3.37.2), and
were even empowered by it.[18]

## *Aretē* and the theorization of rulers and ruling

In fact, it was in democratic Athens that a positive theory of rule by one man
was first systematically developed.[19] Herodotus' Constitution Debate develops
the *topos* of rule of the one, the few and the many. Herodotus was interested
in monarchy in all its forms,[20] and it is here that we first see in a theorizing
context the presentation of rule by one man as rule of the *best* man.[21] Although
Otanes' speech, in which he denigrates the *monarchos* as the opposite to 'the
rule of the multitude' (which has 'the fairest name of all': 3.80.6), generally
attracts most attention in scholarly discussions, Darius also presents the
positive case for rule by one man:

> Nothing would seem better than rule of the best man (*aristos*). Having the
> best opinions, he would govern the multitude blamelessly, and in particular he
> would keep silent about his plans in the face of hostile men. (Hdt. 3.82.2)

He goes on to denounce oligarchy because it leads to factional in-fighting,
which ultimately leads to *mounarchia*, and democracy, on the grounds that
it naturally produces a *prostatēs tou dēmou*, a 'champion of the people', who
because of the people's admiration for him will also become a *mounarchos* –
'so he also is proof that *mounarchia* is best' (Hdt. 3.82.4).[22] Darius wins the
debate (and through cunning the *mounarchia*: Hdt. 3.84–7), although strong
arguments are also made against autocracy and for democracy. His closing
argument is that the Persians attained their freedom (*eleutheria*) through one
man (that is, Cyrus), and so, for that reason, they should retain their ancestral

constitution (*patrioi nomoi*) (Hdt. 3.82.4). Elsewhere Herodotus says that as subjects of a king the Persians did not know freedom (7.135).[23]

It was also at the end of the fifth century that ideas about democratic equality were being revised. There were some who thought that the traditional ways of understanding democracy were neither intelligent (*xunetos*) nor equal (*isos*) (Th. 6.39.1), and, although it was not formalized until the mid fourth century, it appears that arguments were already being formed for an equality based on proportion rather than geometric or strictly democratic equality, where everyone received the same return no matter what their input.[24] Arguments for proportionate equality (greater returns for those who contributed more: e.g. Plato *Laws* 757a–e; *Gorgias* 483a–e; *Rep.* 558c; cf. Arist. *Pol.* 5.1301a25–1301b4) maintained that the best men should rule, and were linked to nature (*physis*) as the main organizing principle of society in opposition to conventional law (cf. Plato, *Gorgias* 483d–e) – though the substance of *physis* and its relation to unwritten law were also disputed (e.g. Antiphon, *On Truth*).[25] The 'democracy' of Pericles' Funeral Oration is a subtle reworking of democratic principles in terms of the principles of proportionate equality, in which 'the rule of all' (Th. 6.39.1) becomes rule 'in the interests of the many', and preference is given not by rotation (cf. Hdt. 3.80.6; Eur. *Suppl.* 404–8), but on the basis of *aretē* (Th. 2.37.1).[26]

Just as this principle of proportionality could be used to support a more moderate form of democracy, so also it formed the cornerstone of the positive theory of kingship. For instance, Isocrates (although elsewhere he advocates a limited democracy based on Spartan oligarchy)[27] also develops models for and arguments in favour of an ideal ruler based on proportionate equality. In his letter *Nicocles*, he says:

> Concerning constitutions … I think that, for everyone, it seems a most dreadful state of affairs that the good (*hoi chrēstoi*) and the wicked (*hoi ponēroi*) should be thought worthy of the same things, but distinctions should be made between them, and those who are not alike should have the same things, but each should fare and be rewarded according to their worth. Indeed oligarchies and democracies seek for equality for those who have a share in the constitutions, and it is regarded as fair in these kinds of constitutions if one man isn't able to have more than another. But this is advantageous to the wicked. But monarchy gives most to the best man, and then second most to the next best after him, and third and fourth most (and so on) in accordance with the same logic. (14–15)

Isocrates then goes on to say that another advantage of individual rule is that monarchs are also able to keep looking out for the best kinds of men, so that men of ability should naturally prefer monarchy over other kinds of constitution (16).

Plato is also preoccupied with equalities and inequalities. While in the *Gorgias* Plato has Socrates criticize Callicles for his claim that the best men should rule (from which Callicles produces the argument that the strong should rule the weak: Plato, *Gorgias* 483b–d), it is not because he does not support proportionate equality, but because he defines 'the best' not as 'the strongest' (as Callicles does), but as those who have pursued the knowledge of virtue, that is the philosophers. Thus in the *Republic* it is the Philosopher King who will rule and bring stability to the state (5.473c–e).

It is Plato who first turns the king, his Philosopher King (*Rep.* 5.473c–e), into an individual so aligned with divinity and orderliness that he becomes as divine and orderly as is humanly possible (*Rep.* 6.500c–e; note esp. c–d), and through his laws creates a god-inspired order (*Rep.* 6.501a–b, 502b).[28] However, outside the idealized world of the *Republic*, Plato cannot achieve this utopia. In the *Politicus* he concedes that the 'divine' king who is able to rule above law cannot exist, and so only a king who is bounded by law is acceptable (301c–e, 302e), and ultimately, for Plato, the king who exists as the creator of law (unless he is a Philosopher King, rather than simply the artisan 'weaver' who oversees law in the community: *Politicus* 305e) is not possible.[29] In the *Laws*, although the possibility of a ruler uncorrupted by pleasure is denied (713c–14a) – for such a man would not honour the laws but his own desires – an element of the ideal is redeemed, in that, although the laws of the idealized community of Magnesia are made by men, the proper education of the lawgivers means that the man-made laws reflect true law or natural law, which in turn is a reflection of the divine order of the *kosmos*. Nevertheless, ultimately for Plato law, not a man, must rule.

Furthermore, while Plato could imagine the best of rulers, the Philosopher King, so he could also imagine the worst, when the champion of the people was transformed (*Rep.* 8, 565e–566a):

> Is it not in the same way that whoever is champion of the people (*prostatēs*), having complete control of a persuaded mob, does not refrain from shedding the blood of his people, but by bringing the customary unjust accusation,

brings a man into court and assassinates him, blotting out the life of a man, and tasting with unholy tongue and mouth the murder of kinsmen, and by driving out exiles, killing, and hinting at the wiping out of debt and the dividing up of land, is it not inevitable after this and the decree of fate for such a man either to be killed by his enemies or to become a tyrant and to be transformed from a man to a wolf?

In the fourth century there had been great interest in the *prostatēs tou dēmou*, the 'champion of the people', and lists of champions of the *dēmos* were also used to structure Athenian political histories.[30] However, for Plato he is the most dangerous person, and when he becomes a tyrant (as inevitably he must) then he becomes the antithesis of the Philosopher King.

It was Xenophon, however, who worked through at greatest length the possibilities of rulers and ruling, especially in the *Cyropaedia*, although as Vivienne Gray has recently shown his interest in leadership is pervasive in most of his corpus.[31] Xenophon was also influenced by proportionate equality as it provided a structure in which one man could rule over others. In the *Cyropaedia*, in particular, the organization Cyrus creates is a meritocracy where the best people are given the highest rewards, and the lazy and wicked must be weeded out (2.2.22–5; cf. *Oec.* 13.10–2; *Anab.* 1.9.14–8). Cyrus rejects completely the notion that all should have the same rewards (2.2.18–21, 2.3.4; cf. 5–16), and transforms his army from one based on a social elite, and a 'common' mercenary contingent, into one based on 'nobility', which is defined by the pursuit of excellence irrespective of social class or nationality (2.2.26).[32] Excellence is achieved through constant training and practice (e.g. 8.1.39), and never sliding into complacency despite success (7.5.75–6; cf. *Mem.* 3.5.13). Beside this ethos of the competitive pursuit of excellence, Cyrus creates a system of hierarchies (8.1.4), which, while allowing equality of opportunity, does not produce equality of either status or reward, but a structured inequality where the merits of the individual are recognized and rewarded.

Most significantly for our purposes, Cyrus himself provides the ultimate model of *aretē* (8.1.33), and so most deserves to rule (1.6.22, 7.5.78–83). It is on account of his superiority that he is able to command the willing obedience of his subjects. As Gray has so clearly set out, willing obedience was the central pillar of Cyrus' success and security as a ruler (*Cyrop.* 1.1.3; cf. *Oec.* 21.12).[33] Cyrus' father advises him that it is not the giving of rewards and punishments

that produce willing obedience and the love of one's subjects but being 'wiser' (*phronimōteron* – in the sense of having greater learning: 1.6.23)[34] than anyone else, and being better able to endure hardship (1.6.20–5; cf. *Ages.* 4.3, 10.2). Likewise, the Armenian Tigranes says to Cyrus: 'If people think others are better than themselves, they will generally obey them willingly without compulsion' (3.1.20; cf. 4.1.19, 22–4, 2.11). Cyrus is so successful at acquiring willing obedience that it is claimed he is a 'king by nature' and that those he leads have a 'terrible passion' (*deinos erōs*) to be ruled by him no less than bees wish to obey the leader of the hive (*Cyrop.* 5.1.24–5). As a result:

> We are different from slaves (Cyrus says to his friends) in that slaves serve their masters unwillingly, but for us, if indeed we think we are free (*eleutheroi*), it is necessary to do everything willingly which we think it is worthwhile to do. (*Cyrop.* 8.1.4)

But Xenophon's Cyrus is not entirely straightforward. Cyrus also thinks that the good ruler can be 'law that sees' (*blepōn nomos*) since he gives orders and punishes wrong-doers (8.1.21–2). This is a difficult passage to understand, though most commentators do not think that Cyrus is placing himself above law.[35] Nevertheless, it has been noted that there are differences between the Cyrus of the earlier parts of the *Cyropaedia* and Xenophon's description of his actions and attitudes once Babylon has been taken. Gera suggests that after Babylon Cyrus becomes a 'benevolent despot'.[36] In particular, although his father Cambyses had advised against the use of deceit against friends and citizens (1.6.27–34), Cyrus adopts Medish dress, because he thought that a ruler ought not just to be superior to his subjects but even to 'bewitch' (*katagoēteuein*) them, and the excesses of the costume would not only make him look taller, but also hide any defects (8.1.40.1; cf. 3.1).[37] In addition, like Herodotus' Medish tyrant Deioces,[38] Cyrus withdraws into his palace and limits access to his person (7.5.37–57). Xenophon also tells us that Cyrus encouraged prostration by initially requiring people to do it, although he tried to pass it off as a spontaneous response to his magnificence (8.3.14). Although Cyrus provides us with much to learn about rulers and ruling, in the end Cyrus is a Persian King.[39]

In contrast, it is the Greek world, and Greek rulers (whether of cities or households), that for Xenophon can provide more appropriate models for

ruling. Notably, Xenophon's Agesilaus, who had *aretē* in his soul (*Ages.* 3.1), considered it a characteristic of the Persian king to hide himself away and be inaccessible to his subjects, whereas for himself he thought it important to be seen, since 'being hidden from sight was appropriate for shameless conduct, but the light provided ornament for a life devoted to nobility' (*Ages.* 9.1–2). He turned away from the opportunity to rule as the greatest in Asia (that is, to rule autocratically as the Great King did), but chose instead to return home to Sparta and to rule and be ruled according to law (*Ages.* 2.16).

For Aristotle, also, the basis for ruling was the possession of *aretē*, either by an individual or by his family, which could place the *basileus* above law. Aristotle's highly schematized analysis is based on the idea that *basileia* is the positive form of monarchy and *tyrannis* is the deviant form, just as all constitutions have a positive and a negative form, which is defined by in whose interests they rule. Tyranny, however, is the most deviant of all deviant forms.[40]

On the other hand, as a 'correct' (*orthos*) form of constitution, Aristotle undertakes to develop a typology of *basileia* (esp. *Pol.* 3.1284b35–12885b33), though many of these so-called correct forms are a mix of *basileia* and *tyrannis*. The first is the 'permanent generalship' as found in Sparta, where the *basileus* has authority on military campaigns and in religious matters. The second type is the ancestral kind (*patria*) found among the barbarians, which are only saved from being tyrannical by the fact that they are under law. The third type is elected *basileia*, which Aristotle calls *aisymneteia*, and gives Pittacus as an example of this kind of *basileia* (*Pol.* 3.1285a29–1285b3). *Aisymnetai* are tyrannical in their power (which Aristotle suggests is absolute), but qualify as *basileis* because they are elected and so rule the willing. The fourth kind of *basileiai*, those of the Heroic Age (*kata hērōkous chronous*), were ancestral and ruled the willing according to law. The fifth kind is the *pambasileia*, which was Absolute Kingship, in which the *basileus* rules over his subjects as a father rules a household, with absolute sovereignty in all issues.

The *pambasileia* is a constitution where a man rules as law (*Pol.* 3.1287a9–10; cf. 3.1286a7–9). Aristotle can imagine a situation which would place a man so far above his contemporaries that it would be unjust for anyone to rule him (*Pol.* 3.1284a3–11). If there was one man so superior in *aretē* that there could be no comparison with the other citizens, it would be unjust for him to be

thought of the same value as the other citizens, for this man would probably be like a god among men (*Pol.* 3.1284a3–11; cf. 3.1284b30–34, 1288a15–30). Aristotle, however, doubts there could be any such man, since he must be so virtuous as to be beyond passion: a man cannot control emotions like anger (*Pol.* 3.1286a33–5; cf. 1286a18–20), and passion warps the rule of even the best men (*Pol.* 3.1287a30).[41] Consequently, law must rule. Blomqvist thinks that Alexander must have been the target of Aristotle's disappointment.[42]

The Athenians' need to theorize rule by one man was important and serious, and was given added impetus by the events following at the end of the Peloponnesian War. In the wake of the Thirty, oligarchy, which had become 'tyrannical',[43] was no longer possible, and (paradoxically perhaps) among Athenian political theorists positive monarchy emerged as a political form which, it was imagined, could deliver fair returns for the most deserving as a critical alternative to democracy.

Athenian democracy defined itself against autocracy; institutionally, it also feared it. But it was still fascinated by it, because Athenian politics and Athenian democracy was still Homeric enough that it yearned for the 'best man'. Athenian democratic theory understood rulers and ruling because it engaged with what were essentially Homeric ideologies of ruling that had currency and importance, even in the fourth century. Even Athens looked to its leaders, like Pericles, Alcibiades – and eventually Demetrius Poliorcetes, who was welcomed into the city as a living god (Douris of Samos, *FGrHist* 76 F13). It was *aretē* in its excess that stood at the heart of the ideologies of ruling in archaic and classical Greece, an *aretē* that made men heroes, more than men, and, if they had enough of it, even gods.

It is often said that personal rule only survived on the fringes of the Greek world, but that is not the case. Sparta, for most of the archaic and classical periods the strongest and most important state in the Greek world, maintained the dyarchy throughout. There were also other cities in the Peloponnese which moved in and out of autocratic forms of rule. Corinth had individual rule in the seventh and sixth centuries. Argos had a *basileus* until the middle of the fifth century. Sicyon had a long-standing dynasty in the archaic period, and probably returned to individual rule in the fourth century. Thessaly had a long tradition of appointing individual rulers. It is difficult to know, in fact, how many Greek cities, especially among the smaller ones, adopted individual

rulers (note especially Euarchus of Astacus in the late fifth century: Th. 2.30.1, 33.1; cf. 101.1).[44] However, what is most striking of all is that Athens – which rejected autocracy most violently – also had the rule of one, of the worst man or best man, deeply embedded in its sense of itself and its democracy.

# Notes

1   Cartledge (2009).

2   Bowra ([1964], 410) thinks the poem dates to 468, though Carey ([1981], 21) considers this impossible since the poem cannot celebrate a victory in any of the major games.

3   Cf. Ostwald (2000), 15–16. In the ode Pindar praises the ruler of Syracuse for securing the safety of the Western Locrians (18–20), for his wise use of his wealth (56–61), for his fame from battle (63–5), and his 'mature counsels' (65). In his praise, Pindar seems to be suggesting that he is an appropriate friend for a ruler, since he is a 'straight-talking' man and not just a flatterer. This apparent self-justification is perhaps ironic (or pre-emptive) since by the end of the century it is the *tyrannos* as the victim of flattery that Herodotus' Otanes says makes a *monarchos* dangerous (3.80.5), and Xenophon is later to describe in his *Hieron* (1.15).

4   V. Parker (1998).

5   See esp. Ostwald (1955). Ostwald thinks that the original archaic law against tyranny must predate Solon (105–10), although Rhodes ([1993], 156) thinks a Solonian law is possible. Hansen ([1975], 15–19) is sceptical that such a law could be tried by the Areopagus this early on the basis that the *nomos eisangeltikos* of the *Ath. Pol.* did not exist prior to 462 BC. See also McGlew (1993), 111–20.

6   Although difficult to date, a *skolion*, or drinking-song, declared that the so-called 'tyrant slayers' made Athens *isonomoi* (either 'equal before the law' or 'equal by law', 'according to an equal distribution': fr. 893 Page *PMG*). The *skolion*, and indeed Antenor's statue group of the Tyrannicides, need to be dated some time after the end of the tyranny because the assassination of Hipparchus did not itself bring an end to the tyranny: Th. 1.20.2, 6.54–9; *Ath. Pol.* 18. However, a certain amount of time must have elapsed before the memory of the end of the tyranny could be 'reinvented', and before Harmodius and Aristogeiton could plausibly become 'Tyrannicides'. See esp. Podlecki (1966). For a date soon after 507 BC: Fornara (1970); Ostwald (1969), 131–3. Thompson

and Wycherley ([1972], 155) opt for a later date, but recognize that there must be a sufficient interval between Antenor's group and their replacement (after the original statue group was taken to Susa by Xerxes) for Pausanias to describe the earlier group as obviously 'older'. See also Brunnsåker (1955).

7　On the inscription and the relief, see Blanshard (2004); L. Mitchell (2007b), 152–8.

8　See esp. L. Mitchell (2006a); see also Introduction.

9　See Calhoun (1913); Connor (1971), 25–32; Rhodes (1995): Mitchell and Rhodes (1996); L. Mitchell (1997), 43–4. Recently, Mann (2007) has also discussed political groups at Athens, but only sees them becoming important at the very end of the fifth century.

10　It is nevertheless also the case that Thucydides overstates Pericles' importance.

11　Henderson (2003), 162–3.

12　On Pericles and Alcibiades as 'good king' and 'wicked tyrant', see L. Mitchell (2008).

13　See Sanders (1987), 7–8.

14　The Persian king is called *basileus* (*megas basileus*: e.g. Aesch. *Pers.* 25; *basileus basileōn*: e.g. ML 12) rather than *tyrannos* (though he is *despotas despotān* in Aesch., *Pers.* 666). The Greeks could use the title 'King of Kings' for other rulers as well: Hecataeus of Abdera, *FGrHist* 264 F 25.635 (fourth century BC, the Egyptian Sesoōis is called *basileus basileōn kai despotēs despotōn*); Diod. 1.47.4 (Osymandyas is *basileus basileōn*), 55.7 (describes a stele on which Sesoōis is called *basileus basileōn kai despotēs despotōn*); Strabo 13.1 (Priam of Troy is *basileus basileōn*).

15　On Theseus at Athens, see L. Mitchell (2008); Rhodes (forthcoming).

16　See Kallet (1998), 53; L. Mitchell (2007), 150.

17　Raaflaub (2009); cf. Root (1985); M. Miller (1997), 243–58.

18　Kallet (2003); Henderson (2003).

19　Mossé (2004), 124–32; Cartledge (2009), 96–103.

20　See Chapter One.

21　On the Debate, see most recently Asheri in Asheri, Lloyd and Corcella (2007), 471–6.

22　Here, in this criticism of democracy, Herodotus' Darius anticipates Plato's critique of democracy, which inevitably results in tyranny: *Rep.* 565c, 565e–566a.

23　Herodotus concedes that the rule of law, as opposed to the rule of the Great King, also created limitations on freedom. Xerxes asked the Spartan Demaratus before the battle of Thermopylae how any group of people could achieve anything if they could do whatever they wanted (7.103.4). Demaratus replied

that the Spartans were free, but not entirely free, because *nomos* was their master (*despotēs*) 'whom they fear more than your subjects fear you' (7.104.4).

24   On the two kinds of equality, see Harvey (1965); id. (1966); Huffman (2005), 212–15.

25   See esp. Moulton (1972).

26   See L. Mitchell (2009), esp. 7, 9. It is worth noting that Thucydides' Pericles here is advocating an understanding of democracy which would allow one such as himself to rise to prominence, and to become the 'first man'. That is not to say that Thucydides whole-heartedly approved of this position. Indeed we know that he favoured a constitution which was a mixing of the few and the many, with no mention of the one (8.97.2). However, he did think that the loss of Pericles was a great blow to the city (2.65.10–12), and that the Athenians made a mistake when they did not entrust their affairs to Alcibiades (6.15.4).

27   For the importance of Sparta as a model for ideal constitutions, see Hodkinson (2005).

28   See Schofield (2006), 161–3 *contra* Cohen ([1995], 43) who argues that Plato rejects the rule of law.

29   Schofield (2006), 166–73.

30   See Rhodes (1993), 345–6. In the mid fourth century, Isocrates provides a list of the best statesmen (who he also thinks are those who have paid most attention to speech-craft), starting from Solon, who he says was the first *prostatēs tou dēmou* (15.231–6). The *Athenaion Politeia*, in the late fourth century, on the other hand, understands Athenian politics in terms of a competition between class-based opposites: the champions of the *dēmos* against the champions of the 'notables' or the 'wealthy' (e.g. *Ath. Pol.* 28).

31   Gray (2011).

32   The theoretical innovation here is not that either rich or poor could excel (Thucydides' Pericles had already claimed that: 2.37.2), but the recognition that the conditions for equality of opportunity have to be created through equality of education, training and equipment so that anyone could be the best. *Pace* Gray (2007), 11–12, Cyrus does not create a 'democratic' reorganization of the army, despite the fact that Pheraulas, the man of the commons (*demotēs*), anticipates with alacrity the 'dēmotic contest' with the elite: 2.3.15, since hierarchical rewards for excellence (despite equality of opportunity) ran against the most basic tenets of democratic theorizing and democratic equality.

33   Gray (2011), 180–96.

34   The art of ruling men can be taught: cf. *Oec.* 13.4–12.

35   E.g. Azoulay (2004), 169; Gray (2011), 288–9.

36    Gera (1993), 285–99, notices Xenophon's less positive attitude towards Cyrus, but then concludes (oddly) that Cyrus has become a benevolent despot because that it what is needed for ruling an empire. Nadon, on the other hand, concludes that Xenophon (who, for Nadon, is interested in studying the best kind of constitution) uses the discrepancies between his representation of the pre-and post-Babylon Cyrus to show (although not uncritically) that Republic rather than Empire is the best form of rule for achieving the common life of virtue: (2001), 161–80.

37    In the *Oeconomicus* Ischomachus rebukes his wife for wearing make-up and taller shoes since such cosmetic changes may trick outsiders, but are deceptions which are bound to be discovered by those who live together (10.2–8). Likewise, Xenophon's Agesilaus also valued simplicity in his dress (*Ages.* 11.11; *Hell.* 4.1.30).

38    Hdt. 1.98.3–99.1.

39    See Gray (2011), 276–89; Tuplin (2013); cf. Azoulay (2004).

40    Blomqvist (1998), 8–9.

41    Cf. Newell (1991); Lindsay (1991); Blomqvist (1998), 8–14; Bates (2003), 83–187.

42    Blomqvist (1998), 29–52.

43    Xenophon says that the Thirty behaved 'tyrannically' (*Hell.* 2.4.1) and at some point during the fourth century the name the 'Thirty Tyrants' was coined (e.g. Arist. *Rhet.* 3.1401a35–6; cf. [for example] Diod. 14.2.1, 4).

44    Note esp. comments by Hornblower (1991–2008), 1.289.

# Bibliography

Adkins, A. W. H. (1960) *Merit and Responsibility. A Study in Greek Values.* Oxford: Oxford University Press.

Adornato, G. (2008) 'Delphic Enigmas? The *Gelas anassōn*, Polyzalos, and the Charioteer Statue', *AJA* 112: 29–55.

Agamben, G. (1998) *Homo Sacer: Sovereign Power and Bare Life*, trans. D. Heller-Roazen. Stanford: Stanford University Press.

al-Azmeh, A. (1988) *Muslim Kingship. Power and the Sacred in Muslim, Christian and Pagan Polities*, 2nd edn. London and New York: I. B. Tauris.

Allan, W. (2000) *The* Andromache *and Euripidean Tragedy.* Oxford: Oxford University Press.

Aloni, A. (1997) 'The Proem of Simonides' Elegy on the Battle of Plataea (Sim. Frs. 10–18 W²) and the Circumstances of its Performance', in L. Edmunds and R. W. Wallace (eds), *Poet, Public and Performance in Ancient Greece.* Baltimore: Johns Hopkins University Press, 8–28.

—(2001) 'The Proem of Simonides' Plataea Elegy and the Circumstances of its Performance', in D. Boedeker and D. Sider (eds), *The New Simonides: Contexts of Praise and Desire.* Oxford: Oxford University Press, 86–105.

Alonso, V. (2007) 'War, Peace and International Law', in K. A. Raaflaub (ed.), *War and Peace in the Ancient World.* Malden, Oxford and Carlton: Blackwell, 206–25.

Anderson, B. R. O'G. (1990) *Language and Power. Exploring Political Cultures in Indonesia.* Ithaca and London: Cornell University Press.

Anderson, G. (2000) 'Before *Turannoi* were Tyrants: Rethinking a Chapter of Early Greek Tyrants', *ClassAnt* 24: 173–222.

Ando, C. (2000) *Imperial Ideology and Provincial Loyalty in the Roman Empire.* Berkeley, Los Angeles and London: University of California Press.

Andrewes, A. (1966) 'The Government of Classical Sparta', in E. Badian (ed.), *Ancient Society and Institutions. Studies Presented to Victor Ehrenberg on his 75th Birthday.* Oxford: Oxford University Press, 8–14.

—(1974) *The Greek Tyrants*, 2nd edn. London: Hutchinson & Co.

Anson, E. (2009) 'Philip II, Amyntas Perdicaa, and Macedonian Royal Succession', *Historia* 58: 276–86.

Antonaccio, C. M. (1995) *An Archaeology of Ancestors. Tomb Cult and Hero Cult in Early Greece*. Maryland and London: Rowman and Littlefield.

—(1999) 'Colonization and the Origins of Hero Cult', in R. Hägg (ed.), *Ancient Greek Hero Cult*. Jonsered: Svenska Institut i Athen, 109–21.

—(2006) 'Religion, *Basileis* and Heroes', in S. Deger-Jalkotzy and I. S. Lemos (eds), *Ancient Greece: From Mycenean Palaces to the Age of Homer*. Edinburgh: Edinburgh University Press, 381–95.

—(2007) 'Elite Mobility in the West', in S. Hornblower and C. Morgan (eds), *Pindar's Poetry, Patrons and Festivals*. Oxford: Oxford University Press, 265–85.

Archibald, Z. (2000) 'Space, Hierarchy, and Community in Archaic and Classical Macedonia, Thessaly, and Thrace', in R. Brock and S. Hodkinson (eds), *Alternatives to Athens. Varieties of Political Organization and Community in Ancient Greece*. Oxford: Oxford University Press, 212–33.

Ashe, L. (2013) 'The Anomalous King of Conquered England', in L. Mitchell and C. Melville (eds), *Every Inch a King: Comparative Studies on Kings and Kingship in the Ancient and Medieval Worlds*. Leiden: Brill, 173–93.

Asheri, D. (1992) 'Sicily, 478–431 BC', *Cambridge Ancient History* V, 2nd edn. Cambridge: Cambridge University Press, 147–70.

Asheri, D., A. B. Lloyd and A. Corcello, (2007) *A Commentary on Herodotus I–IV*. Oxford: Oxford University Press.

Assman, J. (1992) *Das kulturelle Gedächtnis. Schrift, Erinnerung und politische Idenität in frühen Hochkulturen*. Munich: C. H. Beck.

Athanassaki, L. (2003) 'Transformations of Colonial Disruption into Narrative Continuity in Pindar's Epinician Odes', *HSCP* 101: 93–128.

Azoulay, V. (2004) 'The Medo-Persian Ceremonial: Xenophon, Cyrus and the King's Body', in C. Tuplin (ed.), *Xenophon and his World. Papers From a Conference Held in Liverpool in July 1999* (*Historia* Einzelschriften 172). Stuttgart: Franz Verlag, 147–73.

Badian, E. (1981) 'The Deification of Alexander the Great', in H. J. Dell (ed.), *Ancient Macedonian Studies in Honor of Charles F. Eddson*. Thessaloniki: Institute for Balkan Studies, 27–71.

—(1993) 'Thucydides and the *Archē* of Philip', in *From Plataea to Potidaea. Studies in the History and Historiography of the Pentecontaetia*. Baltimore and London: Johns Hopkins University Press, 174–85.

—(1996) 'Alexander the Great between Two Thrones and Heaven: Variations on an Old Theme', in A. Small (ed.), *Subject and Ruler: The Cult of the Ruling Power in Classical Antiquity = Journal of Roman Archaeology* Suppl. 17. Ann Arbor: Journal of Roman Archaeology, 11–26

Baitinger, H. (2001) *Olympische Forschungen* (vol. XXIX) *Angriffswaffen ans Olympia*. Berlin and New York: Walter De Gruyter.

Balot, R. K. (2006) *Greek Political Thought*. Malden, Oxford and Carlton: Blackwell.

Balsdon, J. P. V. D. (1950) 'The 'Divinity' of Alexander', *Historia* 1: 363–88

Bates Jr, C. A. (2003) *Aristotle's "Best Regime": Kingship, Democracy and the Rule of Law*. Baton Rouge: Louisiana State University Press.

Bedford, P. R. (2009) 'The Neo-Assyrian Empire', in I. Morris and W. Scheidel (eds), *The Dynamics of Ancient Empires*. Oxford: Oxford University Press, 30–65.

Bell, M. (1995) 'The Motya Charioteer and Pindar's *Isthmian* II', *MAAR* 40: 1–42.

Beloch, K. J. (1926) *Griechishe Geschichte* vol. 1².2. Berlin and Leipzig: Walter de Gruyter.

—(1923) *Griechische Geschichte*, vol. 3.2. Berlin and Leipzig: Walter de Gruyter.

Benton, S. (1939–40) 'Bronzes from Palaikastro and Praisos', *BSA* 40: 57–9.

Bérard, C. (1972) 'Le sceptre du prince', *MusHelv* 29: 219–27.

—(1982) 'Récupérer la mort du prince: héroïsation et formation de la cité', in G. Gnoli and J.-P. Vernant (eds), *La Mort, les morts dans le société anciennes*. Cambridge and Paris: Cambridge University Press and Editions de la Maison des Sciences de l'Homme, 89–105.

Bernabé, A. (ed.) (2004) *Orphicorum et Orphicis similium testimonia et fragmenta. Poetae Epici Graeci. Pars II. Fasc. I.* Munich/Leipzig: K. G. Saur.

Bertelli, L. (2001) 'Hecataeus: From Genealogy to Historiography', in N. Luraghi (ed.), *The Historians Craft in the Age of Herodotus*. Oxford: Oxford University Press, 67–94.

Berve, H. (1967) *Die Tyrannis bei den Griechen*, in 2 vols. Munich: C. H. Beck'sche Verlagsbuchhandlung.

Binford, L .R. (1983) *In Pursuit of the Past: Decoding the Archaeological Record*. Berkeley and Los Angeles: University of California Press.

Blanshard, A. J. L. (2004) 'Depicting Democracy: An Exploration of Art and Text in the Law of Eukrates', *JHS* 124: 1–15.

Blomqvist, K. (1998) *The Tyrants in Aristotle's* Politics: *Theoretical Assumptions and Historical Background*. Lund: Kungl. Humanistiska Vetenskapssamfundet.

Blundell, M. W. (1989) *Helping Friends and Harming Enemies. A Study in Greek Ethics*. Cambridge: Cambridge University Press.

Boda, M. J. and J. Novotny (eds) (2010) *From the Foundations to the Crenellations. Essays on Temple Building in the Ancient Near East and Hebrew Bible*. Münster: Ugarit-Verlag.

Boiy, T. (2004) *Late Achaemenid and Hellenistic Babylon*. Leuven: Peeters.

Bol, P. C. (1989) *Olympische Forschungen* (vol XVII) *Argivische Schilde*. Berlin: Walter de Gruyter.

Bollansée, J. (1995) 'Hermippos of Smyrna on Lawgivers: Demonax of Mantineia', *Ancient Society* 26: 289–300.

Bommelaer, J.-F. (1971) 'Le monument de Lysandre à Delphes, état actuel de la recherche', *REG* 84: xxii–xxvi.

Bonanno, D. (2010) *Ierone il Dinomenide. Storia e rappresentazione*. Pisa and Rome: Fabrizio Serra Editore.

Borza E. N. (1990) *In the Shadow of Olympus. The Emergence of Macedon*. Princeton: Princeton University Press.

—(1999) *Before Alexander: Constructing Early Macedonia*. Claremont: Regina.

Bosher, K. (2012) 'Hieron's Aeschylus', in K. Bosher (ed.), *Theater Outside Athens: Drama in Greek Sicily and South Italy*. New York: Cambridge University Press, 97–111.

Bosworth, A. B. (1988) *Conquest and Empire: The Reign of Alexander the Great*. Cambridge: Cambridge University Press.

Bowden, H. (1993) 'Hoplites and Homer: Warfare, Hero Cult and the Ideology of the Polis', in J. Rich and G. Shipley (eds), *War and Society in the Greek World*. London: Routledge, 45–63.

Bowie, E. L. (1986) 'Early Greek Elegy, Symposium and Public Festival', *JHS* 106: 13–35.

—(2001) 'Ancestors of Historiography in Early Greek Elegiac and Iambic Poetry?', in N. Luraghi (ed.), *The Historian's Craft in the Age of Herodotus*. Oxford: Oxford University Press, 45–66.

Bowra, C. M. (1964) *Pindar*. Oxford: Oxford University Press.

Braswell, B. K. (1988) *A Commentary on the Fourth Pythian Ode of Pindar*. Berlin and New York: Walter de Gruyter.

Bremmer, J. (1987) 'Scape-goat Rituals in Ancient Greece', *HSCP* 87: 299–320.

Briant, P. (1973) *Antigone le Borgne. Les débuts de sa carrier et les problèmes de l'assembleé macédonienne*. Paris: Les Belles Lettres.

—(2002) *From Cyrus to Alexander. A History of the Persian Empire*, trans. P. T. Daniels. Winona Lake, Indiana: Eisenbrauns.

Broadie, S. (1999) 'Rational Theology', in A. A. Long (ed.), *The Cambridge Companion to Early Greek Philosophy*. Cambridge: Cambridge University Press, 205–24.

Brosius, M. (1996) *Women in Ancient Persia*. Oxford: Oxford University Press.

—(2007) 'New Out of Old? Court and Court Ceremonies in Achaemenid Persia', in A. J. S. Spawforth (ed.), *The Court and Court Society in Ancient Monarchy*. Cambridge: Cambridge University Press, 17–57.

Brunnsåker, S. (1955) *The Tyrant Slayers of Kritios and Nesiotes. A Critical Study of the Sources and Restorations*. Stockholm: Svenska Insitutet i Athen.

Brunt, P. A. (ed.) (1983–9) *Arrian: The History of Alexander and Indica*, 2 vols. Cambridge, MA and London: Heinemanns.

Buraselis, K. *et al.* (2004) 'Einleitung: Terminologische Vorklärung', K. Buraselis *et al.* 'Heroiserung und Apotheose', *ThesCRA*, vol. 2. Los Angeles: J. Paul Getty Museum, 126–9.

Burford, A. (1969) *The Greek Temple Builders at Epidauros*. Liverpool: Liverpool University Press.

Burkert, W. (1985) *Greek Religion: Archaic and Classical*, trans. J. Raffan. Oxford: Oxford University Press.

Burnett, A. (1987) 'The Scrutiny of Song: Pindar, Politics and Poetry', *Critical Inquiry* 13: 434–49.

Burton, R. W. B. (1962) *Pindar's Pythian Odes*. Oxford: Oxford University Press.

Cabanes, P. (1976) *L'Épire de la mort de Pyrrhos à la conquête romaine (272–167 av. J.C.)*. Paris: Les Belles Lettres.

—(2010) 'Institutions politiques et développment urbain (IVᵉ–IIIᶜ) s. avant J.-C.): réflexions historique à partir de l'Épire', in C. Antonetti (ed.), *Lo spazio ionico e le communità della Grecia nord-occidentale: Territorio, società, istituzioni*. Pisa: Edizioni ETS, 117–40.

Calhoun, G. M. (1913) *Athenian Clubs in Politics and Litigation*. New York: Burt Franklin.

Camp, J. M. (1986) *The Athenian Agora: Excavations in the Heart of Classical Athens*. London: Thames and Hudson.

—(1991) *The Archaeology of Athens*. New Haven and London: Yale University Press.

Cannadine, D. (1987) 'Introduction', in D. Cannadine and S. Price (eds), *Rituals of Royalty: Power and Ceremonial in Traditional Societies*. Cambridge: Cambridge University Press, 1–19.

Cannadine, D. and S. Price (eds), *Rituals of Royalty: Power and Ceremonial in Traditional Societies*. Cambridge: Cambridge University Press.

Cantarella, E. (2003) *Ithaque. De la vengeance d'Ulysse à la naissance du droit*. Paris: Albin Michel.

Carawan, E. (1998) *Rhetoric and the Law of Draco*. Oxford: Oxford University Press.

Carey, C. (1980) 'The Epilogue of Pindar's *Fourth Pythian*', *Maia* 32: 143–52.

—(1981) *A Commentary on Five Odes of Pindar: Pythian 2, Pythian 9, Nemean 1, Nemean 7, Isthmian 8*. New York: Arno Press.

Carlier, P. (1984) *La royauté en Grèce avant Alexandre*. Strassburg: AECR.

—(2000) 'Homeric and Macedonian Kingship', in R. Brock and S. Hodkinson (eds), *Alternatives to Athens. Varieties of Political Organization and Community in Ancient Greece*. Oxford: Oxford University Press, 259–68.

Carneiro, R. L. (1967) 'On the Relationship between Size of Population and
    Complexity of Social Organization', *Southwestern Journal of Anthropology* 23:
    234–43 (= [1986] *Journal of Anthropological Research* 42: 355–64).
—(1970) 'A Theory of the Origin of the State', *Science* 169: 733–80.
—(1981) 'The Chiefdom: Precursor of the State', in G. D. Jones and R. R. Kautz (eds), *The*
    *Transition to Statehood in the New World*. Cambridge: Cambridge University Press.
Carney, E. D. (1983) 'Regicide in Macedonia', *La Parola del Passato* 38: 260–72.
—(1995) 'Women and *basileia*: Legitimacy and Female Political Action in
    Macedonia', *CJ* 90: 367–91.
—(2000a) *Women and Monarchy in Macedonia*. Norman: University of Oklahoma
    Press.
—(2000b) 'The Initiation of Cult for Royal Macedonian Women', *CP* 95: 21–43.
—(2006) *Olympias, Mother of Alexander the Great*. New York and Abingdon:
    Routledge.
Carpanos, C. (1878) *Dodone et ses ruines*. Paris: Librairie Hachette.
Cartledge, P. (1982) 'Sparta and Samos: A Special Relationship?', *CQ* 32: 243–65.
—(1987) *Agesilaos and the Crisis of Sparta*. London: Duckworth.
—(1998) 'Writing the History of Archaic Greek Political Thought', in N. Fisher and
    H. van Wees (eds), *Archaic Greece: New Evidence and New Approaches*. London/
    Swansea: Duckworth with the Classical Press of Wales, 379–99.
—(2002). *Sparta and Lakonia. A Regional History 1300 to 362 BC*, 2nd edn. London:
    Routledge.
—(2003) 'Raising Hell? The Helot Mirage – A Personal Review', in N. Luraghi and
    S. E. Alcock (eds), *Helots and their Masters in Laconia and Messenia: Histories,*
    *Ideologies, Structures*. Cambridge, MA and London: Centre for Hellenic Studies,
    12–30.
—(2005) 'Greek Political Thought: The Historical Context', in C. Rowe and M.
    Schofield (eds), *Cambridge History of Greek and Roman Political Thought*.
    Cambridge: Cambridge University Press, 11–22.
—(2009) *Ancient Greek Political Thought in Practice*. Cambridge: Cambridge
    University Press.
Cawkwell, G. (1963) 'Notes on the Peace of 375/4', *Historia* 12: 84–95.
—(1981) 'Notes on the Failure of the Second Athenian Confederacy', *JHS* 101: 40–55.
—(1994) 'The Deification of Alexander the Great: A Note', in I. Worthington (ed.),
    *Ventures into Greek History: Essays in Honour of N. G. L. Hammond*. Oxford:
    Oxford University Press, 293–306.
Chamoux, F. (1953) *Cyrène sous la monarchie des Battiades*. Paris: de Boccard.
Chaniotis, A. (2003) 'The Divinity of Hellenistic Rulers', in A. Erskine (ed.), *A*

*Companion to the Hellenistic World*. Malden, Oxford, Melbourne and Berlin: Blackwell, 431–45.

—(2005) *War in the Hellenistic World*. Malden, Oxford and Carlton: Blackwell.

—(2011) 'The Ithyphallic Hymn for Demetrios Poliorketes and Hellenistic Religious Mentality', in P. P. Iossif, A. S. Chanowski, and C. C. Lorber (eds), *More than Men, Less Than Gods. Studies on Royal Cult and Imperial Worship. Proceedings of the International Colloquium Organised by the Belgian School at Athens (November 1–2, 2007)*. Leuven, Paris and Walpole, MA: Peeters, 157–95.

Chavalas, M. (ed.) (2006) *The Ancient Near East. Historical Sources in Translation*. Malden, Oxford and Carlton: Blackwell.

Christesen, P. (2007) *Olympic Victor Lists and Ancient Greek History*. Cambridge: Cambridge University Press.

Clarke, K. (2008) *Making Time for the Past. Local History and the* Polis. Oxford: Oxford University Press.

Cohen, D. (1995) *Law, Violence and Community in Classical Athens*. Cambridge: Cambridge University Press.

Coldstream, J. N. (2003) *Geometric Greece, 900–700 BC*, 2nd edn. London and New York: Routledge.

Connor, W. R. (1971) *The New Politicians of Fifth-Century Athens*. Princeton: Princeton University Press.

—(1985) 'The Razing of the House in Greek Society', *TAPA* (115): 79–102.

Constantakopoulou, C. (2007) *The Dance of the Islands. Insularity, Networks, the Athenian Empire, and the Aegean World*. Oxford: Oxford University Press.

Cox, C. A. (1989) 'Incest, Inheritance and the Political Forum in Fifth-century Athens', *CJ*: 34–46.

—(2011) 'Marriage in Ancient Athens', in B. Rawson (ed.), *A Companion to Families in the Greek and Roman Worlds*. Malden, Oxford and Chichester: Blackwell Publishing, 231–44.

Crane, G. (1989) 'Creon and the "Ode to Man" in Sophocles' *Antigone*', *HSCP* 92: 103–16.

Crielaard, J. P. (1998) 'Cult and Death in Early 7th-centry Euboea. The Aristocracy and the Polis', in S. Marchegay, M.-T. La Dinahet and J.-F. Salles (eds), *Nécropoles et pouvoir: Idéologies, pratiques et interpretations*. Lyon: Maison de l'Orient Méditerranéan, 43–58.

—(2006) 'Basileis at Sea: Elites and External Contacts in the Euboean Gulf Region From the end of the Bronze to the Beginning of the Iron Age', in S. Deger-Jalkotzy and I. S. Lemos (eds), *Ancient Greece: From Mycenean Palaces to the Age of Homer*. Edinburgh: Edinburgh University Press, 271–97.

—(2009), 'Cities', in K.A. Raaflaub and H. van Wees (eds), *A Companion to Archaic Greece*. Malden, Oxford and Chichester: Blackwell, 349–72.

Crotty, K. (1982) *Song and Action. The Victory Odes of Pindar*. Baltimore and London: Johns Hopkins University Press.

Crouch, C. L. (2009) *War and Ethics in the Ancient Near East. Military Violence in Light of Cosmology and History*. Berlin and New York: Walter de Gruyter.

Curley, E. (ed.) (1994) *Thomas Hobbes*. Leviathan *with Selected Variants from the Latin Edition of 1668*. Indianapolis: Hackett.

Currie, B. (2002) 'Euthymos of Locri: A Case Study in Heroization in the Classical Period', *JHS* 122: 22–44.

—(2005) *Pindar and the Cult of the Heroes*. Oxford: Oxford University Press.

Dakaris, S. (1964) Οἱ γενεαλόγικοι μῦθου τῶν Μολόσσων. Athens: Βιβλιοθήκη τῆς ἐν Ἀθηναῖς Ἀρχαιολογίκης Ἑταιρείας.

Dale, A. (2011) 'Alcaeus on the Career of Myrsilos: Greeks, Lydians and Luwians at the East Aegean-West Anatolian Interface', *JHS* 131: 15–24.

Davies, J. K. (1971) *Athenian Propertied Families, 600–300 BC*. Oxford: Oxford University Press.

—(1981) *Wealth and the Power of Wealth in Classical Athens*. New York: Arno Press.

—(1997) 'The "Origins of the Greek *Polis*"', in L. G. Mitchell and P. J. Rhodes (eds), *The Development of the* Polis *in Archaic Greece*. London and New York: Routledge, 24–38.

—(2000) 'A Wholly Non-Aristotelian Universe: The Molossians as Ethnos, State and Monarchy', in R. Brock and S. Hodkinson (eds), *Alternatives to Athens. Varieties of Political Organization and Community in Ancient Greece*. Oxford: Oxford University Press, 234–58.

—(2007) 'The Origins of the Festivals, especially Delphi and the Pythia', in S. Hornblower and C. Morgan (eds), *Pindar's Poetry, Patrons and Festivals*. Oxford: Oxford University Press, 47–69.

Davis, E. N. (1995) 'Art and Politics in the Aegean: the Missing Ruler', in P. Rehak (ed.), *The Role of the Ruler in the Prehistoric Aegean. Proceedings of a Panel Discussion presented at the Annual Meeting of the Archaeological Institute of America New Orleans, Louisiana 28 December 1992 with Additions*. Liège and Austin: University of Liège and University of Texas, 11–20.

Dearden, C. W. (1990) 'Fourth-Century Tragedy in Sicily: Athenian or Sicilian?' in J.-P. Descoeudres (ed.), *Greek Colonists and Native Populations. Proceedings of the First Australian Congress of Classical Archaeology held in honour of Emeritus Professor A. D. Trendall*. Oxford: Oxford University Press, 231–42.

Deger-Jalkotzy, S. (1991) 'Diskontinuität und Kontinuität: Aspekte politischer und

sozialer Organisation in mykenisher Zeit und in der Welt der Homerischen Epen', in D. Musti, A. Saconni, L. Rochetti, M. Rocchi, E. Scafa, L. Sportiello, M. E. Giannotta (eds), *La transizione dal miceneo all' alto arcaismo. Dal palazzo alla città*. Rome: Consiglio Nazionale Delle Ricerche, 53–66.

—(2006) 'Late Mycenean Warrior Tombs', in S. Deger-Jalkotzy and I. S. Lemos (eds), *Ancient Greece: From Mycenean Palaces to the Age of Homer*. Edinburgh: Edinburgh University Press, 151–79.

Deger-Jalkotzy, S. and I. S. Lemos (eds) (2006) *Ancient Greece: From Mycenean Palaces to the Age of Homer*. Edinburgh: Edinburgh University Press.

Demand, N. H. (1990) *Urban Relocation in Archaic and Classical Greece*. Bristol: Bristol Classical Press.

Dewald, C. (2003) 'Form and Content: The Question of Tyranny in Herodotus', in K. Morgan (ed.), *Popular Tyranny: Sovereignty and its Discontents in Ancient Greece*. Austin: University of Texas Press, 25–58.

Decourt, J.-C., T. H. Nielsen and B. Helly (2004) 'Thessalia and Adjacent Regions', in M. H. Hansen and T. H. Nielsen (eds), *An Inventory of Archaic and Classical Poleis*. Oxford: Oxford University Press, 676–731.

Detienne, M. and J.-P. Vernant (eds) (1989) *The Cuisine of Sacrifice among the Greeks*, trans. P. Wissing. Chicago and London: University of Chicago Press.

Dodds, E. R. (1951) *The Greeks and the Irrational*. Berkeley, LA and London: University of California Press.

Donlan, W. (1981–2) 'Reciprocities in Homer', *CW* 75: 137–75.

—(1997) 'The Relations of Power in the Pre-State and Early State Polities', in L. G. Mitchell and P. J. Rhodes (eds), *The Development of the* Polis *in Archaic Greece*. London and New York: Routledge, 39–48.

Dougherty, C. (1993) *The Poetics of Colonization. From City to Text in Archaic Greece*. New York and Oxford: Oxford University Press.

Dover, K. J. (1960) 'ΔΕΚΑΤΟΣ ΑΥΤΟΣ', *JHS* 80: 61–77.

Drews, R. (1974) 'Sargon, Cyrus and Mesopotamian Folk History', *Journal of Near Eastern Studies* 33: 387–93.

—(1983) *Basileus. The Evidence for Kingship in Geometric Greece*. Yale: Yale University Press.

Duncan, A. (2012) 'A Theseus Outside Athens: Dionysius I of Syracuse and Tragic Self-presentation', in K. Bosher (ed.), *Theater Outside Athens: Drama in Greek Sicily and South Italy*. New York: Cambridge University Press, 137–55.

Dyer, L. (1906) 'Details of the Olympian Treasuries', *JHS* 26: 46–83.

Earle, T. (1991) 'The Evolution of Chiefdoms', in T. Earle (ed.), *Chiefdoms: Power, Economy and Ideology*. Cambridge: Cambridge University Press, 1–15.

Eder, B. (2006) 'The World of Telemachus: Western Greece 1200–700 BC', in
    S. Deger-Jalkotzy and I. S. Lemos (eds), *Ancient Greece: From Mycenean Palaces to
    the Age of Homer*. Edinburgh: Edinburgh University Press, 549–80.

Ellis, J. R. (1973) 'The Step-brothers of Philip II' *Historia* 22: 350–4.

—(1979) *Philip II and Macedonian Imperialism*. London: Thames and Hudson.

Errington, R. M. (1978) 'The Nature of the Macedonian State under the Monarchy',
    *Chiron* 8: 77–133.

Evans, J. A. S. (1991) *Herodotus, Explorer of the Past*. Princeton: Princeton University
    Press.

Farenga, V. (2006) *Citizen and Self in Ancient Greece. Individuals Performing Justice
    and the Law*. Cambridge, New York, Melbourne, Madrid, Cape Town, Singapore,
    São Paulo: Cambridge University Press.

Faulkner, A. (2011) 'Introduction: Modern Scholarship on the *Homeric Hymns*:
    Foundational Issues', in A. Falkner (ed.), *The Homeric Hymns: Interpretative
    Essays*. Oxford: Oxford University Press, 1–25.

Feeley-Harnik, G. (1985) 'Issues in Divine Kingship', *Annual Review of Anthropology*
    14: 273–313.

Feens, N. (1999) 'Fictive *Deixis* in Pindar's *Pythian* Four', *HSCP* 99: 1–31.

Ferill, A. (1978) 'Herodotus on Tyranny', *Historia* 27: 385–98.

Finkelberg, M. (2005) *Greeks and Pre-Greeks. Aegean Prehistory and the Greek Heroic
    Tradition*. Cambridge: Cambridge University Press.

Finley, M. (1977) *The World of Odysseus*, 2nd edn. London: Chatto and Windus.

Fischer-Hansen, T, T. H. Nielsen and C. Ampolo (2004) 'Sikelia', in M. H. Hansen
    and T. H. Nielsen (eds), *An Inventory of Archaic and Classical Poleis*. Oxford:
    Oxford University Press, 172–248.

Fisher, N. (2009), 'The Culture of Competition', in K. A. Raaflaub and H. van Wees
    (eds), *A Companion to Archaic Greece*. Malden, Oxford and Chichester: Wiley-
    Blackwell, 524–41.

Flower, M. A. (1988) 'Agesilaus of Sparta and the Origins of the Ruler Cult', *CQ* 38:
    123–34.

—(2002) 'The Invention of Tradition in Classical and Hellenistic Sparta', in A.
    Powell and S. Hodkinson (eds), *Sparta: Beyond the Mirage*. London and Swansea:
    Duckworth and the Classical Press of Wales, 191–217.

Fol, A. and I. Marazov (1977) *Thrace and the Thracians*. London: Cassell.

Fornara, C. W. (1970) 'The Cult of Harmodius and Aristogeiton', *Philologus* 114:
    55–80.

Forsdyke, S. (2005) *Exile, Ostracism and Democracy: The Politics of Expulsion in
    Ancient Greece*. Princeton: Princeton University Press.

—(2009) 'The Uses and Abuses of Tyranny', in R. K. Balot (ed.), *A Companion to Greek and Roman Political Thought*. Malden, Oxford and Chichester: Blackwell, 231–46.

Fox, P. W. (1960) 'Louis XIV and the Theories of Absolutism and Divine Right', *The Canadian Journal of Economics and Political Science* 26: 128–42.

Foxhall, L. (1997) 'A View from the Top: Evaluating the Solonian Property Classes', in L. G. Mitchell and P. J. Rhodes (eds), *The Development of the* Polis *in Archaic Greece*. London and New York: Routledge, 113–36.

Franklin, J. H. (ed.) (1992) *Jean Bodin,* On Sovereignty. Cambridge: Cambridge University Press.

Fredericksmeyer, E. A. (1979) 'Divine Honours for Philip II', *Transaction of the American Philological Association* 109: 39–61.

—(1981) 'On the Background of the Ruler Cult', in H. J. Dell (ed.), *Ancient Macedonian Studies in Honor of Charles F. Edson*. Thessaloniki: Institute for Balkan Studies, 145–56.

—(2003) 'Alexander's Religion and Divinity', in J. Roisman (ed.), *Brill's Companion to Alexander the Great* (Leiden: Brill), 253–78.

Fried, M. H. (1967) *The Evolution of Political Society. An Essay in Political Anthropology*. New York: McGraw Hill.

Fukuyama, F. (1992) *The End of History and the Last Man*. London: Penguin.

Funck, B. (1996) 'Beobachtung zum Begriff des Herrcherpalastes und seiner machtpolitischen Funktion im hellenistischen Raum. Prolegomena zur Typologie der hellenistischen Herrschaftssprache', in W. G. Hoepfner and G. Brands (eds), *Basileia. Die Paläste der hellenistischen Könige*. Mainz am Rheim: Verlag Philipp van Zabern, 44–55.

Funke, P. (2006) 'Western Greece (Magna Graecia)', in. K. Kinzl (ed.), *A Companion to the Classical Greek World*. Malden, Oxford, Carlton: Blackwell, 153–73.

Gabrielsen, V. (2005) 'Mithradates VI og de greaske byer', in J. M. Højte (ed.), *Mithradates VI af Pontos. Roms perfekte fjende*. Åarhus: Åarhus Universitetsforlag, 25–42.

Gagarin, M. (1974) '*Dike* in Early Greek Thought', *CP* 3: 186–97.

—(1986) *Early Greek Law*. Berkeley, Los Angeles and London: University of California Press.

Garrison, M. B. (2011) '"By the Favour of Auramazdā": Kingship and the Divine in the Early Achaemenid Period', in P. P. Iossif, A. S. Chanowski and C. C. Lorber (eds), *More than Men, Less Than Gods. Studies on Royal Cult and Imperial Worship. Proceedings of the International Colloquium Organised by the Belgian School at Athens (November 1–2, 2007)*. Leuven, Paris, Walpole, MA: Peeters, 15–104.

Gebhard, E. R. (1993) 'The Evolution of a Pan-Hellenic Sanctuary: From Archaeology towards History', in N. Marinatos and R. Hägg (eds), *Greek Sanctuaries: New Approaches*. London and New York: Routledge, 154–77.

—(2002) 'The Beginning of Panhellenic Games at the Isthmus' in H. Kyrieleis (ed.), *Olympia 1875–2000. 125 Jahre Desutche Ausgrabungen*. Mainz am Rhein: Philipp von Zabern, 251–71.

Gehrke, H.-J. and E. Wirbelauer (2004) 'Akarnania and Adjacent Areas', in M. H. Hansen and T. H. Nielsen (eds), *An Inventory of Archaic and Classical* Poleis. Oxford: Oxford University Press, 351–78.

Georges, P. (1994) *Barbarian Asia and the Greek Experience. From the Archaic Period to the Age of Xenophon*. Baltimore and London: Johns Hopkins University Press.

Gera, D. L. (1993) *Xenophon's* Cyropaedia: *Style, Genre and Literary Technique*. Oxford: Oxford University Press.

Gernet, L. (1981) *The Anthropology of Ancient Greece*, trans. J. Hamilton, S. J. Nagy and B. Nagy. Baltimore and London: Johns Hopkins University Press.

Giangiulio, M. (2006) 'Constructing the Past: Colonial Traditions and the Writing of History. The Case of Cyrene', in N. Luraghi (ed.), *The Historian's Craft in the Age of Herodotus*, rev. edn. Oxford: Oxford University Press, 116–37.

Golden, M. (1998) *Sport and Society in Ancient Greece*. Cambridge: Cambridge University Press.

Graham, A. J. (1964) *Colony and Mother City in Ancient Greece*. Manchester: University of Manchester Press.

Gray, V. J. (2005) 'Xenophon and Isocrates', in C. Rowe and M. Schofield (eds), *The Cambridge History of Greek and Roman Thought*. Cambridge: Cambridge University Press, 142–54.

—(2007) *Xenophon. On Government*. Cambridge: Cambridge University Press.

—(2011) *Xenophon's Mirror of Princes. Reading the Reflections*. Oxford: Oxford University Press.

Greenwalt, W. (1989) 'Polygamy and Succession in Argead Macedonia', *Arethusa* 22: 19–45.

Griffiths, A. (1989) 'Was Kleomenes Mad?', in A. Powell (ed.), *Classical Sparta: Techniques Behind her Success*. London: Routledge, 51–78.

Grote, G. (1869) *A History of Greece; From the Earliest Period to the Close of the Generation Contemporary with Alexander the Great* (new edn, 12 vols). London: John Murray.

Gunter, A. C. (2009) *Greek Art and the Orient*. New York: Cambridge University Press.

Habicht, C. (1970) *Gottmenschentum und griechische Städte*. Munich: Beck.

—(1996) 'Athens, Samos, and Alexander the Great', *Proceedings of the American Philosophical Society* 140: 397–405.

Hall, J. (2002) *Hellenicity: Between Ethnicity and Culture*. Chicago and London: Chicago University Press.

—(2007) *A History of the Archaic Greek World, ca. 1200–479 BC*. Oxford: Blackwell.

Hamilton, C. D. (1979) *Sparta's Bitter Victories. Politics and Diplomacy in the Corinthian War*. Ithaca and London: Cornell University Press.

Hammer, D. (2002) *The* Iliad *as Politics. The Performance of Political Thought*. Norman: University of Oklahoma Press.

—(2005) 'Plebiscitary Politics in Archaic Greece', *Historia* 54: 107–31.

Hammond, N. G. L. (1967) *Epirus*. Oxford: Oxford University Press.

—(1989) *The Macedonian State: The Origins, Institutions and History*. Oxford: Oxford University Press.

—(1994) 'Illyrians and North-west Greeks', in *Cambridge Ancient History* VI, 2nd edn. Cambridge: Cambridge University Press, 422–43.

Hammond, N. G. L., and G. T. Griffith (1979) *A History of Macedonia vol. 2: 550–336 BC*. Oxford: Oxford University Press.

Hansen, M. H. (1975) *Eisangelia. The Sovereignty of the People's Court in Athens in the Fourth Century BC and the Impeachment of Generals and Politicians*. Odense: Odense University Press.

—(1991) *The Athenian Democracy in the Age of Demosthenes. Structures, Principles and Ideologies*, trans. J. A. Crook. Oxford: Blackwell.

—(2002) 'Was the *Polis* a State or a Stateless Society', in T. H. Nielsen (ed.), *Even More Studies in the Ancient Greek* Polis*; Papers from the Copenhagen Polis Centre 6 (*Historia* Einzelschriften 162). Stuttgart: Franz Steiner Verlag, 17–47.

—(2004) 'Stasis as an Essential Aspect of the *Polis*', in M. H. Hansen and T. H. Nielsen (eds), *An Inventory of Archaic and Classical* Poleis. Oxford: Oxford University Press, 124–9.

—(2006) *Polis: An Introduction to the Ancient Greek City-State*. Oxford: Oxford University Press.

Harrell, S. (2002) 'King or Private Citizen: Fifth-century Sicilian Tyrants at Olympia and Delphi', *Mnemosyne* 55: 439–64.

Hartog, F. (1988) *The Mirror of Herodotus*, trans. J. Lloyd. Berkeley and Los Angeles: University of California Press.

Harvey, F. D. (1965) 'Two Kinds of Equality', *C&M* 26: 101–46.

—(1966) 'Corrigenda', *C&M* 27: 99–100.

Hatzopoulos, M. B. (1996) *Macedonian Institutions under the Kings*, 2 vols. Athens: Κέντρον Ἑλληνικῆς καὶ Ρωμαϊκῆς Ἀρχαιότητος τοῦ Ἐθνικοῦ Ἰδρύματος Ἐρευνῶν.

—(2001) 'Macedonian Palaces: Where King and City Meet', in I. Nielsen (ed.), *The Royal Palace Institution in the First Millenium BC. Regional Development and Cultural Interchange between East and West*. Athens: The Danish Institute at Athens, 187–97.

Havelock, E. A. (1969) '"Dikaiosune". An Essay in Greek Intellectual History', *Phoenix* 23: 49–70.

—(1978) *The Greek Concept of Justice: From its Shadow in Homer to its Substance in Plato*. Cambridge, MA and London: Harvard University Press.

Heisserer, A. J. (1980) *Alexander the Great and the Greeks: The Epigraphic Evidence*. Norman: University of Oklahoma Press.

Helly, B. (1995) *L'État Thessalien. Aleuas le Roux, les tetrades et les* tagoi. Lyon: Maison de l'Orient méditerranée.

Henderson, J. (2003) 'Demos, Demagogue, Tyrant in Attic Old Comedy', in K. Morgan (ed.), *Popular Tyranny: Sovereignty and its Discontents in Ancient Greece*. Austin: University of Texas Press, 155–79.

Herman, G. (1997) 'Court Society of the Hellenistic Age', in P. Cartledge, P. Garnsey and E. Gruen (eds), *Hellenistic Constructs: Essays in Culture, History and Historiography*. Berkeley, Los Angeles and London: University of California Press, 199–244.

Hind, J. (1994) 'The Bosporan Kingdom', *Cambridge Ancient History* VI, 2nd edn. Cambridge: Cambridge University Press.

Hitch, S. (2009) *King of Sacrifice. Ritual and Royal Authority in the* Iliad. Cambridge, MA: Center for Hellenic Studies.

Hodkinson, S. (1997) 'The Development of Spartan Society and Institutions in the Archaic Period', in L. G. Mitchell and P. J. Rhodes (eds), *The Development of the Polis in Archaic Greece*. London and New York: Routledge, 83–102.

—(2000) *Property and Wealth in Classical Sparta*. Swansea: Classical Press of Wales.

—(2005) 'The Imaginary Spartan Politeia', in M. H. Hansen (ed.), *The Imaginary Polis*. Copenhagen: The Royal Danish Academy of Sciences and Letters, 221–81.

Hölkeskamp, K.-J. (1992a) 'Written Law in Archaic Greece', *PCPS* n.s. 38: 87–117.

—(1992b) 'Arbitrators, Lawgivers and the "Codification of Law" in Archaic Greece. Problems and Perspectives', *Metis* 7: 49–81.

Hooker, T. J. (1980) *Linear B: An Introduction*. Bristol: Bristol Classical Press.

Hornblower, S. (1991–2008) *A Commentary on Thucydides*, 3 vols. Oxford: Oxford University Press.

—(2004) *Thucydides and Pindar. Historical Narrative and the World of Epinikian Poetry*. Oxford: Oxford University Press.

—(2011) *The Greek World 479–323 BC*, 4th edn. London and New York: Routledge.

Houby-Nielsen, S. (2009) 'Attica: A View from the Sea', in K. A. Raaflaub and H. van Wees (eds), *A Companion to Archaic Greece*. Malden, Oxford and Chichester: Wiley-Blackwell, 189–211.

Huffman, C. (2005) *Archytas of Tarentum: Pythagorean, Philosopher, Mathematician King*. Cambridge: Cambridge University Press.

Humphreys, S. C. (1988) 'The Discourse of Law in Archaic and Classical Greece', *Law and History Review* 6: 465–93.

Hurwitt, J. M. (1985) *The Art and Culture of Early Greece, 1100–480 BC*. Ithaca and London: Cornell University Press.

Hussey, E. (1999) 'Heraclitus', in A. A. Long (ed.) *The Cambridge Companion to Early Greek Philosophy*. Cambridge: Cambridge University Press.

Irwin, E. (2005) *Solon and Early Greek Poetry. The Politics of Exhortation*. Cambridge: Cambridge University Press.

Jackson, A. (1999) 'Three Possible Early Dedications of Arms and Armour at Isthmia', in C. Morgan, *Isthmia* (vol 8), *The Late Bronze Age Settlement and Early Iron Age Sanctuary*. Princeton: Princeton University Press, 161–6.

Jacobsen, Th. (1939) *The Sumerian King List*. Chicago: University of Chicago Press.

Jeffery, L. H. (1973–4) 'Demiourgoi in the Archaic Period', *Arch.Class* 25–6: 319–30.

Jones, C. P. (2010) *New Heroes in Antiquity. From Achilles to Antinoos*. Cambridge MA: Harvard University Press.

Jones, P. (2005) 'Divine and Non-divine Kingship', in D. C. Snell (ed.), *A Companion to the Ancient Near East*. Oxford: Blackwell, 353–65.

Jung, M. (2006) *Marathon und Plataia: Zwei Perserschlacten als 'lieux dé mémoire' im antiken Griechenland*. Göttingen: Vandenhoeck & Ruprecht.

Just, R. (1989) *Women in Athenian Law and Life*. London and New York: Routledge.

Kallet, L. (1998) 'Accounting for Culture in Fifth-century Athens', in D. Boedeker and K. A. Raaflaub (eds), *Democracy, Empire and the Arts in Fifth-Century Athens*. Cambridge MA: Harvard University Press, 45–58.

—(2003) '*Demos Tyrannos*: Wealth, Power and Economic Patronage', in K. Morgan (ed.), *Popular Tyranny: Sovereignty and its Discontents in Ancient Greece*. Austin: University of Texas Press, 117–53.

Kantorowicz, E. H. (1997) *The King's Two Bodies. A Study in Mediaeval Political Theology*, 2nd edn. Princeton: Princeton University Press.

Kennell, N. and N. Luraghi (2009) 'Laconia and Messenia', in K. A. Raaflaub and H. van Wees (eds), *A Companion to Archaic Greece*. Malden, Oxford and Chichester: Wiley-Blackwell, 239–54.

Kilian, K. (1988) 'The Emergence of Wanax Ideology in the Mycenean Palaces', *OJA* 7 (1988): 291–302.

King, C. J. (2010) 'Macedonian Kingship and other Political Institutions', in
J. Roisman and I. Worthington (eds), *A Companion to Ancient Macedonia*.
Malden, Oxford and Chichester: Wiley-Blackwell, 373–91.

Kinzl, K. H. (1979) 'Betrachtungen zur älteren griechischen Tyrannis', *AJAH* 4: 23–45
(= 'Betrachtungen zur älteren griechischen Tyrannis', in K. H. Kinzl [ed.] [1979],
*Die ältere Tyrannis bis zu den Perseskriegen: Beiträge zur greichischen Tyrannis*.
Darmstadt: Wissenschaftliche Buchgesellschaft, 298–325).

Kirk, G. S. (1962) *Heraclitus: The Cosmic Fragments*, 2nd edn. Cambridge:
Cambridge University Press.

—(1985) *The* Iliad*: A Commentary*, vol. 1. Cambridge: Cambridge University Press.

Kirk, G. S., J. E. Raven and M. Schofield (eds) (1983) *The Presocratic Philosophers*,
2nd edn. Cambridge: Cambridge University Press.

Kleingünther, A. (1933) *ΠΡΩΤΟΣ ΕΥΡΕΤΗΣ: Untersuchungen zur Geschichte einer
Fragestellung*. Leipzig: Dieterich'sche Verlagsbuchhandlung.

Kottaridi, A. (2011a) 'The Palace of Aegae', in R. J. Lane Fox (ed.), *Brill's Companion
to Ancient Macedon. Studies in the Archaeology and History of Macedon,
650 BC–300 AD*. Leiden: Brill, 297–333.

—(2011b) 'Appendix: The Palace of Philip II in Aegae', in A. Kottaridi and S. Walker
(eds), *Heracles to Alexander the Great: Treasures from the Royal Capital of
Macedon, a Hellenic Kingdom in the Age of Democracy*. Oxford: Ashmolean
Museum and Hellenic Ministry of Culture and Tourism, 233–6.

Koukouli-Chrysanthaki (2011) 'Philippi', in R. J. Lane Fox (ed.), *Brill's Companion
to Ancient Macedon. Studies in the Archaeology and History of Macedon,
650 BC–300 AD*. Leiden: Brill, 437–52.

Kourouniotis, K. (1910) 'Τὸ ἐν Βάσσαις ἀρχαιότερον ἴερον τοῦ Ἀπόλλωνος', *Eph.
Arch.*, 309–12.

Kremydi, S. (2011) 'Coinage and Finance', in R. J. Lane Fox (ed.), *Brill's Companion
to Ancient Macedon. Studies in the Archaeology and History of Macedon,
650 BC–300 AD*. Leiden: Brill, 159–78.

Kristiansen, K. (1991) 'Chiefdoms, States and Systems of Evolution', in T. Earle (ed.),
*Chiefdoms: Power, Economy and Ideology*. Cambridge: Cambridge University
Press, 16–43.

Kuhrt, A. (1995) *The Ancient Near East c. 3000–33 BC*, 2 vols. London: Routledge.

—(2007) *The Persian Empire. A Corpus of Sources from the Achaemenid Period*,
2 vols. London: Routledge.

Kunze, K. (1950) *Olympishe Forschungen* (vol. II) *Archaïsche Schildebände*. Berlin:
Walter de Gruyter.

—(1991) *Olympische Forschungen* (vol. XXI) *Beinschienen*. Berlin: Walter de Gruyter.

Kurke, L. (1991) *Traffic in Praise. Pindar and the Poetics of Social Economy*. Ithaca and London: Cornell University Press.

—(1993) 'The Economy of *Kudos*', in C. Dougherty and L. Kurke (eds), *Cultural Poetics in Archaic Greece: Cult, Performance, Politics*. New York and Cambridge: Cambridge University Press, 131–63.

—(1994) 'Crisis and Decorum in Sixth-century Lesbos: Reading Alkaios Otherwise', *QUCC* 47: 67–92.

Kyriakou, P. (2002) 'The Violence of Nomos in Pindar fr. 169a', *Materiali e discussion per l'analisi dei testi classici* 48: 195–206.

Læssøe, J. (1959) 'A Statue of Shalmaneser II, from Nimrud', *Iraq* 21: 147–57.

Lane Fox, R. (1985) 'Aspects of Inheritance in the Greek World', in F. D. Harvey and P. Cartledge (eds), *Crux. Essays in Greek History Presented to G. E. M. de Ste Croix on his 75th Birthday*. Exeter: Duckworth and Imprint Academic, 208–32.

—(2000) 'Theognis: An Alternative to Democracy', in R. Brock and S. Hodkinson (eds), *Alternatives to Athens. Varieties of Political Organization and Community in Ancient Greece*. Oxford: Oxford University Press, 35–51.

—(2011) 'Philip's and Alexander's Macedon', in R. J. Lane Fox (ed.), *Brill's Companion to Ancient Macedon. Studies in the Archaeology and History of Macedon, 650 BC–300 AD*. Leiden: Brill, 367–91.

Lateiner, D. (1989), *The Historical Method of Herodotus*. Toronto, Buffalo, and London: University of Toronto Press.

Lavelle, B. M. (1993) *The Sorrow and the Pity. A Prolegomenon to a History of Athens under the Peisistratids, c. 560–510 BC* (*Historia* Einzelshcriften 80). Stuttgart: Franz Steiner Verlag.

—(2005) *Fame, Money and Power: The Rise of Peisistratos and 'Democratic' Tyranny at Athens*. Ann Arbor: University of Michigan Press.

Lawrence, A. W. (1979) *Greek Aims in Fortification*. Oxford: Oxford University Press.

Leahy, D. M. 'The Dating of the Orthagorid Dynasty', *Historia* 17 (1968): 1–23.

Lemos, I. S. (2002) *The Protogeometric Aegean. The Archaeology of the Late Eleventh and Tenth Centuries BC*. Oxford: Oxford University Press.

Lenfant, D. (2004) *Ctésias de Cnide*. Paris: Les Belles Lettres.

Lenz, J. R. (1993) *Kings and the Ideology of Kingship in Early Greece (c. 1200–700 BC): Epic, Archaeology and History*, Diss. Columbia University.

Lesher, J. H. (2001) *Xenophanes of Colophon: Fragments. A Text and Translation with a Commentary*. Toronto: University of Toronto Press.

Lewis, D. M. (1963) 'Cleisthenes and Attica', *Historia* 12: 22–40.

—(1977) *Sparta and Persia*, Cincinnati Classical Studies, New Series 1. Leiden: Brill.

—(1992) 'Mainland Greece, 479–451 BC', in *Cambridge Ancient History* V, 2nd edn. Cambridge: Cambridge University Press, 96–120.

—(1994) 'Sicily, 413–368 BC', *Cambridge Ancient History* VI, 2nd edn. Cambridge: Cambridge University Press, 120–55.

Lewis, S. (2000) 'The Tyrant's Myth', in C. Smith and J. Serrati (eds), *Sicily from Aeneas to Augustus: New Approaches in Archaeology and History*. Edinburgh: Edinburgh Univeristy Press, 97–106.

—(2004) 'καὶ σαφῶς τύραννος ἦν: Xenophon's Account of Euphron of Sicyon', *JHS* 124: 65–74.

—(2006) 'Introduction', in S. Lewis (ed.), *Ancient Tyranny*. Edinburgh: Edinburgh University Press, 1–14.

—(2009) *Greek Tyranny*. Exeter: Bristol Phoenix Press.

—(2011) 'Women and Tyranny', in S. D. Lambert (ed.), *Sociable Man: Essays on Ancient Greek Social Behaviour in Honour of Nick Fisher*. Swansea: Classical Press of Wales, 215–30.

Lincoln, B. (2008), 'The Role of Religion in Achaemenian Imperialism', in N. Brisch (ed.), *Religion and Power: Divine Kingship in the Ancient World and Beyond*. Chicago: University of Chicago Press, 221–41.

Lindsay, T. H. (1991) 'The "God-like man" Versus the "Best Laws": Politics and Religion in Aristotle's *Politics*', *Review of Politics* 53: 488–509.

Liverani, M. (1979) 'The Ideology of the Assyrian Empire', in M. T. Larsen (ed.), *Power and Propaganda. A Symposium on Ancient Empires*. Copenhagen: Akademisk Forlag, 297–317.

Lloyd-Jones, H. (1971) *The Justice of Zeus*. Berkeley, Los Angeles and London: University of California Press.

—(1972) 'Pindar Fr. 169', *HSCP* 76: 45–56.

Lobel, E. and D. Page (1953) *Poetarum Lesbiorum Fragmenta*. Oxford: Oxford University Press.

Lock, R. (1977) 'The Macedonian Army Assembly in the Time of Alexander the Great', *CP* 72: 91–107.

Luraghi, N. (1994) *Tirannidi archaiche in Sicilia e Magna Grecia*. Firenze: Leo S. Olschki Editore.

—(2003) 'The Imaginary Conquest of the Helots', in N. Luraghi and S. E. Alcock (eds), *Helots and their Masters in Laconia and Messenia: Histories, Ideologies, Structures*. Cambridge MA and London: Centre for Hellenic Studies, 109–41.

—(2008) *The Ancient Messenians*. Cambridge: Cambridge University Press.

MacDowell, D. M. (1978) *The Law in Classical Athens*. London: Thames and Hudson.

Maehler, H. (2002), 'Bakchylides and the Polyzalos Inscription', *ZPE* 139: 19–21.

Malkin, I. (1987) *Religion and Colonization in Ancient Greece*. Leiden: Brill.

—(1998) *The Returns of Odysseus: Colonization and Ethnicity*. Berkeley, Los Angeles and London: University of California Press.

—(2001) 'Greek Ambiguities: Between "Ancient Hellas" and "Barbarian Epirus"', in I. Malkin (ed.), *Ancient Perceptions of Greek Ethnicity*. Washington, DC: Center for Hellenic Studies/Trustees for Harvard University, 187–212.

—(2002) 'Exploring the Validity of the Concept of "Foundation": A Visit to Megara Hyblaea', in V. B. Gorman and E. W. Robinson (eds), Oikistes. *Studies in Constiututions, Colonies and Military Power in the Ancient World offered in Honor of A. J. Graham*. Leiden: Brill, 195–224.

—(2009) 'Foundations', in K. A. Raaflaub and H. van Wees (eds), *A Companion to Archaic Greece*. Malden, Oxford and Chichester: Wiley–Blackwell, 373–94.

—(2011) *A Small Greek World. Networks in the Ancient Mediterranean*. Oxford: Oxford University Press.

Mandel, J. (1980) 'Jason: The Tyrant of Pherae, Tagus of Thessaly, as Reflected in Ancient Sources and Modern Literature – The Image of the "New" Tyrant', *RivStorAnt* 10: 47–77.

Mann, Ch. (2007) *Die Demagogen und das Volk. Zur politischen Kommunikation im Athen des 5. Jahrhunderts v. Chr.* Berlin: Akadamie Verlag.

Maran, J. (2001) 'Political and Religious Aspects of Architectural Change on the Upper Citadel of Tiryns. The Case of Building T', in R. Laffineur and R. Hägg (eds), *POTNIA. Deities and Religion in the Aegean Bronze Age* [*Aegaeum* 22]. Liège/Austin: Université de Liège in collaboration with the University of Texas, 113–22.

—(2006) 'Coming to Terms with the Past: Ideology and Power in Late Helladic IIIC', in S. Deger-Jalkotzy and I. S. Lemos (eds), *Ancient Greece: From Mycenean Palaces to the Age of Homer*. Edinburgh: Edinburgh University Press, 123–79.

Marincola, J. (2001) *Greek Historians, Greece and Rome*, New Surveys in the Classics no. 31. Oxford: Oxford University Press.

Mazarakis Ainian, A. (1997) *From Rulers' Dwellings to Temples: Architecture, Religion and Society in Early Iron Age Greece (1100–700 BC)*. Jonsered: Paul Åströms Förlag.

—(2004) 'From the Beginnings to the Archaic Age. Hero Cults of Homeric Society', in K. Buraselis *et al.* 'Heroiserung und Apotheose', *ThesCRA*, vol. 2. Los Angeles: J. Paul Getty Museum, 131–40.

—(2006) 'The Archaeology of *Basileis*', in S. Deger-Jalkotzy and I. S. Lemos (eds), *Ancient Greece: From Mycenean Palaces to the Age of Homer*. Edinburgh University Press: Edinburgh, 181–211.

McDonald, W. A., W. D. E Coulson and J. Rosser (eds) (1983) *Excavations at Nichoria in Southwest Greece. Volume III: Dark Age and Byzantine Occupation.* Minneapolis: University of Minnesota Press.

McGlew, J. F. (1993) *Tyranny and Political Culture in Ancient Greece.* Cambridge: Cambridge University Press.

Meiggs, R. and D. M. Lewis (eds) (1988) *A Selection of Greek Historical Inscriptions to the End of the Fifth Century BC*, rev. edn. Oxford: Oxford University Press.

Mélèze Mordzejewski, J. (2005) 'Greek Law in the Hellenistic Period: Family and Marriage', in M. Gagarin and D. Cohen (eds), *The Cambridge Companion to Ancient Greek Law.* Cambridge: Cambridge University Press, 343–54.

Mettam, R. (1988) *Power and Faction in Louis XIV's France.* Oxford and New York: Basil Blackwell.

Meyer, E. A. (2012) 'Two Grants of *Politeia* and the Molossians at Dodona', *ZPE* 180: 205–16.

Millender, E. (2009) 'The Spartan Dyarchy: A Comparative Perspective', in S. Hodkinson (ed.), *Sparta: Comparative Approaches.* Swansea: Classical Press of Wales, 1–67.

Miller, Jr, F. D. (2005) 'Naturalism', in C. Rowe and M. Schofield (eds), *The Cambridge History of Greek and Roman Political Thought.* Cambridge: Cambridge University Press, 321–43.

Miller, M. C. (1997) *Athens and Persia in the Fifth Century BC. A Study in Cultural Receptivity.* Cambridge, New York and Melbourne: Cambridge University Press.

Mitchell, B. (1966) 'Cyrene and Persia', *JHS* 86: 99–113.

—(2000) 'Cyrene: Typical or Atypical?', in R. Brock and S. Hodkinson (eds), *Alternatives to Athens. Varieites of Political Organization and Community in Ancient Greece.* Oxford: Oxford University Press, 82–102.

Mitchell, L. G. (1997) *Greeks Bearing Gifts. The Private use of Public Relationships, 435-323 BC.* Cambridge: Cambridge University Press.

—(2006a) 'Tyrannical Oligarchs at Athens', in S. Lewis (ed.), *Ancient Tyranny.* Edinburgh: Edinburgh University Press, 178–87.

—(2006b) 'Greeks, Barbarians and Aeschylus' *Suppliants*', *G&R* 53 (2006), 205–23.

—(2007a) 'Born to Rule? The Argead Royal Succession', in W. Heckel, P. Wheatley and L. Tritle (eds), *Alexander's Empire: Formulation to Decay.* Claremont: Regina, 61–74.

—(2007b) *Panhellenism and the Barbarian in Archaic and Classical Greece.* Swansea: Classical Press of Wales.

—(2008) 'Thucydides and the Monarch in Democracy', *Polis* 25: 1–30.

—(2009) 'The Rules of the Game: Three Studies in Friendship, Equality and Politics',

in L. Mitchell and L. Rubinstein (eds), *Greek History and Epigraphy. Essays in Honour of P. J. Rhodes*. Swansea: Classical Press of Wales, 1–32.

—(2012) 'The Ruling Women of Archaic and Classical Greece', *CQ* 62: 1–21.

—(2013a) 'Alexander the Great: Divinity and the Rule of Law', in L. Mitchell and C. Melville (eds), *Every Inch a King: Comparative Studies on Kings and Kingship in the Ancient and Medieval Worlds*. Leiden: Brill, 91–107.

—(forthcoming 2013b) 'Remembering Cyrus the Persian: Exploring Monarchy and Freedom in Classical Greece', in E. Ben Zvi and D. Edelman (eds), *Bringing the Past to the Present in the Late Persian and Early Hellenistic Period: Images of Central Figures*. Oxford: Oxford University Press.

—(forthcoming 2013c) 'Herodotus' Cyrus and Political Freedom', in A. Ansari (ed.), *Perceptions of Iran: History, Myths and Nationalism from Medieval Persia to the Islamic Republic*. London and New York: I. B. Tauris.

Mitchell, L. G. and C. Melville (2013) ' "Every Inch a King". Kings and Kingship in the Ancient and Medieval Worlds', in L. Mitchell and C. Melville (eds), *Every Inch a King: Comparative Studies on Kings and Kingship in the Ancient and Medieval Worlds*. Leiden: Brill, 1–21.

Mitchell, L. G. and P. J. Rhodes (1996) 'Friends and Enemies in Athenian Politics', *G&R* 43: 11–30.

Mondi, R. (1980) '*Skēptouchoi Basileis*: Divine Kingship in Early Greece', *Arethusa* 13: 203–16.

Moretti, L. (1957) *Olympionikai. I vincitori negli antichi agoni Olimpici*. Rome: Signorelli.

Morgan, C. (1990) *Athletes and Oracles*. Cambridge: Cambridge University Press.

—(1993) 'The Origins of Pan-Hellenism', in N. Marinatos and R. Hägg (eds), *Greek Sanctuaries: New Approaches*. London and New York: Routledge, 18–44.

—(2003) *Early Greek States beyond the Polis*. London and New York: Routledge.

—(2007) 'Debating Patronage: The Cases of Argos and Corinth', in S. Hornblower and C. Morgan (eds), *Pindar's Poetry, Patrons and Festivals*. Oxford: Oxford University Press, 213–63.

—(2009) 'The Early Iron Age', in K. A. Raaflaub and H. van Wees (eds), *A Companion to Archaic Greece*. Malden, Oxford and Chichester: Wiley-Blackwell, 43–63.

Morris, I. (1986) 'The Use and Abuse of Homer', *ClassAnt* 5: 81–138.

—(1989) *Burial and Ancient Society: The Rise of the Greek City-state*. Cambridge: Cambridge University Press.

—(1991a) 'The Archaeology of Ancestors: The Saxe/Goldstein Hypothesis Revisited', *Cambridge Archaeological Journal* 1: 147–69.

—(1991b) 'The Early *Polis* as City and State', in J. Rich and A. Wallace-Hadrill (eds), *City and Country in the Ancient World*. Routledge: London and New York, 24–57.

—(1992) *Death Ritual and Social Structure in Classical Antiquity*. Cambridge: Cambridge University Press.

—(1996) 'The Strong Principle of Equality and the Archaic Origins of Greek Democracy', in J. Ober and C. Hedrick (eds), *Dēmokratia: A Conversation on Democracies, Ancient and Modern*. Princeton: Princeton University Press, 19–48.

—(1997) 'Periodization and the Heroes: Inventing a Dark Age', in M. Golden and P. Toohey (eds), *Inventing Ancient Culture: Historicism, Periodization and the Ancient World*. London and New York: Routledge, 96–131.

—(1999) 'Iron Age Greece and the Meaning of "Princely Tombs"', in R. Ruby (ed.), *Les princes de la protohistoire et l'émergence de l'état*. Naples and Rome: Centre Jean Bérard/École française de Rome, 57–80.

—(2000) *Archaeology as Cultural History. Words and Things in Iron Age Greece*. Malden and Oxford: Blackwell.

—(2009) 'The Eighth-Century Revolution', in K. A. Raaflaub and H. van Wees (eds), *A Companion to Archaic Greece*. Malden, Oxford and Chichester: Wiley-Blackwell, 64–80.

Morris, S. (2003) 'Imaginary Kings: Alternatives to Monarchy in Early Greece', in K. A. Morgan (ed.), *Popular Tyranny: Sovereignty and its Discontents*. Austin: University of Texas, 1–24.

Mosley, D. J. (1971) 'Spartan Kings and Proxeny', *Athenaeum*[2] 49: 433–5.

Mossé, C. (1969) *La tyrannie dans la Grèce antique*. Paris: Presses Universitaires de France.

—(2004) *Alexander: Destiny and Myth*, trans. J. Lloyd. Edinburgh: Edinburgh University Press.

Mosshamer, A. A. (1982) 'The Date of the First Pythiad – Again', *GRBS* 23: 15–30.

Most, G. W. (1999) 'The Poetics of Early Greek Philosophy', in A. A. Long (ed.), *The Cambridge Companion to Early Greek Philosophy*. Cambridge: Cambridge University Press, 332–62.

Moulton, C. (1972) 'Antiphon the Sophist, On Truth', *TAPA* 103: 329–66.

Müller, S. (2010) 'Philip II', in J. Roisman and I. Worthington (eds), *A Companion to Ancient Macedonia*. Malden MA, Oxford and Chichester: Wiley-Blackwell, 166–85.

Munn, M. (2006) *The Mother of the Gods, Athens, and the Tyranny of Asia. A Study of Sovereignty in Ancient Religion*. Berkeley, Los Angeles and London: University of California Press.

Munson, R. V. (2001) *Telling Wonders. Ethnographic and Political Discourse in the Work of Herodotus*. Ann Arbor: University of Michigan Press.

Murakawa, K. (1957), 'Demiurgos', *Historia* 6: 385–417.

Murray, O. (1983a) *Early Greece*, 2nd edn. London: Fontana Press.

—(1983b) 'The Symposion as Social Organisation', in R. Hägg (ed.), *The Greek Renaissance of the Eighth Century BC: Tradition and Innovation. Proceedings of the Second International Symposium at the Swedish Institute in Athens, 1–5 June, 1981*. Stockhom: Svenska Institutet i Athen, 195–9.

Musson, A. (2013), 'Ruling "Virtually"? Royal Images in Medieval English Law Books', in L. Mitchell and C. Melville (eds), *Every Inch a King: Comparative Studies on Kings and Kingship in the Ancient and Medieval Worlds*. Leiden: Brill, 151–71.

Nadon, C. (2001) *Xenophon's Prince. Republic and Empire in the* Cyropaedia. Berkeley, Los Angeles and London: University of California Press.

Nafissi, M. (1991) *Lanascita del* kosmos. *Studi sulla storia e la società di Sparta*. Napoli: Edizioni Scientiche Italiane/Università degli Studi di Perugia.

—(1999) 'From Sparta to Taras: *Nomima, Ktiseis* and Relationships between Colony and Mother City', in S. Hodkinson and A. Powell (eds), *Sparta: New Perspectives*. London and Swansea: Duckworth for the Classical Press of Wales, 245–72.

Nagy, G. (1990) *Pindar's Homer. The Lyric Possession of an Epic Past*. Baltimore and London: Johns Hopkins University Press.

—(2003) *Homeric Responses*. Austin: University of Texas Press.

Newell, W. R. (1991) 'Superlative Virtue: The Problem of Monarchy in Aristotle's *Politics*', in C. Lord and D. O'Connor (eds), *Essays on the Foundation of Aristotelian Political Science*. Berkeley, Los Angeles and Oxford: University of California Press, 192–211.

Nielsen, T. H. (2007) *Olympia and the Classical Hellenic City-State Culture*. Copenhagen: The Royal Danish Academy of Sciences and Letters.

Oakley, F. (2006) *Kingship: The Politics of Enchantment*. Malden, Oxford and Carlton: Blackwell.

Ober, J. (1996) *Athenian Revolution. Essays on Ancient Greek Democracy and Political Theory*. Princeton: Princeton University Press.

—(2002) *Political Dissent in Democratic Athens. Intellectual Critics of Popular Rule*. Princeton: Princeton University Press.

O'Connor, D. and D. P. Silverman (1995) 'Introduction', in D. O'Connor and D. P. Silverman (eds), *Ancient Egyptian Kingship*. Leiden, New York and Köln: Brill, XVII–XXVII.

Oded, B. (1992) *War, Peace and Empire: Justifications for War in Assyrian Royal Inscriptions*. Wiesbaden: Ludwig Reichert.

Ogden, D. (1996) *Greek Bastardy*. Oxford: Oxford University Press.

—(1997) *The Crooked Kings of Ancient Greece*. London: Duckworth.

—(1999) *Polygamy, Prostitutes and Death: The Hellenistic Dynasties*. London and Swansea: Duckworth with the Classical Press of Wales.

Oost, S. (1976) 'The Tyrant Kings of Syracuse', *CP* 71: 224–36.

Osborne, M. J. (1981) *Naturalization in Athens*, 4 vols. Brussels: Paleis der Academeïn.

Osborne, R. (1987) *Classical Landscape with Figures: The Ancient Greek City and its Countryside*. London: George Philip.

—(1998) 'Early Greek Colonization? The Nature of Greek Settlement in the West', in N. Fisher and H. van Wees (eds), *Archaic Greece: New Approaches and New Evidence*. London and Swansea: Duckworth and Classical Press of Wales, 251–69.

—(2004) *Greek History*. London and New York: Routledge.

—(2009) *Greece in the Making 1200–478 BC*, 2nd edn. London: Routledge.

Ostwald, M. (1955) 'The Athenian Legislation against Tyranny and Subversion', *TAPA* 86, 103–28.

—(1965) 'Pindar, *Nomos*, and Heracles (Pindar, frg. 169 [Snell²] + *POxy*. No. 2450, frg. 1)', *HSCP* 69: 109–38.

—(1969) *Nomos and the Beginnings of Athenian Democracy*. Oxford: Oxford University Press.

—(2000) *Oligarchia. The Development of a Constitutional Form in Ancient Greece* (*Historia* Einzelschriften 144). Stuttgart: Franz Steiner Verlag.

Ostwald, M. and J. P. Lynch (1994) 'The Growth of Schools and the Advance of Knowledge', *Cambridge Ancient History* VI, 2nd edn. Cambridge: Cambridge University Press, 592–633.

Page, D. (1955) *Sappho and Alcaeus. An Introduction to the Study of Ancient Lesbian Poetry*. Oxford: Oxford University Press.

Palagia, O. (2009) 'Self-Presentation in the Panhellenic Sanctuaries of Delphi and Olympia in the Classical Period', in N. Kaltsas (ed.), *Athens-Sparta. Contributions to the Research on the History and Archaeology of the Two City-States*. New York: Alexander S. Onassis Public Benefit Foundation (USA), 32–40.

Palaima, T. G. (1995) 'The Nature of the Mycenean *Wanax*: Non-Indo-European Origins and Priestly Functions', in P. Rehak (ed.), *The Role of the Ruler in the Prehistoric Aegean. Proceedings of a Panel Discussion presented at the Annual Meeting of the Archaeological Institute of America New Orleans, Louisiana 28 December 1992 with Additions*. Liège and Austin: University of Liège and University of Texas, 119–43.

Panagiotou, S. (1983) 'Empedocles on his Own Divinty', *Mnemosyne* 36: 276–85.

Parker, R. (1996) *Athenian Religion: A History*. Oxford: Oxford University Press.

—(2005) *Polytheism and Society at Athens*. Oxford: Oxford University Press.

—(2011) *On Greek Religion*. Ithaca and London: Cornell University Press.

Parker, V. (1998) '*Tyrannos*. The Semantics of a Political Concept from Archilochus to Aristotle', *Hermes* 126: 145–72.

—(2007) 'Tyrants and Lawgivers', in H. A. Shapiro (ed.), *The Cambridge Companion to Archaic Greece*. New York: Cambridge University Press, 13–39.

Parker Pearson, M. (1999) *The Archaeology of Death and Burial*. Stroud: The History Press.

Patterson, J. (2007) 'Friends in High Places: The Creation of the Court of the Roman Emperor', in A. J. S. Spawforth (ed.), *The Court and Court Societies in Ancient Monarchies*. Cambridge: Cambridge University Press, 121–56.

Pavese, C. O. (1968) 'The New Heracles Poem of Pindar', *HSCP* 72: 47–88.

—(1993). 'On Pindar, fr. 169', *HSCP* 95: 143–57.

Perdrizet, P. (1908) *Les Fouilles de Delphes* (vol. 5[1]), *Monuments Figures, Petits Bronze, Terres-cuites, Antiquités Diverses*. Paris: E. de Boccard.

Perreau-Saussine, E. (2006) 'Why Draw a Politics from Scripture? Bossuet and the Divine Right of Kings', *Hebraic Political Studies* 1: 224–37.

Philipp, H. (1994) 'Olympia, die Peloponnes und die Westgriechen', *JDAI* 109: 77–92.

Piérart, M. (2004). 'Argolis', in M. H. Hansen and T. H. Nielsen (eds), *An Inventory of Archaic and Classical* Poleis. Oxford: Oxford University Press, 599–619.

Podlecki, A. J. (1966) 'The Political Significance of the Athenian "Tyrannicide" Cult', *Historia* 15: 129–41.

Poggo, G. (2006) *Weber. A Short Introduction*. Cambridge and Malden: Polity Press.

Polignac, F. de (1995) *Cults, Territory and the Origin of the Greek City-State*, trans. J. Lloyd. Chicago: University of Chicago Press.

Pomeroy, S. (1975) *Goddesses, Whores, Wives and Slaves*. New York: Dorset.

—(1997) *Families in Classical and Hellenistic Greece*. Oxford: Oxford University Press.

—(2002) *Spartan Women*. Oxford: Oxford University Press.

Popham, M. R., E. Toloupa and L. H. Sackett (1982) 'The Hero of Lefkandi', *Antiquity* 56: 169–74, plates XXII–V.

Popham, M. R., P. G. Calligas and L. H. Sackett (1993) *Lefkandi II: The Protogeometric Building at Toumba*, Part 2. Athens: British School at Athens.

Price, S. R. F. (1984) *Rituals and Power. The Roman Imperial Cult in Asia Minor*. Cambridge: Cambridge University Press.

Qviller, B. (1981) 'The Dynamics of Homeric Society', *SO* 56: 109–55.

Raaflaub, K. A. (1996) 'Equalities and Inequalities in Athenian Democracy', in J. Ober and C. Hedrick (eds), *Dēmokratia: A Conversation on Democracies, Ancient and Modern*. Princeton: Princeton University Press, 139–74.

—(1997) 'Soldiers, Citizens, and the Evolution of the Early Greek *Polis*', in L. G.
    Mitchell and P. J. Rhodes (eds), *The Development of the* Polis *in Archaic Greece*.
    London and New York: Routledge, 49–59.

—(1998) 'A Historian's Headache: How to Read "Homeric Society"?', in N. Fisher and
    H. van Wees (eds), *Archaic Greece: New Evidence and New Approaches*. London/
    Swansea: Duckworth with the Classical Press of Wales, 169–93.

—(2004) *The Discovery of Freedom in Ancient Greece*, rev. edn, trans. R. Franciscono.
    Chicago: University of Chicago Press.

—(2005) 'Poets, Lawgivers, and the Beginnings of Political Reflection in Archaic
    Greece', in C. Rowe and M. Schofield (eds), *The Cambridge History of Greek and
    Roman Political Thought*. Cambridge: Cambridge University Press, 23–59.

—(2007) 'Searching for Peace in the Ancient World', in K. A. Raaflaub (ed.), *War and
    Peace in the Ancient World*. Malden, Oxford and Carlton: Blackwell, 1–33.

—(2009) 'Learning from the Enemy: Athenian and Persian Instruments of Power',
    in J. Ma, N. Papazarkadas and R. Parker (eds), *Interpreting the Athenian Empire*.
    London: Duckworth, 89–124.

Raschke, W. J. (1988) 'Images of Victory: Some New Considerations of Athletic
    Monuments', in W. J. Raschke (ed.), *The Archaeology of the Olympics. The
    Olympics and Other Festivals in Antiquity*. Madison: University of Wisconsin
    Press.

Redfield, J. M. (1994) *Nature and Culture in the Iliad. The Tragedy of Hector*,
    expanded edn. Durham and London: Duke University Press.

Rhodes, P. J. (1995) 'The "Acephalous" Polis', *Historia* 44: 153–67.

—(2000) 'Oligarchs in Athens', in R. Brock and S. Hodkinson (eds), *Alternatives
    to Athens: Varieties of Political Organization and Community in Ancient Greece*.
    Oxford: Oxford University Press, 119–36.

—(2003) *A Commentary on the Aristotelian* Athenaion Politeia, 2nd edn. Oxford:
    Oxford University Press.

—(2009) 'State and Religion in Athenian Inscriptions', *G&R* 56: 1–13.

—(2010) *History of the Classical Greek World, 478–323 BC*, 2nd edn. Oxford:
    Blackwell.

—(2013) 'Theseus the Democrat', in N. Sekunda and K. Ulanowski (eds), *Concepts of
    Humanity and Divinity in Antiquity*, Akanthina Monograph Series No. 6. Gdansk:
    Fundacja Rozwoju Uniwersytetu Gdanskiego.

Rhodes, P. J. and R. Osborne (eds) ( 2003) *Greek Historical Inscriptions, 404–323 BC*.
    Oxford: Oxford University Press.

Rolley, C. (1990) 'En regardant l'aurige', *BCH* 114: 285–97.

Rollinger, R. (2011) 'Herrsherkult und Königsvergöttlichung bei Teispiden und

Achaimeniden. Realität oder Fiktion?', in L.-M. Günther and S. Plischke (eds), *Studien zum vorhellistischen und hellenistischen Herrscherkult*. Berlin: Verlag Antike e.K, 11–54.

Root, M. C. (1985) 'The Parthenon Frieze and the Apadana Reliefs at Persepolis: Reassessing a Programmatic Relationship', *AJA* 89: 103–20.

—(2013) 'Defining the Divine in Achaemenid Persian Kingship: The View from Bisitun', in L. Mitchell and C. Melville (eds), *Every Inch a King: Comparative Studies on Kings and Kingship in the Ancient and Medieval Worlds*. Leiden: Brill, 23–65.

Runciman, W. G. (1982) 'The Origins of States: The Case of Archaic Greece', *CSSH* 24: 351–77.

Rutter, N. K. (2000) 'Syracusan Democracy: "Most Like the Athenian"?', in R. Brock and S. Hodkinson (eds), *Alternatives to Athens. Varieties of Political Organization and Community in Greece*. Oxford: Oxford University Press, 137–51.

Sahlins, M. (1958) *Social Stratification in Polynesia*. Seattle: University of Washington Press.

—(1968) *Tribesmen*. Englewood Cliffs: Prentice Hall.

—(2004) *Stone Age Economics*, 2nd edn. Abingdon: Routledge.

Sakellariou, M. B. (1990) *Between Memory and Oblivion. The Transmission of Early Greek Historical Traditions* [*Meletēmata* 12]. Athens: Research Centre for Greek and Roman Antiquity/National Hellenic Research Foundation.

Salmon, J. B. (1984) *Wealthy Corinth: A History of the City to 338 BC*. Oxford: Oxford University Press.

—(1997) 'Lopping off the Heads: Tyrants, Politics and the *Polis*', in L. G. Mitchell and P. J. Rhodes (eds), *The Development of the* Polis *in Archaic Greece*. London and New York: Routledge, 60–73.

Salviat, F. (1958) 'Une nouvelle loi Thasienne: institutions judicaires et fêtes réligieuses à la fin du IV$^e$ siècle av. J.C.', *BCH* 82: 193–267.

Sanders. L. J. (1987) *Dionysius I of Syracuse and Greek Tyranny*. London, New York and Sydney: Croom Helm.

Schaps, D. M. (2004) *The Invention of Coinage and the Monetization of Ancient Greece*. Ann Arbor: University of Michigan Press.

Scheidel, W. (2011) 'Monogamy and Polygyny', in B. Rawson (ed.), *A Companion to Families in the Greek and Roman Worlds*. Malden, Oxford and Chichester: Blackwell, 108–15.

Schmitt, T. (2009) 'Kein König im Palast. Heterodoxe Überlegungen zur politischen und sozialen Ordnung in der mykenischen Zeit', *Historische Zeitschrift* 288: 281–346.

Schofield, M. (1986) '*Euboulia* in the *Iliad*', *CQ* 36: 6–31.

—(2005) 'Aristotle: An Introduction', in C. Rowe and M. Schofield (eds), *The

*Cambridge History of Greek and Roman Political Thought*. Cambridge: Cambridge University Press, 310–20.

—(2006) *Plato: Political Philosophy*. Oxford: Oxford University Press.

Schuller, W. and W. Leschhorn (2004) 'Religionsgeschichtliche Entwicklung', in K. Buraselis *et al.* 'Heroiserung und Apotheose', *ThesCRA*, vol. 2. Los Angeles: J. Paul Getty Museum, 140–2.

Schultz, P. (2007) '"Leochares" Argead portraits in the Philippeion', in P. Schultz and R. von den Hoff (eds), *Early Hellenistic Portraiture: Image, Style, Context*. New York and Cambridge: Cambridge University Press, 205–33.

Scott, M. (2010) *Delphi and Olympia. The Spatial Politics of Panhellenism in the Archaic and Classical Periods*. Cambridge: Cambridge University Press.

Seaford, R. (1994) *Reciprocity and Ritual: Homer and Tragedy in the Developing City-state*. Oxford: Oxford University Press.

—(2003) 'Tragic Tyranny', in K. A. Morgan (ed.), *Popular Tyranny: Sovereignty and its Discontents*. Austin: University of Texas, 95–115.

—(2004) *Money and the Early Greek Mind*. Cambridge: Cambridge University Press.

—(2012) *Cosmology and the Polis. The Social Construction of Space and Time in the Tragedies of Aeschylus*. Cambridge: Cambridge University Press.

Seager, R. (1994) 'The King's Peace and the Second Athenian Naval Confederacy', in *Cambridge Ancient History* VI, 2nd edn. Cambridge: Cambridge University Press, 156–86.

Sealey, R. (1976) *A History of the Greek City States 700–338 BC*. Berkeley, Los Angeles and London: University of California Press.

—(1994) *The Justice of the Greeks*. Ann Arbor: University of Michigan Press.

Service, E. R. (1971) *Primitive Social Organization: An Evolutionary Perspective*, 2nd edn. New York: Random House.

Shear, T. L. Jr (1994) Ἰσονόμους τ᾽ Ἀθήνας ἐποησάτην: 'The Agora and Democracy', in W. D. E. Coulson, O. Palagia, T. L. Shear Jr, H. A Shapiro and F. J. Frost (eds), *The Archaeology of Athens under the Democracy*. Oxford: Oxbow Books, 224–8.

Shipley, G. (1987) *A History of Samos 800–188 BC*. Oxford: Oxford University Press.

Sider, D. (2006) 'The New Simonides and the Question of Historical Elegy', *AJP* 127: 327–46.

Skalník, P. (2001–2) 'Chiefdoms and Kingdoms in Africa: Why they are Neither States nor Empires', available at http://www.uneca.org/itca/governance/documents/chiefdomsandkingdoms.pdf (retrieved 3 February 2009).

Snell, B. (1986) *Tragicorum Graecorum Fragmenta*, vol. 1, 2nd edn. Göttingen: Vadenhoeck and Ruprecht.

Snodgrass, A. (1980) *Archaic Greece: The Age of Experiment*. London, Melbourne and Toronto: J. M. Dent & Sons.

—(1999) *Arms and Armour of the Greeks*, rev. edn. Baltimore: Johns Hopkins University Press.

—(2006) *Archaeology and the Emergence of Greece*. Edinburgh: Edinburgh University Press.

Sommerstein, A. H. (ed.) (1991) *Aristophanes:* Birds, rev. edn. Oxford: Aris & Phillips.

—(ed.) (2001) *Wealth*. Warminster: Aris & Phillips.

Sordi, M. (1958) *La Lega Tessala Fino ad Alessandro Magno*. Rome and Milan: Instituto Italiano per la Storia Antica.

—(1997) 'I *tagoi* tessali come suprema magistratura militare del *koinon* tessalico', *Topoi* 7: 177–82.

Sourvinou-Inwood, C. (1995) *'Reading' Greek Death to the End of the Classical Period*. Oxford: Oxford University Press.

Spawforth, A. J. S. (2007) 'The Court of Alexander the Great between Europe and Asia', in A. J. S. Spawforth (ed.), *The Court and Court Society in Ancient Monarchies*. Cambridge: Cambridge University Press, 82–120.

Spencer, J. (2002) 'Kingship', in A. Barnard and J. Spencer (eds), *Encyclopedia of Social and Cultural Anthropology* 3rd edn. London and New York: Routledge, 467–8.

Spencer, N. (2000) 'Exchange and Stasis in Archaic Mytilene', in R. Brock and S. Hodkinson (eds), *Alternatives to Athens. Varieties of Political Organization and Community in Greece*. Oxford: Oxford University Press, 68–81.

Sprawski, S. (1999) *Jason of Pherae. A Study on the History of Thessaly in the Years 431–370 BC*. Krakow: Jagiellonian University Press.

—(2006) 'Alexander of Pherae: *Infelix* Tyrant', in S. Lewis (ed.), *Ancient Tyranny*. Edinburgh: Edinburgh University Press, 135–47.

—(2004) 'Were Lycophron and Jason Tyrants of Pherae? Xenophon on the History of Thessaly', in C. Tuplin (ed.), *Xenophon and his World* (*Historia* Einzelschriften 172). Stuttgart: Franz Steiner Verlag, 437–52.

Starn, D. T. (2001) *Images in Mind. Statues in Archaic and Classical Greek Literature and Thought*. Princeton and Oxford: Princeton University Press.

Starr, C. G. (1961) 'The Decline of the Early Greek Kings', *Historia* 10: 129–38.

Stewart, A. (1993) *Faces of Power. Alexander's Image and Hellenisitic Politics*. Berkeley, Los Angeles and Oxford: University of California Press.

Stein-Hölkeskamp, E. (2009) 'The Tyrants', in K. A. Raaflaub and H. van Wees (eds), *A Companion to Archaic Greece*. Malden, Oxford and Chichester: Wiley-Blackwell, 100–16.

Strauss, B. S. (1997) 'The Problem of Periodization: The Case of the Peloponnesian

War', in M. Golden and P. Toohey (eds), *Inventing Ancient Culture: Historicism, Periodizaton and the Ancient World*. London and New York: Routledge, 165–75.

Tadmoor, H. (1999) 'World Dominion: The Expanding Horizon of the Assyrian Empire', in L. Milano, S. De Martino, G. B. Lanfranchi (eds), *Landscapes: Territories, Frontiers and Horizons in the Ancient Near East*. Padua: Sargon, 55–62.

Talbert, J. A. (1974) *Timoleon and the Revival of Greek Sicily 344–317 BC*. Cambridge: Cambridge University Press.

Tandy, D. W. (1997) *Warriors into Traders. The Power of the Market in Early Greece*. Berkeley, Los Angeles and London: University of California Press.

Thalmann, W. G. (1998) *The Swinherd and the Bow. Representations of Class in the* Odyssey. New York: Cornell University Press.

Thatcher, M. R. (2011) *A Variable Tapestry: Identity and Politics in Greek Sicily and Southern Italy*. Diss. Brown University.

Theodossiev, N. (1994) 'The Thracian Ithyphallic Altar from Polianthos and the Sacred Marriage of the Gods', *OJA* 13: 313–23.

Thomas, R. (1989) *Oral Tradition and Written Record in Classical Athens*. Cambridge: Cambridge University Press.

—(2007) 'Fame, Memorial, and Choral Poetry: The Origins of Epinikian Poetry – An Historical Study', in S. Hornblower and C. Morgan (eds), *Pindar's Poetry, Patrons and Festivals*. Oxford: Oxford University Press, 141–66.

Thompson, H. A. and R. E. Wycherley (1972) *Athenian Agora XIV. The Agora of Athens: The History, Shape and Uses of an Ancient City Centre*. Princeton: Princeton University Press.

Thorne, T. C. (1993) 'Black Bird, "King of the Mahars:" Autocrat, Big Man, Chief', *Ethnohistory* 40.3: 410–37

Thür, G. (1996) 'Oaths and Dispute Settlement in Ancient Greek Law', in L. Foxhall and A. D. E. Lewis (eds), *Greek Law in its Political Setting. Justifications not Justice*. Oxford and New York: Oxford University Press, 57–72.

Tod, M. (1933–48) *A Selection of Greek Historical Inscriptions*, 2 vols. Oxford: Oxford University Press.

Todd, S. (1993) *The Shape of Athenian Law*. Oxford: Oxford University Press.

Tuplin, C. J. (2013) 'Xenophon's *Cyropaedia*: Fictive History, Political Analysis and Thinking with Iranian Kings', in L. Mitchell and C. Melville (eds), *Every Inch a King. Comparative Studies on Kings and Kingship in the Ancient and Medieval Worlds*. Leiden: Brill, 67–90.

Umholtz, U. (2002) 'Architraval Arrogance? Dedicatory Inscriptions in Greek Architecture of the Classical Period', *Hesperia* 71: 261–93.

Vansina, J. (1985) *Oral Tradition as History*. Oxford: University of Wisconsin Press.

Vernant, J.-P. (1980) *Myth and Society in Ancient Greece*, trans. J. Lloyd. Brighton/ New Jersey: Harvester Press/Humanities Press.

Vlastos, G. (1953) 'Isonomia', *AJP* 74: 337–66.

—(1981) 'ΙΣΟΝΟΜΙΑ ΠΟΛΙΤΙΚΗ', *Platonic Studies*. Princeton: Princeton University Press, 164–203.

Wace, A. J. B. (1929) 'The Lead Figurines', in R. M. Dawkins (ed.), *The Sanctuary of Artemis Orthia at Sparta* (*JHS* suppl. vol. 5). London: British School at Athens, 249–84.

Wallace, M. B. (1970) 'Early Greek *Proxenoi*', *Phoenix* 24: 189–208.

Weber, M. (1947) *The Theory of Social and Economic Organization*, trans. A. M. Henderson and T. Parsons. New York: The Free Press.

—(1948) *From Max Weber: Essays in Sociology*, trans. H. H. Gerth and C. Wright Mills. Abingdon and New York: Routledge.

Wees, H. van (1988) 'Kings in Combat: Battles and Heroes in the *Iliad*', *CQ* 38: 1–24.

—(1992) *Status Warriors. War, Violence and Society in Homer and History*. Amsterdam: G. C. Gieben.

—(1998) 'Greeks Bearing Arms: The State, the Leisure Class and the Display of Weapons in Archaic Greece', in N. Fisher and H. van Wees (eds), *Archaic Greece: New Approaches and New Evidence*. London and Swansea: Duckworth with the Classical Press of Wales, 333–78.

—(2000) 'Megara's Mafiosi: Timocracy and Violence in Theognis', in R. Brock and S. Hodkinson (eds), *Alternatives to Athens. Varieties of Political Organization and Community in Ancient Greece*. Oxford: Oxford University Press, 52–67.

—(2002) 'Tyrants, Oligarchs and Citizen Militias', in A. Chaniotis and P. Ducrey (eds), *Army and Power in the Ancient World*. Stuttgart: Franz Steiner, 61–82.

—(2003) 'Conquerors and Serfs: Wars of Conquest and Forced Labour in Archaic Greece', in N. Luraghi and S. E. Alcock (eds) *Helots and their Masters in Laconia and Messenia: Histories, Ideologies, Structures*. Cambridge MA and London: Centre for Hellenic Studies, 33–80.

—(2004) *Greek Warfare: Myths and Realities*. London: Duckworth.

—(2006) 'From Kings to Demi-Gods: Epic Heroes and Social Change', in S. Deger-Jalkotzy and I. S. Lemos (eds), *Ancient Greece: From Mycenean Palaces to the Age of Homer*. Edinburgh: Edinburgh University Press, 363–79.

—(2009) 'The Economy', in K. A. Raaflaub and H. van Wees (eds), *A Companion to Archaic Greece*. Malden, Oxford and Chichester: Wiley-Blackwell, 444–67.

Weisehöfer, J. (1996) *Ancient Persia*, trans. A. Azodi. London and New York: I. B. Tauris.

—(2004) ' "O Master, Remember the Athenians": Herodotus and Persian Foreign

Policy', in V. Karageorhis and I. Taifacos (eds), *The World of Herodotus*. Nicosia: A. G. Leventis Foundation, 209–20.

—(2009a) 'Greeks and Persians', in K. A. Raaflaub and H. van Wees (eds), *Companion to Archaic Greece*. Malden, Oxford and Chichester: Wiley-Blackwell, 162–85.

—(2009b) 'The Achaemenid Empire', in I. Morris and W. Scheidel (eds), *The Dynamics of Ancient Empires: State Power from Assyria to Byzantium*. Oxford: Oxford University Press, 66–98.

West, M. L. (1971–2) *Iambi et Elegi Graeci*, vol. 1. Oxford: Oxford University Press.

—(1978) *Theognidis et Phocylidis Fragmenta et Adespota Quaedam Gnomica*. Berlin: Walter de Gruyter.

—(1992) *Iambi et Elegi Graeci*, vol. 2, 2nd edn. Oxford: Oxford University Press.

—(1997) *The East Face of Helicon. West Asiatic Elements in Early Poetry and Myth*. Oxford: Oxford University Press.

Westbrook, R. (1992) 'The Trial Scene in the *Iliad*', *HSCP* 94: 53–76.

Westlake, H. D. (1935) *Thessaly in the Fourth Century*. London: Methuen and Co.

—(1976) 'Re-election to the Ephorate', *GRBS* 17: 343–52.

—(1994) 'Dion and Timoleon', in *Cambridge Ancient History* VI, 2nd edn. Cambridge: Cambridge University Press, 693–722.

White, M. (1958) 'The Dates of the Orthagorids', *Phoenix* 12: 2–14.

Whitehead, D. (2009) '*Andragathia* and *Aretē*', in L. G. Mitchell and L. Rubinstein (eds), *Greek History and Epigraphy. Essays in honour of P. J. Rhodes*. Swansea: Classical Press of Wales, 47–58.

Whitley, J. (1991a) 'Social Diversity in Dark Age Greece', *ABSA* 86: 341–65.

—(1991b) *Style and Society in Ancient Greece*. Cambridge: Cambridge University Press.

—(1994) 'The Monuments that Stood before Marathon: Tomb Cult and Hero Cult in Archaic Attica', *AJA* 98: 213–30.

Wilgaux, J. (2011) 'Consubstantiality, Incest and Kinship in Ancient Greece', in B. Rawson (ed.), *A Companion to Families in the Greek and Roman Worlds*. Malden, Oxford and Chichester: Blackwell, 217–30.

Winter, F. E. (1971) *Greek Fortifications*. London: Routledge and Kegan Paul.

Woodbury, L. (1945) 'The Epilogue of Pindar's *Second Pythian*', *TAPA* 76: 11–30.

Wolff, H. J. (1946) 'The Origin of Judicial Litigation among the Greeks', *Traditio* 4: 31–87.

Woolf, G. (2008) 'Divinity and Power in Ancient Rome', in N. Brisch (ed.), *Religion and Power: Divine Kingship in the Ancient World and Beyond*. Chicago: Oriental Institute of the University of Chicago, 243–59.

Wright, J. C. (1994) 'The Spatial Configuration of Belief: The Archaeology of
Mycenean Religion', in S. Alcock and R. Osborne (eds), *Placing the Gods:
Sanctuaries and Sacred Space in Ancient Greece*. Oxford: Oxford University Press,
37–78.

—(1995) 'From Chief to King in Mycenean Society', in P. Rehak (ed.), *The Role of the
Ruler in the Prehistoric Aegean. Proceedings of a Panel Discussion presented at the
Annual Meeting of the Archaeological Institute of America New Orleans, Louisiana
28 December 1992 with Additions*. Liège and Austin: University of Liège and
University of Texas, 63–80.

—(2006) 'The Formation of the Mycenean Palace, in S. Deger-Jalkotzy and I. S.
Lemos (eds), *Ancient Greece: From Mycenean Palaces to the Age of Homer*.
Edinburgh: Edinburgh University Press, 7–52.

Wycherley, R. E. (1978) *The Stones of Athens*. Princeton: Princeton University Press.

Young, D. C. (1993) 'Something Like the Gods: A Pindaric Theme and the Myth of
*Nemean* 10', *GRBS* 34: 123–32.

# Index